EARLY FLEMISH PAINTING

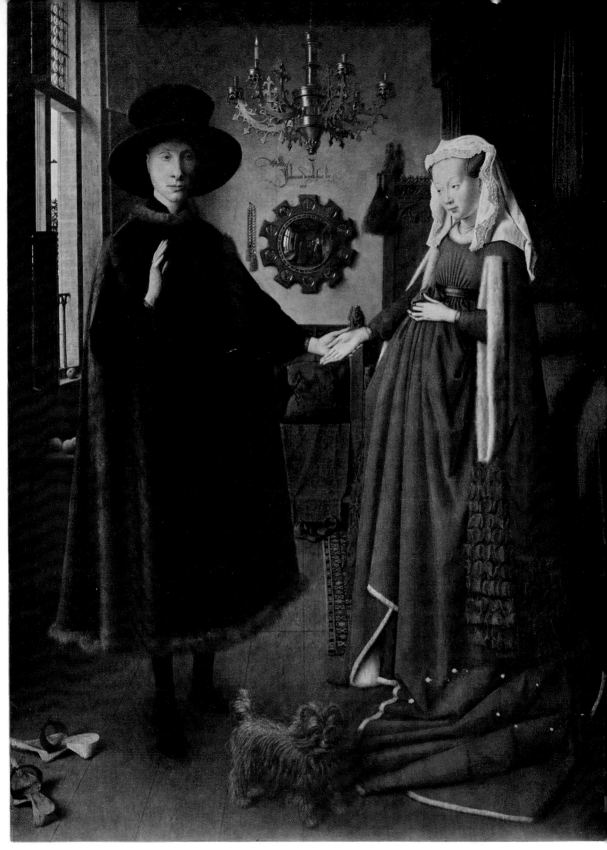

Jan van Eyck: *The Marriage of Giovanni Arnolfini and Giovanna Cenami* (1434)
London, National Gallery

EARLY FLEMISH PAINTING

Margaret Whinney

FABER AND FABER
London: 24 Russell Square

First published in mcmlxviii
by Faber and Faber Limited
24 Russell Square London WC1
Printed in Great Britain by
R. MacLehose and Company Ltd
The University Press, Glasgow
All rights reserved

S.B.N. 571 08491 5

To
ANTHONY BLUNT

CONTENTS

PLATES

COLOUR

MONOCHROME
at the end of the book

[11]

7. (a) Robert Campin(?) : *The Nativity*. Dijon, Musée.
 (b) Jacques Daret : *The Nativity* (1434). Lugano, Baron Thyssen-Bornemiza Coll.
8. Robert Campin(?) : *The Dying Thief*. Frankfurt, Staedel Institut.
9. (a) Robert Campin(?) : *The Dying Thief* (*detail*). Frankfurt, Staedel Institut.
 (b) After Robert Campin(?) : *The Descent from the Cross* : Liverpool, Walker Art Gallery.
10. (a) Robert Campin(?) : *St. Veronica*. Frankfurt, Staedel Institut.
 (b) Robert Campin(?) : *Virgin and Child*. Frankfurt, Staedel Institut.
11. (a) Robert Campin(?) : *Heinrich Werl and St. John the Baptist* (1438). Madrid, Prado.
 (b) Robert Campin(?) : *St. Barbara* (1438). Madrid, Prado.
12. Hubert and Jan van Eyck : *The Adoration of the Lamb altar* (*wings open*). (Finished 1432). Ghent, Cathedral.
13. Hubert and Jan van Eyck : *The Adoration of the Lamb altar, Adoration panel*. (Finished 1432). Ghent, Cathedral.
14. (a) Hubert and Jan van Eyck : *The Adoration of the Lamb altar* (*detail, head of the Virgin*). (Finished 1432). Ghent, Cathedral.
 (b) Hubert and Jan van Eyck : *The Adoration of the Lamb altar* (*detail, group of Virgins from Adoration panel*). (Finished 1432). Ghent, Cathedral.
15. Hubert and Jan van Eyck : *The Adoration of the Lamb altar* (*wings closed*). (Finished 1432). Ghent, Cathedral.
16. Hubert and Jan van Eyck : *The Adoration of the Lamb altar* (*detail, Jodoc Vyt*). (Finished 1432). Ghent, Cathedral.
17. Jan van Eyck : *Portrait of a young Man* (1432). London, National Gallery.
18. (a) Jan van Eyck : *The Madonna of Canon van der Paele* (1436). Bruges, Musée Communale des Beaux-Arts.
 (b) Hubert and Jan van Eyck(?) : *The Three Maries at the Sepulchre*. Rotterdam, Boymans-Van Beuningen Museum.
19. Jan van Eyck : *St. Barbara* (1437). Antwerp, Musée Royal des Beaux-Arts.
20. (a) Jan van Eyck : *Margaret van Eyck* (1439). Bruges, Musée Communale des Beaux-Arts.
 (b) Jan van Eyck : *A Man in a Turban* (1433). London, National Gallery.
21. (a) Jan van Eyck : *Cardinal Albergati* (*so-called*). Drawing. Dresden, Staatliches Kunstsammlungen.
 (b) Jan van Eyck : *Cardinal Albergati* (*so-called*). Vienna, Kunsthistorisches Museum.

22. (a) Jan van Eyck : *The Madonna of Chancellor Rolin.* Paris, Louvre.

 (b) Hubert van Eyck(?) : *The Hours of Turin. Birth of the Baptist.* Turin, Museo Civico.

23. (a) Jan van Eyck : *The Madonna of the Fountain* (1439). Antwerp, Musée Royal des Beaux-Arts.

 (b) Jan van Eyck : *The Madonna in a Cathedral.* Berlin-Dahlem, Staatliche Museen.

24. Roger van der Weyden : *The Descent from the Cross.* Madrid, Prado.

25. (a) Roger van der Weyden : *St. Luke painting the Virgin.* Boston, Museum of Fine Arts.

 (b) Roger van der Weyden : *Christ appearing to His Mother.* New York, Metropolitan Museum.

26. (a) Roger van der Weyden : *The Descent from the Cross* (*detail*). Madrid, Prado.

 (b) Roger van der Weyden : *The Descent from the Cross* (*detail*). Madrid, Prado.

27. Roger van der Weyden : *St. Luke painting the Virgin* (*detail*). Boston, Museum of Fine Arts.

28. Roger van der Weyden : *The Annunciation.* Paris, Louvre.

29. Roger van der Weyden : *Portrait of a Young Woman.* London, National Gallery.

30. Roger van der Weyden : *The Crucifixion.* Vienna, Kunsthistorisches Museum.

31. Roger van der Weyden : *The Last Judgment.* Beaune, Hôtel Dieu.

32. (a) Roger van der Weyden : *The Madonna and Child with four Saints.* Frankfurt, Staedel Institut.

 (b) Roger van der Weyden : *The Entombment.* Florence, Uffizi.

33. (a) Roger van der Weyden : *The Virgin and Child.* San Marino, California, Henry E. Huntington Library.

 (b) Roger van der Weyden : *Philippe de Croy.* Antwerp, Musée Royal des Beaux-Arts.

34. Roger van der Weyden : *The Adoration of the Magi* (*The St. Columba altar*). Munich, Staatsgemäldesammlungen.

35. (a) Petrus Christus : *Edward Grimston* (1446). Gorhambury, Earl of Verulam Coll.

 (b) Petrus Christus : *St. Eligius and two Lovers* (1449). New York, Mr. Robert E. Lehmann Coll.

36. Petrus Christus : *The Virgin and Child with St. Francis and St. Jerome* (1457) Frankfurt, Staedel Institut.

37. Petrus Christus : *The Nativity*. Washington, National Gallery.
38. Dirk Bouts : *The Last Supper altar (centre panel)* (1464–68). Louvain, S. Pierre.
39. (a) Dirk Bouts : *The Last Supper altar (left wing panels)* (1464–68). Louvain, S. Pierre.
 (b) Dirk Bouts : *The Last Supper altar (right wing panels)* (1464–68). Louvain, S. Pierre.
40. Dirk Bouts : *The Justice of the Emperor Otto, Execution panel* (1473–82). Brussels, Musées Royaux des Beaux-Arts.
41. Dirk Bouts : *The Justice of the Emperor Otto, The Ordeal by Fire* (1470–73). Brussels, Musées Royaux des Beaux-Arts.
42. (a) Dirk Bouts : *The Justice of the Emperor Otto. The Ordeal by Fire (detail)* (1470–73). Brussels, Musées Royaux des Beaux-Arts.
 (b) Dirk Bouts : *Portrait of a Man* (1462). London, National Gallery.
43. (a) Dirk Bouts : *The Descent from the Cross*. Granada, Capilla Real.
 (b) Dirk Bouts : *The Adoration of the Magi (The Pearl of Brabant altar)*. Munich, Staatsgemäldesammlungen.
44. (a) Hugo van der Goes : *The Lamentation*. Vienna, Kunsthistorisches Museum.
 (b) Hugo van der Goes : *The Fall of Man*. Vienna, Kunsthistorisches Museum.
45. Justus of Ghent : *The Communion of the Apostles* (1472). Urbino, Palazzo Ducale.
46. Hugo van der Goes : *The Adoration of the Magi (The Monforte altar)*. Berlin-Dahlem, Staatliche Museen.
47. Hugo van der Goes : *The Adoration of the Shepherds (The Portinari altar) (centre panel)*. (Before 1476). Florence, Uffizi.
48. (a) Hugo van der Goes : *The Portinari altar (left wing)*. (Before 1476). Florence, Uffizi.
 (b) Hugo van der Goes : *The Portinari altar (right wing)*. (Before 1476). Florence, Uffizi.
49. Hugo van der Goes : *The Portinari altar (detail of right wing)*. (Before 1476). Florence, Uffizi.
50. Hugo van der Goes : *The Death of the Virgin*. Bruges, Musée Communale des Beaux-Arts.
51. (a) Hugo van der Goes : *The Portinari altar (detail of left wing)*. (Before 1476). Florence, Uffizi.
 (b) Hugo van der Goes : *The Death of the Virgin (detail)*. Bruges, Musée Communale des Beaux-Arts.

52. (a) Hugo van der Goes: *The Bonkil wings, The Trinity.* H.M. the Queen (on loan to National Gallery of Scotland, Edinburgh).

(b) Hugo van der Goes: *The Bonkil wings, donor panel.* H.M. the Queen (on loan to National Gallery of Scotland, Edinburgh).

53. Hans Memlinc: *The Donne Triptych.* London, National Gallery.

54. (a) Hans Memlinc: *The Marriage of St. Catherine* (1479). Bruges, Hôpital de St. Jean.

(b) Hans Memlinc: *The Shrine of St. Ursula* (1489). Bruges, Hôpital de St. Jean.

55. Hans Memlinc: *The Man with the Arrow.* Washington, National Gallery.

56. Hans Memlinc: *The Adoration of the Magi (The Floreins altar)* (1479). Bruges, Hôpital de St. Jean.

57. (a) Hans Memlinc: *The Diptych of Martin van Nieuwenhove (left panel)* (1487). Bruges, Hôpital de St. Jean.

(b) Hans Memlinc: *The Diptych of Martin van Nieuwenhove (right panel)* (1487). Bruges, Hôpital de St. Jean.

58. (a) Geertgen tot Sin Jans: *The Virgin in Glory.* Rotterdam, Boymans-Van Beuningen Museum.

(b) Hans Memlinc: *Portrait of a Man.* Venice, Accademia.

59. (a) Aelbert van Ouwater: *The Raising of Lazarus.* Berlin-Dahlem, Staatliche Museen.

(b) Geertgen tot Sin Jans: *The Relations of the Virgin in a Church.* Amsterdam, Rijksmuseum.

60. Geertgen tot Sin Jans: *The Burning of the Bones of St. John the Baptist.* Vienna, Kunsthistorisches Museum.

61. Geertgen tot Sin Jans: *The Lamentation.* Vienna, Kunsthistorisches Museum.

62. The Master of the Virgo inter Virgines: *The Entombment.* Liverpool, Walker Art Gallery.

63. Geertgen tot Sin Jans: *Christ as the Man of Sorrows.* Utrecht, Centraal Museum.

64. Geertgen tot Sin Jans: *St. John the Baptist in the Wilderness.* Berlin-Dahlem, Staatliche Museen.

65. Jerome Bosch: *The Cure of Folly.* Madrid, Prado.

66. Jerome Bosch: *The Hay-wain (centre panel).* Madrid, Prado.

67. Jerome Bosch: *The Temptation of St. Anthony.* Madrid, Prado.

68. Jerome Bosch: *The Temptation of St. Anthony.* Lisbon, Museu Nacional de Arte Antiga.

69. Jerome Bosch: *The Temptation of St. Anthony* (*detail*). Lisbon, Museu Nacional de Arte Antiga.
70. Jerome Bosch: *The Garden of Delights* (*centre panel*). Madrid, Prado.
71. (a) Jerome Bosch: *The Garden of Delights* (*left wing*). Madrid, Prado.
 (b) Jerome Bosch: *The Garden of Delights* (*right wing*). Madrid, Prado.
72. Jerome Bosch: *The Adoration of the Magi*. Madrid, Prado.
73. Jerome Bosch: *Christ Mocked*. London, National Gallery.
74. (a) Gerard David: *The Judgment of Cambyses* (1498). Bruges, Musée Communale des Beaux-Arts.
 (b) Gerard David: *The Crucifixion*. Genoa, Palazzo Bianco.
75. Gerard David: *The Baptism of Christ* (1502–8). Bruges, Musée Communale des Beaux-Arts.
76. Gerard David: *The Virgin and Child with female Saints* (1509). Rouen, Musée.
77. (a) Quentin Matsys: *The Virgin and Child enthroned*. London, National Gallery.
 (b) Quentin Matsys: *St. Mary Magdalen*. Antwerp, Musée Royal des Beaux-Arts.
78. Gerard David: *The Virgin with a Bowl of Milk*. Brussels, Musées Royaux des Beaux-Arts.
79. Quentin Matsys: *The St. Anne altar* (*centre panel*) (1507–9). Brussels, Musées Royaux des Beaux-Arts.
80. Quentin Matsys: *The Entombment* (1508–11). Antwerp, Musée Royal des Beaux-Arts.
81. Quentin Matsys: *The Banker and his Wife* (1512). Paris, Louvre.
82. (a) Quentin Matsys: *Erasmus* (1517). Rome, Museo Nazionale.
 (b) Quentin Matsys: *Aegidius* (1517). Longford Castle, Earl of Radnor Coll.
83. (a) Quentin Matsys: *Portrait of a Man* (1513). Paris, Jacquemart-André Museum.
 (b) Quentin Matsys: *Portrait of a Canon*. Vaduz, H.S.H. The Prince of Liechtenstein Coll.
84. (a) Quentin Matsys: *Portrait of a Man*. Frankfurt, Staedel Institut.
 (b) Bernard van Orley: *Dr. Georges de Zelle*. Brussels, Musées Royaux des Beaux-Arts.
85. (a) Quentin Matsys: *The Rattier Madonna* (1529). Paris, Louvre.
 (b) Joos van Cleve: *The Virgin and Child*. Cambridge, Fitzwilliam Museum.

PLATES

86. (a) Quentin Matsys and Joachim Patinir : *The Temptation of St. Anthony.* Madrid, Prado.

 (b) Joachim Patinir : *St. Jerome.* Madrid, Prado.

87. Joachim Patinir : *St. Jerome (detail).* Madrid, Prado.

88. Mabuse : *The Adoration of the Magi.* London, National Gallery.

89. Mabuse : *The Virgin and Child (The Malvagna Triptych, centre panel).* Palermo, Museo.

90. Mabuse : *St. Luke painting the Virgin.* Prague, Rudolfinum.

91. Adriaen Isenbrandt : *The Virgin of Sorrows.* Bruges, Musée Communale des Beaux-Arts.

92. Mabuse : *Neptune and Amphitrite* (1516). Berlin-Dahlem, Staatliche Museen.

93. Mabuse : *Danae* (1527). Munich, Staatsgemäldesammlungen.

94. (a) Mabuse : *The Children of Christian II of Denmark.* (After 1523). H.M. the Queen, Hampton Court Palace.

 (b) Mabuse : *The Carondelet Diptych (left panel)* (1517). Paris, Louvre.

 (c) Mabuse : *The Carondelet Diptych (right panel)* (1517). Paris, Louvre.

95. Bernard van Orley : *The Trials of Job* (1521). Brussels, Musées Royaux des Beaux-Arts.

96. Bernard van Orley : *The Virgin and Child* (1522). Madrid, Prado.

ACKNOWLEDGEMENTS

I acknowledge with gratitude the gracious permission of Her Majesty the Queen for permission to reproduce pictures in the Royal Collection (*52 a and b, 94 a*) and the kindness of the following owners who have allowed me to reproduce works in their possession: Mr. Robert E. Lehmann, New York (*35 b*); H.S.H. The Prince of Liechtenstein, Vaduz (*83 b*); The Earl of Radnor, Longford Castle (*82 b*); Count Antoine Seilern (*5*); Baron Thyssen-Bornemiza, Lugano (*7 b*); The Earl of Verulam, Gorhambury (*35 a*).

I am also grateful to the authorities of the following galleries, who have allowed me to reproduce pictures under their care: Amsterdam, Rijksmuseum (*59 b*); Antwerp, Musée Royale des Beaux-Arts (*33 b, 77 b, 80*); Beaune, Hôtel Dieu (*31*); Berlin-Dahlem, Staatliche Museen (*23 b, 46, 59 a, 64*); Bruges, Hôpital de St. Jean (*57 a* and *b*); Bruges, Musée Communale des Beaux-Arts (*50, 74 a, 75*); Brussels, Musées Royaux des Beaux-Arts (*41, 42 a, 84 b*); Cambridge, Fitzwilliam Museum (*85 b*); Chantilly, Musée Condé (*1 a and b*); Dijon, Musée (*2 a and b, 3 a, 4 a, 7 a*); Dresden, Staatliche Kunstsammlungen (*21 a*); Florence, Uffizi (*32 b*); Frankfurt, Staedel Institut (*8, 9 a, 10 a and b, 32 a, 84 a*); Genoa, Palazzo Bianco (*74 b*); Granada, Capilla Real (*43 a*); Lisbon, Museu Nacional de Arte Antiga (*68, 69*); Liverpool, Walker Art Gallery (*9 b*); London, National Gallery (*Frontispiece, 17, 20 b, 29, 42 b, 53, 73, 77 a, 88*); Madrid, Prado (*4 b, 11 a and b, 24, 26 a and b*); Munich, Staatsgemäldesammlungen (*34*); New York, Metropolitan Museum, The Cloisters Collection (*6*); Palermo, Museo (*89*); Paris, Louvre (*B, 22 a, 28, 85 a, 94 b and c*); Paris, Musée Jacquemart-André (*83 a*); Rome, Museo Nazionale (*82 a*); Rotterdam, Boymans-Van Beuningen Museum (*18 b, 58 a*); San Marino, California, Henry E. Huntington Library (*33 a*); Turin, Museo Civico (*22 b*); Urbino, Palazzo Ducale (*45*); Utrecht, Centraal Museum (*63*); Venice, Accademia (*58 b*); Vienna, Kunsthistorisches Museum (*21 b, 30*).

Photographs have also been supplied by the following: Amsterdam, Rijksmuseum (*44 b*); Brussels, A.C.L. (*12, 13, 14 a and b, 22 a, 28, 32 b, 33 b, 39 a and b, 41, 42 a, 43 a, 45, 50, 51 b, 57 a and b, 80, 82 a, 89*); Dijon, P. Rémy

ACKNOWLEDGEMENTS

(2 a and b, 3 a and b); The Hague, A. Fréquin *(7 a)*; London, The Arts Council *(21 b)*; London, National Gallery *(35 a)*; London, Royal Academy of Arts *(9 b, 20 a, 58 b, 82 b, 83 a and b, 84 b)*; Lugano, Brunel *(7 b)*; Paris, CAP *(31)*; Paris, Giraudon *(1 a and b, 94 b and c)*.

PREFACE

This book is intended to be an Introduction to the painting of the Low Countries between *c*. 1420 and *c*. 1530. Much of the ground it covers is, and is likely to remain, exceedingly controversial, and though an attempt has been made to summarize the main points at issue and to record modern opinions concerning them, new solutions would be both out of place in a general book and beyond the intentions of the writer.

My thanks are due to many students of the Courtauld Institute who have discussed different aspects of the subject with me and have often enlivened them by their arguments; and to my former colleagues, above all to the Director of the Institute, for encouraging me to write the book. I am deeply grateful to Professor E. K. Waterhouse for his constant help and for his kindness in reading the book in draft, and to Mr. Stephen Rees Jones for advice on questions of technique. To Dr. Peter Murray I owe a special debt for his patient help over the laborious collection of photographs for the plates. It must, however, be clearly stated that weaknesses which may appear in the book are not their responsibility but my own.

November, 1966 M.D.W.

THE HISTORICAL BACKGROUND
OF THE FIFTEENTH CENTURY

1. INTRODUCTION

The contribution of the Low Countries to the development of European paint-ing in the fifteenth century was very great. Artists, working mainly in the prosperous towns of Bruges and Ghent, Brussels and Tournai, turned their backs on the sweet, decorative late Gothic style, with its elegant, slender but boneless figures, and moved towards a more forceful type of painting in which sturdy figures are set firmly in a room or in front of a landscape. Late Gothic painting, for all its elegance, had often shown great interest in realistic detail, but the new style is interested not only in realism of detail but also in realism of general effect. Indeed, the first great masters of the new manner, Robert Campin and Jan van Eyck, were to devote their main energies to the achieve-ment of an illusion of three-dimensional reality in their two-dimensional paint-ings. This desire to represent reality as actually seen by the human eye was something totally new in Northern painting. A similar conquest of reality was being achieved in the early fifteenth century in Florence by Masaccio and his contemporaries; but in Italy the men of this generation could build on the discoveries of earlier artists, above all on Giotto, and could also learn from examples of the naturalistic art of classical antiquity. Such sources were un-known to Northern artists. They had to find the way themselves, with little on which they could build, and therefore their success becomes all the more remarkable.

The method whereby Flemish painters were to reach their goal was a search-ing analysis of the precise appearance of things, and of the fall of light on both men and objects. They saw that the fall of light was a unifying factor, since it touched all objects within a picture; it also gave to each part a solid shape built up by light and shadow, so that it had a reality of its own. This new and careful observation of the fall of light was combined with technical advances which made it possible to render the luminosity of bright colours and the subtlety of the gradation of shadows.

Colours had hitherto lacked luminosity because the pigments were bound with a medium of white or yolk of egg or both, which made them opaque. Now, though the same pigments, ground to powder by the master or his apprentices were used, they were bound with oil, and so became transparent glazes. It is this use of glazes which gives early Flemish painting its brilliance of hue, for light permeates the coloured glaze and makes the colour glow, instead of being reflected back off an opaque surface. Moreover, the oil seals the colours and prevents them from deteriorating, and, owing to the way in which glazes could be superimposed, a far greater range of colour could be achieved.

All Flemish painting is on wood panel, for canvas had not yet come into use. The wood was carefully chosen, and the panels prepared by covering them with a skin of gesso (finely ground chalk mixed with size) polished to an ivory-like surface. On this the painter drew with his brush, and then worked over the design in an opaque monochrome under-painting, modelling the shadows with care. On top of this under-painting he laid his colours, in two or more layers. The first layer might, for instance, be in light blue opaque colour, over which was superimposed a darker blue translucent glaze. Finally a red glaze of madder might be used in the recesses of the folds to give purplish shadows. Or again, vermilion, which is always an opaque colour, might be used for the first layer, but it would be glazed with madder which is slightly deeper in tone, and so become immensely rich and glowing. This method of building up in layers to a smooth surface, always ending with a transparent layer, was a slow and laborious process, since oil is slow in drying and one glaze could not be superimposed on another till the lower was dry. Moreover, the inherent character of Flemish painting demands much fine detail, only achieved by many minute brush-strokes. The exacting nature of Flemish technique makes it all the more remarkable that the general level attained, even by minor masters, was so high.

The use of oil was not in itself new. It had been used in Northern Europe earlier in the Middle Ages, for instance in the Westminster Retable perhaps given to Westminster Abbey by Henry III about 1270. But in such cases the oil was thick and darkened the colours, whereas the Flemings used refined and clarified oil, mixed for the first time with turpentine to thin the paint, and so rendered the colours more brilliant and glowing. Although the credit for the new development of oil glazes is usually given to Jan van Eyck, it cannot be proved with any certainty that the process was evolved in his workshop only, for other contemporary masters were certainly aware of it, though none at first used it with his assurance.

It is this combination of technical mastery and detailed observation which

gives Early Flemish painting its own peculiar character. The general standard of accomplishment was high, for the Guild requirements were rigorous. An apprenticeship, usually of seven years, had to be served before a man could call himself Master; and after that it was common for a young master to work for three or four years as a journeyman (a man who worked by the day — 'journée' — and was not tied for a long term) before setting up his own studio. Some painters seem hardly to have got beyond the journeyman stage, but there was plenty of work for them, for the greater masters, whose work will be discussed in this book, must all of them have had large studios with a number of trained assistants in order to carry out the many commissions they received. This studio method has made things difficult for the modern art-historian. Many works are known in more than one version, suggesting that they were admired when first created and that repetitions, sometimes with slight variations, were ordered by other patrons from the master's studio. The quality of the repetition is occasionally so high that it is not always easy to be positive which was the original work. Sometimes parts of a version are superior to the rest, in which case it seems probable that those parts may have been painted by the master himself, and the rest done under his eye by his assistants. In other cases a work may exist in several versions, none of which seem to have the sensitivity of the master's own hand, though they are clearly in his style. Here it is possible that the original may have been lost, though not enough is known about studio organization for it to be certain that all versions are necessarily based on a painted original, since it is conceivable that in some cases a master, or even a chief assistant, made a design, and merely super-intended the execution. The manner, however, remains close to that of the master, and the technical quality is often high. Many of these puzzling paintings exist, and are generally and rightly described as 'School of' or 'Workshop of' a known master.

Though the main character of Flemish painting is easy to grasp, many problems beyond the question of workshop pieces exist about the work of individual masters, and also about the relation of one painter to another. To a large extent these are due to accidents of survival. From the time of the Wars of Religion in the sixteenth century down to the Second World War, Flanders and northern France have been more continuously fought over than any other part of Europe. Destruction both of works of art and of documents which might have contained records of them, or information about painters, has been enor-mous. Important works are known to have been destroyed by war, others have disappeared, perhaps as the result of looting, and what has survived is only a small fraction of what once existed. Moreover, those Flemish paintings

which exist are now much scattered. Though many major examples still remain in modern Belgium, some few of them in the churches for which they were painted, others were removed to Spain in the sixteenth century. Both Spain and Flanders have, at different periods, suffered much from looting, and small pictures are easy prey. Some are now in the major galleries of Europe, but others have found their way to public or private collections in America. Although many conclusions can safely be drawn from works which still exist, and from documents giving facts about the lives of artists, it should never be forgotten that judgments must now be based on a part only of the original material, and that though it is probable that enough survives to set the work of most masters in the right perspective, there are often some elements of doubt, because we cannot now see the whole.

Moreover, though some Flemish painters signed and dated their works, others did not. When they did not, the development of a painter's work can only be determined on grounds of the style of those works which are generally accepted. This is a valid method, and indeed the only one which can be used, but the lack of documents should induce caution. The lack of documents is indeed far greater than it is in fifteenth-century Italy, and there is also an almost complete dearth of recorded contemporary opinion concerning Flemish painters. In many cases we know the death dates of artists, but rarely how old they were when they died; in several cases all the dated works of an artist come from a short period late in his life, and it is hard to determine the development of his earlier style. Moreover, no fifteenth-century life of any painter is known to have been written in Flanders, though short and misleading biographies of Jan van Eyck and Roger van der Weyden were included in two Italian collections.[1] It is not until the early sixteenth century that first-hand information about the works and reputation of both living and dead artists can be gleaned from travellers to the Netherlands such as Antonio de Beatis, the secretary of Cardinal Louis of Aragon, who paid a visit in 1517 and Albrecht Dürer, who left a diary of his long stay in 1519–20.[2]

Such a situation, in which facts are few and sometimes confused, but pictures are many, has given rise to much conjecture both about the interpretation of what is known and also about the probable sequence of what has survived. Opinion on some problems is still sharply divided, and it may well be that a final answer can never be given. The major fields of controversy surrounding individual masters will be indicated in later chapters; here it must be emphasized that though details are obscure and arguments about them lengthy, the main achievement of Flemish artists is clear, and cannot be contested.

2. THE HISTORICAL BACKGROUND

The term 'Flemish' has so far been somewhat loosely used to describe the art produced mainly in the southern part of the Low Countries in the fifteenth century. Some writers prefer to use the term 'Netherlandish'. Both require further clarification if the position of the painters and their patrons is to be understood. The County of Flanders was in itself much smaller than modern Belgium, but it included the great trading centres of Ghent and Bruges, and other towns now in northern France, such as Lille. It was, however, only one part, though a very important part, of the group of states running from eastern France to Holland (and therefore including the whole of the Netherlands) which owed allegiance to the Dukes of Burgundy. These facts are of paramount importance for the development of Flemish painting and are therefore worth some further investigation.

The Duchy of Burgundy, which by the middle of the fifteenth century was one of the richest states in Europe, was closely associated with the royal house of France. The original territory, consisting of lands in eastern France, with Dijon as the chief city, had reverted to the French crown in 1363, after the death of the last Capetian Duke, and had immediately been granted by King John of France to his fourth son, Philip the Bold, who had distinguished himself in an attempt to save his father's life at the Battle of Poitiers in 1356. By his marriage to the daughter of the Count of Flanders, by marriages of other members of his house, and by alliances planned with the idea of inheriting territory, Philip at his death in 1404 was able to leave his son, Jean-sans-Peur (1404–19), overlord of large parts of France and the Low Countries. The policy of prudent marriages and alliances was to be continued, and by about 1430 Jean's son, Philip the Good, held a great dominion stretching from Dijon to the Zuyder Zee, which included the whole of modern Belgium and Luxembourg, most of Holland, northern France as far south as Amiens, Lorraine and Upper Alsace as well as the original Burgundian lands in eastern France.

Philip the Bold, the true architect of the Burgundian state, remained throughout his life a Frenchman at heart. He kept his court chiefly at Dijon or Paris, and was indeed to play a great part in French politics, for with his brothers, Louis Duke of Anjou and Jean Duke of Berry, he acted as Regent for his young nephew Charles VI (1380–1422), and when Charles became insane in 1392 he was virtually ruler of France. Though, however, Philip's instincts were pro-French, those of his Flemish subjects were strongly pro-English whenever fighting in the Hundred Years War was renewed, for the Flemish wool merchants, a powerful and wealthy section of the community, depended

on English wool for their cloth weaving. The commercial interests of the Flemish towns not only provided a brake on the political activities of the Dukes — the latter were reluctant to quarrel with independent-minded men who could, if they were humoured, provide them with a great deal of money — but they also laid their mark on the character of Flemish painting. Ghent and Bruges were then the most prosperous towns of Northern Europe. Bruges was still a major port, for ships used in the coastal trade round Europe were small, and the Zwyn (an arm of the sea which has since silted up) was deep enough to take them. Before the rise of Antwerp and London, these towns were the chief general markets for trade between Northern and Southern Europe. Many Italian merchants, among them the Medici, had their resident agents in Bruges; other Italians, such as Giovanni Arnolfini of Lucca, whose portraits by Jan van Eyck will be described later, carried on a trade in Italian silks, and no doubt exported Northern goods in exchange. The merchant community was immensely rich, but like other bourgeois communities, it modelled its taste on that of the aristocracy, and could afford elaborate clothes, good furniture and fine pictures. The Duke's painters were willing enough to work for it.

The Flemish towns were indeed so powerful that they forced Philip's successor, Jean-sans-Peur, to negotiate a treaty with England in return for support which Jean needed because his cousin, Louis, Duke of Orleans was proving a dangerous rival to his policies in France. The long struggle between the Burgundians and Armagnacs (the followers of the Orleans faction) need not be followed here, though it included such dramatic events as the murder of Louis of Orleans in 1407 and of Jean-sans-Peur at the Bridge of Montereau in 1419. Its main effect on Burgundy, and consequently on Flanders, was that the cleavage between French and Burgundian interests became, to a great extent, accepted. The Dukes spent less of their time in France and more in their northern dominions, holding their court in different towns — Lille, Ghent, Bruges and Arras; and finally, though at the price of breaking the English alliance, Philip the Good obtained freedom for life from all feudal dependence on the French King. He thereafter regarded himself as an equal, establishing the Order of the Golden Fleece in 1431, which after the Garter, is still one of the oldest Orders of Chivalry in Europe, holding a court whose richness was the admiration of Europe (in strong contrast to the impoverished court of France), and above all pursuing a policy which was to keep Burgundy out of war for about thirty years. It is, indeed, during the rule of Philip the Good (1419–67) that Flanders enjoyed its greatest prosperity and most of the greatest triumphs of Flemish painting were created. Moreover, the Duke's

realization that scholarship might be so guided that it would contribute to his policy is shown by his foundation in 1426 of the University of Louvain, a move intended both to increase the prestige of Flanders, and also to prevent his subjects from a continued dependence on the University of Paris.

Much of Philip's work was to be undone by his successor, Charles the Bold (1467–77), whose name, Charles-le-Téméraire should more properly be translated as Charles the Rash. His overweening ambition brought him into conflict with a far cleverer man, Louis XI of France who, when Charles's dream of extending his dominions east and south and of aspiring to the succession of the Holy Roman Empire led to war with the Swiss, gave support to his enemies. Charles was killed at the Battle of Nancy in 1477 and his dominions, reduced in size, passed to his young daughter, Mary, who had married Maximilian of Habsburg. The effect of this new situation on Flemish painting will best be discussed in the later chapters of this book.

During the greater part of the fifteenth century, under the wise rule of Philip the Good, the position was fairly stable. Burgundy remained a loose conglomeration of states, in which local interests were strong and so deeply opposed to centralization that no single city became the permanent seat of government. The Duke moved from place to place in his dominions, the permanent Council of State, though technically based at Lille, usually accompanying him. Sometimes painters are known to have possessed houses in a given town, but it is by no means certain, especially in the case of those who worked for the court, that all their works were produced in their own homes. Many Flemish paintings are small, and for these painters would not necessarily have needed a large studio in which to work. A single room in a patron's house might well have been sufficient.

Some works commissioned by rich patrons were almost certainly for use in their private oratories, and so were not widely known. Others were given by a patron to a church, where they could be seen by other painters, who were often much influenced by them. The great majority of paintings were of religious subjects, since religion controlled the lives of all men from the cradle to the grave; but portraiture, as will be seen, plays an important part in the history of Flemish painting, and some secular pictures are known to have been created, though few of these have survived. The court was, however, by no means the only source of patronage. Confraternities, both religious and lay, ordered altarpieces to be set up in churches, the merchants of Ghent and Bruges were prepared to spend money on both portraits and religious paintings, and several important commissions came from foreigners, among them both Italians and Englishmen. There can have been no lack of work for artists;

and it must be remembered that though this book is concerned with pictures, painters were also employed in a number of other ways. Even a great painter was willing to paint candlesticks or to colour statues, to blazon pennons, devise decorations for processions or for feasts, and some at least of them also probably worked on book decoration.[3] The inevitable loss of all the immensely rich decorative work connected with feasts, tourneys and processions, the last both secular and religious, has left a gap in our knowledge of Flemish art which can never be filled. Clothes which were fantastic in cut, brilliant in colour, decorated with jewels, embroidered devices or even little tinkling bells, are described by chroniclers, but cannot now be seen. Nothing except descriptions remain of the elaborate set pieces, generally representing allegories, which were part of every show. Only a few ecclesiastical vestments, notably the splendid set in Vienna, and some ecclesiastical metal-work has survived, and this gives only a small part of the picture of the activities and of the surroundings of Flemish artists and their patrons.

3. THE PATRONAGE OF PHILIP THE BOLD

Although the new style of painting seems to have emerged in the towns of Flanders between about 1420 and 1430, the seeds were sown in work executed for Philip the Bold in Dijon some twenty years earlier. Philip, like his brothers the Dukes of Anjou and Berry, was a great patron of the arts. Berry, indeed, who did not die till 1416, was perhaps the greatest patron of his day in Northern Europe, above all in the field of illuminated books. The best-known of his books, the *Très Riches Heures* (Chantilly) had its Calendar pages (Pls. 1a and 1b) painted shortly before his death by Pol de Limbourg and his brothers, whose name proclaims that they were Flemings. These pages, one for each month of the year, are the quintessence of the courtly style current in many countries of Europe at the beginning of the fifteenth century. Indeed, so widespread is it that it is generally termed International Gothic. It delights in slender figures dressed in the rich fantastic clothes of the day, shown feasting in January, exchanging betrothal rings in the country in April or riding out with their hawks in August. A few, continuing the tradition of the Labours of the Months of the earlier Middle Ages,[4] show rustic occupations, peasants working in the snow and warming themselves in a hut in February, or killing pigs in December. In all, however, the figures lack substance and are tall, with small heads. On the other hand, as in most late Gothic art, there is a great preoccupation with small but vivid details, and the landscapes, rising sharply behind the figures, have great beauty. Each shows a great building

with such accuracy that all can be identified.[5] The realism of the landscape may well be due to the fact that the painters were Flemings and not Frenchmen, but though there is a fascinating account of individual buildings, trees and other objects, there is little attempt to bind figures and setting into a unity. The colours are bright, hard and all equally clear, and though shadows are sometimes observed, they do not run throughout each scene with consistency, and so the fall of light is not yet employed as a unifying factor.

Philip the Bold also owned a book, in this case a Bible, illuminated by the de Limbourg brothers, but though he left a library of about seventy books, he was not nearly so great a bibliophile as his brother, or indeed as his son and grandson, who were to rule Burgundy after him.[6] His chief patronage lay in other fields. In 1384 he founded a new Carthusian monastery, or Chartreuse, at Champmol, close to Dijon, which was to be the burying-place for his house.[7] The works with which this was decorated, though mainly of sculpture and not of painting, are of such importance that they must be considered here. A carved wooden altarpiece was made by Jacques de Baerze between 1392 and 1399 (Pl. 4a). In the centre was the Crucifixion, flanked by the Adoration of the Magi and the Entombment, set under elaborate canopy work. Beyond, on the folding wings, were carved figures of saints. All is in the typical late Gothic manner, the figures being wrapped in soft draperies which curve and swing round their bodies in such a way that the folds make a pleasing linear pattern which has no reference to the forms of the bodies beneath. The backs of the wings, on the other hand, which would be seen when the altar was closed, were not carved but painted by Melchior Broederlam of Ypres (worked 1381–1409) (Pls. 2a and 2b). Each wing has two disconnected scenes; on the left the Annunciation and the Visitation, and on the right the Presentation at the Temple and the Flight into Egypt. Though Broederlam was a Fleming, his work shows the mixture of styles current in France at the time. Most of the figures, like those carved on the front, are enveloped in soft, swinging draperies; the Annunciation and the Presentation take place in fantastic Gothic buildings which bear little relation in size to the figures and which seem to be derived from Italian patterns; the rocky, unreal landscapes behind the Visitation and the Flight shoot sharply up against a gold background. Only in the Flight is there something new. The figure of St. Joseph, squat and sturdy like a peasant, is seen from the back, his head thrown up, drinking from a gourd. This clown-like figure has at once a greater solidity and a greater reality than anything else in the altarpiece, and in both it points the way towards the new developments to come.

Far grander than the wooden altarpiece was the stone sculpture com-

missioned by the Duke for the Chartreuse. Again the artist was a man from the north, Claus Sluter of Haarlem, who counts among the greatest sculptors of Northern Europe. He entered the Duke's service in 1389, was sent to the Duke of Berry's court to see the works of his artists, and to Paris and the cities of Flanders to buy fine materials — alabaster, marble and glass — for the Chartreuse; and was still working on the Duke's tomb at his own death in 1406. On the portal of the Chartreuse (Pl. 3a) Sluter set a standing Virgin and Child between the two doors, and at the sides kneeling figures of the Duke and Duchess with their patron saints.[8] Both design and treatment were new; for though standing Virgins were normal enough on the middle-post or *trumeau* of a French Gothic portal, they were flanked by other standing figures under little canopies at the sides. Such figures in fact played the part of small columns below the arches over the portal, and though they sometimes turn slightly towards each other, the movement is very gentle and they remain tied to the architecture. Sluter's side figures are completely free; they have no relation to the arches above them, and there is an entirely new emotional theme linking the praying figures to the Virgin between them. All the figures are strong and bold. Their draperies, which seem to be made of thick, woollen stuff, fall in heavy folds, though at the same time they stress the bulk and movement of the limbs beneath them. In this vigorous treatment, with the heavy stuff bunched up or falling in large masses on the ground, they are quite unlike the softly draped figures of the wooden altar. The figure of the Duchess is now much damaged, but that of the Duke is a virile, realistic portrait.

The same powerful style, and the same interest in characterization, can be seen in the six prophets who stand round what was once the base of a Calvary, but which has since been turned into a well-head, and is always known to-day as the *Puits de Moïse* (Pl. 3b). This was commissioned in 1395, three prophets being finished by 1402, and the remainder in 1406. Each prophet holds a scroll with the words assigned to him in a mystery play, 'The Trial of Jesus', and each has his individual character — Moses majestic and upright, with his long forked beard, Isaiah lean and bowed with grief, Daniel with head thrown back and eyes straining to see his vision. Above are angels huddled under the parapet, their faces contorted with pain at the thought of the Crucifixion which stood above their heads.

The violence of grief was again expressed in the mourners which Sluter made for the base of the tomb of Philip the Bold. These little figures, muffled in heavy garments, show his superb and original invention. No two are alike; some have their heads bowed and their faces hidden by their hoods, in others the head is thrown back and the ravaged face emerges from a heavy cowl.[9] In

all these works Sluter seems to thrash his way out of the elegance of late Gothic art towards the creation of a new, powerful and realistic style. In this he was the forerunner of the new style of painting, and there can be no doubt that some of the earliest Flemish painters were to be deeply influenced by his work.

ROBERT CAMPIN

The earliest Flemish painter to experiment in the new manner was probably Robert Campin of Tournai (*c.* 1378–1444). His identity, though probable, is not, however, finally established. A considerable body of work, powerful and original in conception, and often daring in its attempt to place figures in their setting, can reasonably be claimed as the output of a single painter, working from some date rather before 1420 and continuing into the 1430's. Certain pictures in this group are very closely connected with documented works of 1434 by a not very original master, Jacques Daret, and with other works of the same decade which are universally assigned to the great painter, Roger van der Weyden, who will be discussed in Chapter IV. It is known beyond doubt that Jacques Daret was apprenticed to Robert Campin of Tournai from 1427–32, his fellow-apprentice being Rogelet de la Pasture, which is the French form of Roger van der Weyden's name, both meaning 'Roger of the Fields'. Moreover, we know that Roger van der Weyden was born in Tournai, and both his works and to a far greater extent those of Daret, suggest a master-pupil relation with those now usually assigned to Campin. On the other hand, though a fair number of facts are known about Campin's life, no documents exist which connect him with any of the pictures which may be his, none of them is signed, and only one is dated. Since that would fall late in his life (1438), it is not by itself an adequate basis for judging the development of his style. The facts taken as a whole, however, seem to justify a cautious attribution of the whole group to Campin, though some scholars insist that the case is so dubious that they prefer to speak of the painter by the artificial names of the Master of Mérode or the Master of Flémalle.[1]

Robert Campin, who was probably born shortly before 1380, perhaps in Valenciennes, was a Master Painter in Tournai in 1406. He evidently prospered, for two years later he bought a house, in 1410 he became a burgess and in 1415 he is known to have received a rich pupil. He had therefore gained by then prestige as a painter as well as material prosperity, for it is likely that a rich man would have sent his son to the best painter in the town. Although Tournai was an important Bishopric, its citizens were not always content with

aristocratic rule. A democratic revolt took place in 1423, the town then being controlled for about five years by three Communal Councils. Campin was a member of one of these from 1425–7. The Councils cannot, however, have been very rabid in their views, since in 1427 they entertained Jan van Eyck, who was a member of the household of the Duke of Burgundy. In the same year Daret and Rogelet de la Pasture entered Campin's studio. The rule of the Communes did not last long, for in 1428 a reaction took place, and Campin's name no longer appears as a Councillor. It would seem, however, that his personal as well as his political conduct led him to extremes, for in 1432 an order that he should go on a pilgrimage to St. Gilles in Provence as a punishment for his dissolute life was commuted to a fine. Nothing else is known beyond the fact that he painted a sculptured Annunciation for the church of St. Marie Madeleine in Tournai in 1428, and that he died in 1444.

We have, therefore, the biography, scanty though it is, of an artist working from at least 1406 until perhaps as late as the early 1440's. The group of works which are assigned to him could be fitted into this pattern, though it must then be admitted that no early works have survived. It seems, moreover, almost certain that the painter must have known the work of Sluter and been deeply influenced by it. Indeed, his bulky figures have far more in common with sculpture than with illuminated manuscripts, and it is improbable that he had been trained, as would have been normal slightly before 1400, as a manuscript painter.

Three pictures, all of them breaking new ground, and yet at the same time having links with the past, may well date from between 1415 and 1425. They are a triptych of the *Entombment* (Count Seilern Coll., London) (Pl. 5), the *Marriage of the Virgin* (Madrid) (Pl. 4b) and the *Nativity* (Dijon) (Pl. 7a). None of them is large, the biggest being the Dijon picture, which is about three feet high.

The *Entombment* may well be the earliest. The centre panel shows in effect a group of coloured figures in full relief, set against a gold ground decorated with a raised scrolling pattern of grapes and vines. There is therefore no attempt to place figures in a real spatial setting. The figures themselves, however, are not flat shapes silhouetted against the ground, but are strongly and roundly conceived, each having a reality conveyed by vigorous modelling in light and shade. The group is compact and dramatic, bound together by abrupt rather than by swinging rhythms, the main composition lines being verticals and horizontals; and it is steadied in front by two upright kneeling figures seen from the back. In the main groups the figures are bulky and even clumsy; only the angels flying above holding Instruments of the Passion have

a linear grace, for their draperies toss in curving patterns against the gold ground. There is much in the main group which is reminiscent of Sluter. The draperies, like his, are of thick material, and the cloak of the left-hand kneeling figure falls from the shoulders and fans out on the ground in a manner very close to that of Philip the Bold from the portal of the Chartreuse. More significant, the angel standing on the right, holding the Lance with the Sponge, is wiping away tears with the back of his hand in exactly the same way as one of the angels on the *Puits de Moïse*. The gesture is not a common one in painting, and its appearance here would suggest that Campin had been impressed with Sluter's ability to observe the effect of grief in living people, and therefore to give his supernatural beings a new reality.

The wings of the altarpiece are less advanced than the central panel, and display less interest in the solidity of the figures. The left shows the donor and the two crucified thieves, the right the *Resurrection*. Here again is the decorated gold ground instead of sky, but in front of it a landscape which runs sharply up-hill and has no recession. The figure of Christ, stepping from a rectangular stone tomb set on the ground, and not from the sepulchre as in Gospel narrative, is slender, with long falling draperies which are closer than those of the centre panel to late Gothic art; and the figures of the sleeping guards, fantastically dressed, but sprawled in ungainly attitudes in front of the tomb, lack the force and gravity of the centre figures. They have, indeed, a grotesque quality, linked perhaps with Broederlam's St. Joseph in the Dijon altar, but much less solidly conveyed.

The *Marriage of the Virgin* (Pl. 4b) has the same bulky, rather clumsy figures, some of which are again seen from the back. It is more ambitious, since it includes two separate scenes in architectural settings, but less impressive, for the figures are crowded together and the composition is confused. It betrays, however, both considerable narrative ability and a strong sense of character. The figures are not types but individuals, capable of expressing anger or curiosity or quiet resignation. On the back of the panel are two saints, St. James and St. Clare, painted in grisaille and therefore appearing as simulated statues, set in niches. Both are tall majestic figures, strongly reminiscent of Sluter's sculpture and, perhaps because the artist is not thinking in terms of colour, he is able to concentrate entirely on light and shade, and so to convey not only the mass of figure and drapery but also, by observation of the cast shadow, the depth of the niche in which it stands. Such grisaille figures were to be constantly used on the outsides of the wings of altarpieces, but these seem to be the earliest which have survived.

The *Nativity* (Pl. 7a) is in many ways a more advanced work than either of

those so far discussed.[2] The figures are more loosely but more ambitiously grouped; the artist no longer feels he must weld them into a tight mass to give them reality, but attempts to set them apart, and to give to each single figure a separate solidity. There is the same strong characterization enhancing the narrative as in the *Marriage of the Virgin* — Mary serenely adoring the Child, Joseph carefully shading the candle which he always carried in Mystery plays to bring light into the stable, the shepherds a little uncertain as to what they should do. The fall of Mary's cloak is again reminiscent of that of Sluter's Philip the Bold, and Joseph's head, its bony structure clearly understood, is nearer to the heads of the prophets on the *Puits de Moïse* than to those of old men in manuscript painting. On the right of the picture are the two midwives, the nearer being one of Campin's favourite figures seen from the back. The other is Salome, who doubted the Miraculous Birth, and whose right hand withered because of her unbelief. These figures, and the angels flying above, carry scrolls with words on them (those of the angels bear the *Gloria*), which may be linked with sentences spoken in Mystery plays, but which seem out of place in so realistic a picture. Their curling lines, and the tossed draperies of the angels, are the chief links between this picture and earlier Gothic art.

On the other hand, there is nothing conservative in the treatment of the landscape. Here Campin indulges in bold experiment, based on precise, first-hand observation. The stable, though its perspective is empirical (for the rules of linear perspective were not yet known in Northern Europe), is a real dilapidated shed, each detail painted with loving care. Behind it is a little hill, and behind again, reached by a winding road, a landscape of quite astonishing reality. Each of the pollarded trees, the horseman on the road and the figures approaching it, cast long shadows on the ground, showing that the artist has realized, in a way which the de Limbourg brothers in the *Très Riches Heures* did not, the importance of light as a unifying factor. He has not, however, pushed his discovery to its limits, for in order to give each object its separate existence he draws a hard line down the light side of a tree; but even so, his landscape is a very remarkable achievement. It is also true that he cannot yet weld together the foreground and the background; the light falls in different directions in the two parts of the picture, nor can he manage very well the transition from one to the other, but the gap between this work and Melchior Broederlam's wings of 1399 is immense. The sweetness and the fantasy has gone; instead there is a new, serious, dramatic and realistic if rather clumsy style on which other masters could build. Jacques Daret did indeed borrow from this picture for his *Nativity* (Thyssen Coll., Lugano) (Pl. 7*b*), one of

the four panels of his documented altar painted for the Abbey of St. Vaast in 1434. His work is much weaker in drawing than Campin's, the position of the figures is changed and the landscape is far more summary. It is certainly also a later picture; the sense of effort and experiment has disappeared and the younger man, who is uninventive, takes what he needs, but adds little to it.[3]

The *Mérode Annunciation*, now in the Cloisters, New York (Pl. 6), was for many years in the possession of the Mérode family in Brussels, but was painted for the Ingelbrechts family of Malines, whose arms appear on the left window at the back of the room shown in the central panel.[4] A member of this family is known to have invested money in Tournai in 1427, which makes a possible link with Robert Campin, though the picture may well have been finished, or nearly finished by that time, for it seems likely that it was seen by Jan van Eyck when he visited Tournai in that year.

This picture breaks entirely new ground. The theme of the Annunciation had, of course, been a common one throughout the Middle Ages, but Mary and Gabriel had been shown silhouetted against a gold background, or else beside or under an open loggia, such as the one in Broederlam's altar wings. Campin's *Annunciation* takes place inside an ordinary but comfortably furnished room, no doubt typical of the Flanders of its day, and neither the Virgin nor the angel have haloes, so their natural rather than their supernatural character is stressed. The artist cannot entirely manage his daring innovation; he has great difficulty in suggesting recession, and in consequence the table is uncomfortably tilted, and its relation to the floor, and to the long settle beside it, is not clear. In the *Nativity* the artist had dared to leave space between the figures surrounding the Child; here, because he cannot yet manage the recession of the floor, he must mask the space with his table. Nevertheless, he does achieve a surprisingly convincing account of a room, largely because he has perceived the fall of light, coming strongly through the open door by which Gabriel has entered on the left, and more weakly through the windows on the left and in the back wall. The gradation of light on the walls is not very subtly perceived, but it is perceived; and the fall of light on each object — the shining brass vessel in the niche, which casts its shadow on the wall, the towel hanging beside it, the Italian pot in which the lily, the emblem of purity, is placed and the metal candlestick on the table — is most lovingly rendered.

The figures, too, are original, though ungainly. The Virgin, as yet unaware of her heavenly visitor, is studying her book, evidently a precious one, since she holds it in a cloth. She has a large oval face with big features, which is typical of the artist's style, but small and rather boneless hands. Moreover, her position is not clearly conveyed. She seems to be sitting on the narrow

step of the settle, but the direction of her legs is lost under the heavy drapery. The action of the angel is more convincing, for the folds of his robes define and do not muffle the lines of his limbs. Both figures, however, reveal an attempt to convey solid, indeed massive forms set in a real interior space, and now there is nowhere any reminiscence of Gothic elegance or swinging line.

The wings, also, have much of interest. The left reveals that the Virgin's room opened on to a courtyard, in which the donor and his wife are kneeling, with a servant standing behind them, near the archway into the street. The right wing is a remarkable representation of a craftsman's shop, with its shutters pegged up to the ceiling, and the lower half of one let down into the street to form a counter. St. Joseph is seated at his bench, plying his trade as a carpenter, and on the counter, ready for sale, he has put a mouse-trap.[5] Through the open shutters may be seen what is perhaps the earliest of many enchanting views of Flemish towns, with citizens going about their business — in other words the whole setting is consistently placed in a contemporary Northern town. The linear perspective of St. Joseph's workshop is as insecure as that of the central panel; but perhaps because the space is narrower and the artist has only one figure to include, the weakness is less disturbing. Moreover, the fall of light is more convincingly observed.

The *Madonna of the Firescreen* (National Gallery) (Pl. A) must be later than the *Mérode Annunciation*, for though the two pictures have much in common, many problems the artist could not handle in the first picture are solved, or almost solved, in the second. Again the setting is an ordinary room, here with a view from the window on the town below. But the Virgin's settle is now swung round so that it is parallel to the picture plane; it masks most of the middle distance, and it is only in the left corner of the room that the lines of the tiled floor and of the triangular stool still betray the painter's inability to construct a room in depth. The Virgin is of the same heavy type as in the earlier picture, but she is drawn with much more assurance. It is easier to understand how she sits, the position of her knees is defined with sufficient clarity to make a believable lap on which the Child rests, and the drawing of her hands and also of the limbs of the Child is now far firmer.

A brief comparison between this picture and Masaccio's *Pisa Madonna* (1426) in the same Gallery, which cannot be more than a few years earlier, reveals that though both artists are interested in monumental form and in the fall of light, the Flemish picture is far more intimate than the Italian. Masaccio's Madonna is the Queen of Heaven, seen against a gold ground and attended by angels; but there is nothing supernatural in Campin's picture. His Virgin is a mother giving her breast to her child (though it is true that she

has been reading a book of prayers), and neither she nor the Infant Christ have haloes, though the firescreen of plaited rushes behind her head, which serves as a halo is, like the book of prayers, some indication that this is no ordinary woman. Masaccio's perspective is far more advanced than that of Campin (the rules of linear perspective were being discovered in his circle in Florence), but for all the reality of his solid throne, his remains a visionary picture, intentionally remote from the spectator. The difference in approach of North and South is very easy to see.

Campin's most important later works remain chiefly as a series of splendid fragments, though in one case at least we can guess something of the whole. The Staedel Institute at Frankfurt owns three fragments belonging to two different altarpieces, both of which were at one time supposed to have come from the Castle or Abbey of Flémalle. Though this is now thought to be unlikely, the name 'The Master of Flémalle' is still used by writers who doubt the Campin identification. The altarpiece which seems the earlier, because it is harsher in style than the other, is represented by a fragment of one wing, about four feet six inches high, showing the *Dying Thief* (Pls. 8 and 9a). Fortunately the Walker Art Gallery, Liverpool has a small copy of the whole altarpiece (Pl. 9b), and though it is a poor, dry thing, it is for that very reason convincing; for so indifferent an artist is unlikely to have invented anything new.[6] The Liverpool copy proves that the Frankfurt panel is only about two-thirds of the height of the original wing, and that the whole must therefore have been very large, about seven feet six inches high, and something like twelve feet wide. No other painting of these dimensions by the master has survived, though this does not necessarily mean that it was the only occasion on which he painted on so large a scale.

The Liverpool copy shows that the central panel was a *Descent from the Cross*, with the *Repentant Thief* on the left wing, and the *Unrepentant Thief* on the right. It is a fragment of the right wing which has survived. For the central panel we can, of course, only judge the design, but it is fair to assume that the handling would have been similar to that of the remaining fragment. It would seem to have been a daring and dramatic attempt to arrange a large group of big figures, spread across the panel, with the fainting Virgin on the left and Christ being lowered from the Cross towards the right. It does not, however, seem to have been entirely successful. The figures, though strongly built, are awkwardly posed, and their relation to each other is clumsily planned. In front of the Cross is one of Campin's favourite figures seen from the back, here used partly to strengthen the central emphasis, but partly also to fill the ugly gap between the groups to left and right.

[40]

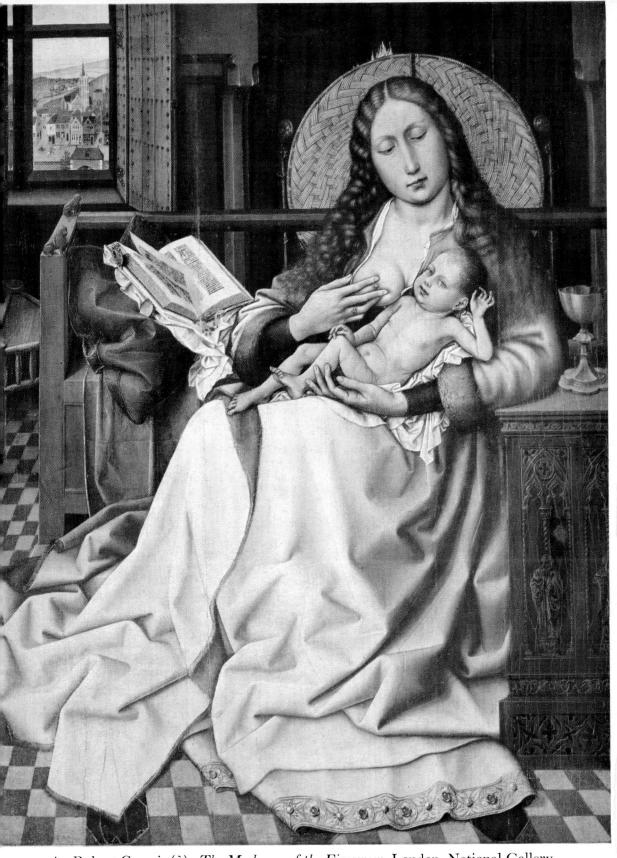

A. Robert Campin (?): *The Madonna of the Firescreen*. London, National Gallery

The *Dying Thief* at Frankfurt, however, reveals that the whole must have been far more impressive than the Liverpool copy would suggest, for it is filled with a powerful, horrifying, but most dramatic realism. This same drama, extended to every figure in the central panel, would have infused the whole altar with a stark, overwhelming tragedy. There are no longer any hesitations in drawing or in modelling, the forms are sharp and sculptural, and every detail stands clear in the harsh light.[7]

The other altarpiece at Frankfurt was rather smaller, for the two uncut wings which remain are about five feet six inches high. One shows the *Virgin and Child* (Pl. 10b), the other *St. Veronica* (Pl. 10a) with her handkerchief with which she wiped Christ's face on his way to Calvary, and on which his image was miraculously imprinted. On the back of the Veronica wing is a grisaille of the *Trinity*. Nothing is known of the subject of the lost centre panel.

The first impression of these wings is of the splendour of their colour. The Virgin in white and gold, her cloak having blue shadows, stands holding the Child who wears a dark blue tunic with a red sash, against a background of fine Persian silk with a pattern in gold, blue and green on a red ground. In the Veronica wing the colours are reversed. The figure is in strong colours — a red cloak with loose green sleeves falling back over a blue and gold dress — but the background has a brown and grey pattern (representing gold and silver) on white. The use of the Eastern brocades, which add so much to the beauty of the panels is, like the Florentine pot in the *Mérode Annunciation*, testimony of the importance of Flanders as a centre of international trade. These panels are stronger and richer than Count Seilern's *Entombment*, which though bright is lighter in tone. In his earlier pictures, notably in the *Marriage of the Virgin*, Campin had shown something of that interest in plants which appears here in the flowery meadows on which the figures stand, and also in the jewelled edges of garments. But the love of rich detail seems to have increased, and since the modelling is now also softer, it is possible that Campin had seen Van Eyck's *Adoration of the Lamb* altarpiece at Ghent (Pls. 12 to 16), which was finished in 1432. The *Trinity* on the back of the Veronica wing is also a remarkable work. It is far more subtle in modelling than the grisailles of St. James and St. Clare on the back of the *Marriage of the Virgin*, and shows a greater sense of the value of reflected lights. It is also grand and very moving in its tragedy.

It is not surprising that Campin should have been especially accomplished in the painting of grisailles. Tournai had an active school of sculptors, and though their work lacked the force of that of Sluter, Campin with his innate interest in solid form, was no doubt attracted by it. His only known connection

with sculpture was in 1428, when he coloured the group of the *Annunciation* for the church of St. Marie Madeleine in Tournai, but he may well often have visited sculptors' studios, and been interested in the problems of their art.

 The softer modelling and greater elegance of the second Frankfurt altar reappear in two wings, one showing *Heinrich Werl and St. John the Baptist* and the other *St. Barbara* (Madrid) (Pls. 11*a* and 11*b*), which are dated 1438. The donor's name and the date are inscribed at the bottom of the frame. It is only necessary to compare St. Barbara with the Virgin in the *Mérode Annunciation* to see the development which has taken place in Campin's style. There is no longer the immense struggle to set figures in a room. Here, though St. Barbara's room is deeper than the Virgin's, the placing of the objects in it, above all the settle, the carved cupboard behind it and the line of the open shutters, lead the eye gently backward, so that it hardly notices the confused perspective of the floor. In the far distance, through the window, the eye finally rests on the tower in which St. Barbara was imprisoned by her angry father, and which is always used as her emblem. She herself is a more refined figure than the massive Virgin of the earlier picture, and she sits more convincingly. This increased gentleness of type, which can also be seen in St. John the Baptist in the other wing, may perhaps be due to the influence of Campin's gifted pupil, Roger van der Weyden, by now an important master in his own right, whose work will be discussed in a later chapter. But the mastery shown in painting the interiors, and above all the presence of the round mirror in the left wing, makes it almost certain that Campin had seen and learnt much from Jan van Eyck's portrait of *Giovanni Arnolfini and his Wife* (National Gallery) (Frontis.), painted in 1434. We do not know that he went to Bruges, where Van Eyck and Arnolfini both lived, any more than we know that he went to Dijon to see Sluter's works; but it would be as impossible to account for his earlier works without a knowledge of Sluter as it is to account for the *Werl wings* without a knowledge of Van Eyck, and it is reasonable to suppose that so successful a painter would have sometimes travelled to other cities. Bruges, moreover, is no great distance from Tournai.

 A number of other pictures were certainly designed by Campin, though in most cases the versions of them now known were painted by other hands. Among the most influential of these were the design of a standing *Virgin flanked by two music-making angels* in the apse of a church, and bust-length paintings of the *Madonna* and *Christ as Redeemer*.[8] A few portraits remain, almost certainly by his hand. One of a fat man, *Robert de Masmines*, who died in 1430, exists in two versions, at Berlin and in the Thyssen Collection at Lugano.[9] The Lugano version is more forceful, the drawing firm and the

modelling hard, so that the features seem almost to be cut out of wood. The pair of portraits of a *Man and a Woman* (National Gallery) must be later, for they are less harsh and, like the *Werl wings*, suggest that Campin must have studied the work of Van Eyck. The development of the Flemish portrait will be discussed in connection with that master, but the account of Campin would not have been complete without some mention of his work in this field.

His chief contribution, however, lies in his bold experiments in setting his heavy figures in space and in giving them a true solidity. The earlier pictures discussed in this chapter suggest that the painter, whether he is Campin or not, was moving sharply away from International Gothic in the first quarter of the fifteenth century, perhaps at the same time, but almost certainly independently of the Van Eycks. Which began to experiment first cannot now be decided. Later in life, Campin seems to have been willing to learn from other masters and so to develop a less rugged style; but even so he remains a powerful personality whose influence on later painters was profound.

HUBERT AND JAN VAN EYCK

1. THE PAINTERS' LIVES

Van Eyck is beyond question the most famous name in Flemish painting. It was widely known in the fifteenth century inside and outside Flanders, and it has never been forgotten. Jan's outstanding technical mastery, which within its limits has never been surpassed, his ability to see and set down on panel every minute detail of the world before him, have been constantly admired, even at times when the contribution of other masters has been less readily appreciated. His achievement can very easily be grasped from a number of signed and dated pictures which remain, all of them from the ten years before his death in 1441; but though in addition to these paintings we know much about his life, many teasing problems remain, the greatest perhaps being his relation to his brother, Hubert.

The *Adoration of the Lamb* altarpiece (Pls. 12 to 16) in the cathedral at Ghent, which must shortly be discussed in detail, bears on the lower edge of the outside of the frame the following inscription :

'. . . . ubertus eyck maior quo nemo repertus
incepit pondusq johannes arte secundus
. iodici vyd prece fretus
uersu sexta mai vos collocat acta tueri'

The letters underlined in the last line are painted in red, and give the date : 1432. Whatever the words now missing in the inscription may have been, its meaning is clear. It can roughly be translated : 'ubertus Eyck than whom none was greater, began it, and the weight, Jan, who comes second in his art (words missing, perhaps "finished it"), according to the request of Jodoc Vyt, invites you in a verse to-day, the sixth of May, to contemplate the finished work.'

The inscription therefore states that the altarpiece was begun by one great artist, Hubert, and finished by his brother Jan in 1432, the patron being Jodoc Vyt. Though the authenticity of the inscription has been challenged, and it has been thought a sixteenth-century forgery, chiefly because neither it nor

Hubert's share in the work are clearly referred to before that time, it is now known that the altarpiece originally stood in a chapel in the crypt, so placed that it could not easily be closed, and therefore the inscription can seldom have been seen. Moreover, the recent technical examination, though not conclusive, adds to the probability that the inscription in fact dates from 1432.

Before examining the altarpiece, or any of Jan's signed pictures, it is necessary to see what is known of the lives of the two brothers. The birth date of neither is known, but a sixteenth-century tradition states that they came from Maaseyck, near Maastricht, that is to say, from the eastern part of Flanders. About Hubert we know nothing except that a painter referred to as Lubrecht or Ubrechts or Hubrechte van Heyke was working for the magistrates of Ghent in 1424/5, and that he died in that city in 1426. The grave of 'magister tabellae' in front of the altarpiece was shown to a German traveller, Hieronymus Münzer in 1495, and it cannot have been Jan's grave, since he was certainly buried in Bruges. Much more is known about the life of Jan, who was probably the younger brother, though even this cannot be proved. He first appears in 1422, when he was paid for painting the Paschal candle at Cambrai. For the next two years he was in the service of John of Bavaria, Count of Holland, and was paid for decorations in his palace in the Hague. Nothing is known of their character. In 1425, on the death of John of Bavaria, Jan van Eyck entered the service of John's overlord, and relation by marriage, Philip the Good, Duke of Burgundy. He became his 'peintre et varlet de chambre', and was to remain in the Duke's service until his own death in 1441. Philip seems to have used him as a confidential agent (just as Rubens was to be used two centuries later), no doubt finding that an unobtrusive painter, but one with remarkable powers of observation, was often more use to him than an aristocratic envoy. Unfortunately there are far more records of this side of Jan's work for his master than there are of paintings for him. He was constantly sent on journeys, some short, such as journeys to Lille in 1425 and 1428, or to Tournai in 1427. But in 1426 (the year of Hubert's death) Jan was sent on 'long and secret journeys', and from October 1428 to Christmas 1429 he was away from the Netherlands; for he was part of the embassy sent to Portugal to fetch home Philip's bride, the Infanta Isabella. The ships are known to have put in at Dover, but whether, as has been suggested, Jan van Eyck then visited Canterbury and London cannot be proved. It is also often suggested but non-proven, that on this journey he also visited Spain. Unfortunately the portrait he painted of the Infanta Isabella has disappeared.

In 1430 he was in Bruges, and during the next year he bought a house there. In both July and August, 1432, the Burgomaster of Bruges visited his work-

shop to see some of his works (we do not know whether the *Adoration of the Lamb* altar had actually been sent to Ghent in the May of that year, or if it was still in the studio), and the Duke came to the workshop in 1433. Perhaps about this time Jan married, for in 1434 his child was baptized, the Duke then presenting the father with six silver cups. In the same year Jan worked on eight statues for the new Stadthaus at Bruges, painting and gilding six of them. His service with the Duke was not yet over, for in 1436 he was again sent on a secret journey. His master had, however, already made it clear that it was not only as a confidential servant that he valued Jan, for he had written in 1435 to his Council sitting at Lille, complaining that he could not find another painter so much to his taste, or of so much proficiency in his art. Jan died in Bruges on the 9th of July, 1441, and was buried in the church of St. Donatian. His widow was still living in the town in 1456.

Jan's fame in his own day was partly due to his association with the Burgundian court, and also with the Italian merchants who lived in Bruges. Hubert may never have worked outside Flanders. Even so, the silence concerning him is mysterious for, apart from the inscription on the Ghent altar, the first reference to him after his death is in 1517. Then Don Antonio de Beatis, secretary to Cardinal Louis of Aragon, was told that the altar was painted 'about a hundred years ago by a master from Germany named Robert, who had not been able to finish it because he died', and that it was 'finished by his brother, who was also a great painter'.[1] It is not much, but enough to show that a tradition was still alive; and the question of the 'accident of survival', discussed in Chapter I, may well have some relevance here.

Since no separate works by Hubert are known, it will be safest first to examine the Ghent altar, then to discuss the signed and dated works by Jan between 1432 and 1441 and a few other works which are related to them, and afterwards to consider what can be deduced about the earlier styles of either master. Though this may be confusing and perhaps long-winded, it is always better, in such complicated questions, to proceed from what is known to what is unknown.

2. THE GHENT ALTARPIECE

The *Adoration of the Lamb* altar (Pls. 12 to 16) is very large. It is composed of twelve panels, set in two rows one above the other, the whole being about twelve feet high and fifteen feet wide when the wings are open (Pl. 12). It has also undergone many vicissitudes, some of which have undoubtedly caused damage and led to repainting.[2] The most important points in its history are

that it was restored, probably drastically, in 1550 by two competent artists, Lancelot Blondeel and Jan Scorel, having already been subjected to a bad cleaning and to the destruction of an additional lower panel, or predella. Twice during the Wars of Religion it was taken out of the church; after the second time it was set up in its present position in a chapel on the right side of the ambulatory (1586–9), having till then been in the chapel below it in the crypt. In 1640 all the roofs of the cathedral were burnt, and a further serious fire occurred in the roof of the chapel in 1822. During the Napoleonic Wars it had been taken to Paris, only part of it being returned; but the whole was reassembled under a special clause of the Treaty of Versailles in 1919. One panel was stolen in 1934, and though the back of it was returned, the front has never re-appeared, and the *Just Judges* (the extreme left panel) is a modern copy. It was again removed, first to France and then to Germany in the Second World War. Moreover, it is known to have been cleaned at least six times between 1588 and 1939, and though at the time of the technical investigation in 1951, much nineteenth-century over-painting was discovered and some of it removed, many problems of its condition, especially those caused by damage from fire all down the centre, remain unsolved. Some caution is therefore necessary in conclusions drawn from its appearance to-day.

The panels are unified by their content rather than by their design. In the lower row all the panels have small figures, set in a landscape which runs through, as it were, behind the frames. Groups of people advance from all sides to adore the Lamb set on an altar in a flowery meadow, in front being the Fountain of Life, and above, in a glory of rays, the Dove, the symbol of the Holy Ghost. In the centre panel (Pl. 13), as well as angels carrying the Instruments of the Passion, are Patriarchs, Prophets, Apostles, Martyrs, Confessors and Virgins. Coming from the right are Hermits and Pilgrims, the latter led by the giant St. Christopher, and from the left the Just Judges and in front of them, the Knights of Christ. In the upper row God the Father is enthroned in the centre, with the Virgin and St. John the Baptist seated on either side. Beyond them are two panels of music-making angels, and at the ends Adam and Eve, the parents of all mankind. Above the heads of the two last figures are small groups in grisaille showing the Sacrifice of Cain and Abel and the Slaying of Abel.

The first impression of the altarpiece is one of overwhelming richness and brilliance. The colours are strong and bright, scarlet, white and blue against the bright green ground being dominant, though there are also some duller colours, brown and grey, in the group of pilgrims. There is also much gold; the Bishops have jewelled mitres and croziers and often gold embroidery on

their robes, the Knights have burnished armour and they and the Judges have jewelled trappings on their horses; and in the upper row the use of jewels on clothes or crowns (Pl. 14a), and of rich brocades is even more lavish. The same astonishing richness of detail may be seen in the landscape. There are orange trees heavy with fruit, rose bushes, flowers of endless variety, and in the background, beyond the palms and cypresses and other trees, the towers and spires of a series of great cathedrals. One can look again and again and find new beauties of detail, and there can be little doubt that this was one of the objects of the artist. He wished to create a work which would cause men to reflect on the endless splendours of Heaven, and the fact that the figures were of different sizes and not related to each other in a single, understandable space, concerned him much less. On the other hand, the figures themselves have an astonishing reality, which must have added much to their value in convincing men of the meaning of the doctrines of the Church.

The exact meaning of the whole altarpiece has given rise to a great deal of argument. Some writers, disturbed by the discrepancy in size between the figures in the upper and lower row, and by the fact that both rows, except for the Adam and Eve panels, are seen from above, have argued that the two rows were part of two separate altars, perhaps left unfinished at Hubert's death in 1426, taken over by Jodoc Vyt, who was a member of a Ghent patrician family, and finished for him by Jan as a single altarpiece. Such scholars hold that the central upper figure is not God the Father, but Christ as Judge, as He can be seen in many representations of the Last Judgment carved or painted in Gothic churches, with the Virgin and the Baptist beside Him. They therefore suppose the upper row to be part of a Last Judgment altarpiece, and the lower an All Saints' picture. This can hardly be so, for read vertically through both rows, the central figures show the Trinity — the Father above, the Dove representing the Holy Spirit, and the Lamb representing Christ, and neither row could be complete alone.[3]

The true explanation would seem to be that both halves, read together, are to a large extent an All Saints' picture. The lower row is largely based on the passage read for the Epistle on All Saints' Day (Revelation vii. 2–12), which describes St. John's vision in which 'all nations and kindreds, and people, and tongues, stood before the throne and before the Lamb', but with added elements. These are taken from a separate vision of a sexton of St. Peter's, recorded in the *Golden Legend* under the Feast of All Hallows (i.e. All Saints).[4] This speaks of multitudes headed by the Virgin and St. John the Baptist adoring the Lord upon the throne, and thus includes both upper and lower rows. Some things in the altarpiece are in neither passage. Adam and Eve are

not mentioned, but they are not inappropriate as representatives of fallen humanity. The Fountain of Life is not traditionally part of the All Saints' theme, but it is mentioned later in the chapter from the Book of Revelation read for the Epistle, and again in Chapter xii; and it is a well-known symbol of salvation.[5] The unique feature in the Ghent altarpiece is the panel of the Just Judges, and it looks as if they must have been devised and included for some special reason. Perhaps indeed the altarpiece was originally commissioned by the Magistracy of Ghent, from whom Hubert had a small payment in 1426 for designs for an altarpiece, and the Judges serve, as it were, as patron saints or almost as donor portraits.

There can be little doubt that the altarpiece was devised as a whole, and for an immensely rich patron or group of patrons.[6] It must also have taken a very long time to execute. It is at least possible that almost the whole was designed by Hubert and partly painted by him before 1426, but that it was worked over by Jan between 1430 and 1432 after his return from Portugal. The orange trees and cypresses could hardly have been painted by a man who had not seen them growing. Moreover, X-ray photographs showed some slight changes in plan during execution, which could be read as alterations by Jan to Hubert's work. It seems indeed possible that Jan repainted most of the landscape, for those parts which have been fully cleaned, for instance the grove of trees in front of the group of Virgins in the Adoration panel, show an ability to render objects in space which is not entirely realized in the figures. The Virgins (Pl. 14b) are packed together so that it is impossible to know how they stand; their heads, all the same height, are ranged regularly behind each other like a series of cobble-stones on which one could walk, and their dresses fall in long soft folds to the ground, making curling patterns close to those of the older Gothic art of the late fourteenth century. The kneeling Apostles in the right foreground are also a trifle unsubstantial. Their heads, mainly seen in profile, tend to repeat each other, and the arrangement of the draperies does not give them quite the same solidity as the figures on the other side of the Fountain. In other words, there are some passages which seem more archaic than others, and if it can be accepted that the two brothers worked in the same technique, it is possible to believe that the work was begun by one and finished by the other. Only the Adam and Eve, far more brutally realistic than anything else on the front of the altar, and designed to be seen from below rather than, like the other figures on the same level, from above, are so close to the known works of Jan in the 1430's that it seems probable that they are entirely his.

The outside of the altarpiece (Pl. 15), seen when the wings are closed, underwent a more profound modification of plan. It consists of eight panels,

again in two rows, the lower having kneeling figures of Jodoc Vyt (Pl. 16) and his wife in colour, and between them grisailles of St. John the Baptist and St. John the Evangelist which, like Campin's figures on the back of the *Marriage of the Virgin*, are statues rather than living people. All these four panels have a traceried arch painted at the top, suggesting that the figures are in niches. The technical examination showed that the upper row of panels were also originally set out with traceried arches, though these were in the underpainting only. A second row of figures in niches must therefore have at first been intended, but before the work was finished the plan was completely changed, and they were replaced by the present arrangement of the Virgin and the Angel of the Annunciation seen in a room, with a view of the town out of the window. Jan van Eyck had been to Tournai in 1427, after his brother's death, but before he can reasonably be supposed to have done much work on the altar himself (it is, indeed, unlikely in view of his recorded journeys, that he settled down to work on it before about 1430). Did he, in Tournai, see Campin's *Mérode Annunciation* (Pl. 6), and was he so excited with the new way of presenting the subject that he altered his brother's traceried arches, which were presumably to contain more simulated statues, to the Campinesque setting? These are questions no one can answer with certainty, but the explanation is a possible one, and the alteration in plan is an indisputable fact.

Jan's Annunciation figures are less clumsy than Campin's, he can manage an interior better, and he is not afraid of leaving the centre of the room empty. Nevertheless, his Virgin has a heavier head than in any of his dated works of the 1430's, her features are large and her hands are very small.[7] Altogether the alteration is a puzzling one, for the figures are too big for the room, and the room itself has no door. It is, however, clearly thought of as part of the real world, for the frames cast their shadows on the floor. On the inside there are no such shadows, for there is neither day nor night in Heaven and light proceeds eternally from God. The colour of the outside, too, is very different from that of the inside, for it is mainly white and brown, though Jodoc Vyt is in scarlet and his wife in duller red and green. In the upper row, only the wings of the angel, red and yellow with a green edge, have any strong colour, for the robes of both the Angel and the Virgin are white.

Much space has been given to the problems of the Ghent altar, for they are very great and much has been, and no doubt will yet be written on them. The fascination which it has exercised is, in one way, the result of the splendour of its achievement. For it is a major monument not only of Flemish but of European art. It marks a great cleavage with the art of the Middle Ages, for it treats a religious subject with a new reality which embraces landscape and

figures alike. Whether what we see was partly painted by Hubert or not, it must all have been conceived at least by 1430 to be finished by 1432, and it therefore antedates all Jan's certain works. Campin was, no doubt, already moving in the same direction, but Campin was a less accomplished painter than Jan van Eyck. Jan's association with the Burgundian court had shown him the glitter of jewels and the beauty of rich stuffs. His journey to Portugal had opened his eyes to the charm of landscape and of exotic flowers and fruits, and his visits to many Northern towns had introduced him to a great variety of noble buildings. All these were stored in his memory (and perhaps also in his note-books, though none of these remain), and set down in paint, but above all he had perceived that it is the fall of light which gives to each object its own reality. His unmatched technical accomplishment was so great that he could convey the multiplicity of tiny things which he clearly loved, and which were part of the rich civilization in which he lived. But the Ghent altarpiece is more than a collection of intricate details. It is a great religious painting, a serene tribute to what both painter and patron recognized as the glory of God and of His creation.

3. THE WORKS OF JAN VAN EYCK

The signed and dated works of Jan van Eyck between 1432 and 1441, though of great importance, cannot be discussed in the same detail as the Ghent altar. They fall into two clear groups, religious pictures and portraits, for though he almost certainly created a small number of secular paintings,[8] none of these have survived. There are also a few works which, though not signed, are so obviously by him that they can safely be included in any survey.

The earliest dated religious painting which survives is the *Madonna of Canon van der Paele* (1436) (Pl. 18a), made for the church of St. Donatian in Bruges, but now in the Bruges Gallery. Next to the Ghent altar it was the most influential of his works, since all artists could see it, whereas others were clearly in private possession and so were less well known. This altarpiece, four feet high, shows the Virgin and Child enthroned in the apse of a church, with on the left, St. Donatian, and on the right the old canon being presented to the Virgin by his patron saint, St. George. The difference between this picture and Campin's *Madonna of the Firescreen* (Pl. A) is very great. Jan van Eyck has a far greater ability in dealing with the problem of figures in space; he loves more brilliant colour and much richer detail. The throne of the Virgin is pushed back, and its position is firmly fixed by the receding lines of the carpet; and the arrangement of the steps on which it stands is clearly indicated

both by the carpet and by the fall of the Virgin's cloak. Moreover, the position of the Virgin is completely credible; she sits firmly on the throne and does not slide forward off it, and the line of her knees is stressed by the break in the fall of her mantle. Though she is a massive figure, her features are less heavy than those of Campin's Virgins, and the angular folds of her heavy mantle explain rather than muffle the position of her limbs. The Child, holding a parrot and grasping His mother's bunch of flowers, is a child-like figure, chubbier than Campin's Christ-child, and far more subtle in modelling. The attendant figures form two great triangular blocks, both nearer the eye than the central pyramid made by the Madonna and Child. St. Donatian wears a magnificent dark blue cope, richly embroidered in gold, and so precise is Jan's eye that the direction of the threads can plainly be seen. His cross, a splendid example of late mediaeval metal work, and his jewelled mitre catch the light in the same way as the richly decorated armour of St. George.[9] The Canon in his plain white surplice is a contrast to all this magnificence, but the characterization of his head is so strong, the rendering of every wrinkle so remarkable that, though he himself would hardly have wished it, the eye ceaselessly returns to him. This picture, with its amazing wealth of detail — the pillars round the apse with capitals carved with Old Testament scenes prefiguring the Coming of Christ, the Virgin's throne with Adam and Eve and Cain and Abel on the arms, the bottle-glass windows each making a circle of light, the imported tiles and carpet and brocade — is one of the richest of Jan's works. In spite of the humanity of the old Canon it is, however, a strangely detached, indeed almost a frozen picture, which perhaps more than any other is completely characteristic of Jan van Eyck at the height of his accomplishment.

The small triptych at Dresden, only ten and a half inches high, is now known to bear the date 1437. Although again the artist is concerned with pushing the central group of the Virgin and Child back in space and again they are shown in a church, it is more intimate and less overwhelming than the *Van der Paele Madonna*. The lighting of the church is brilliantly handled, the figures in the wings, St. Michael and a donor on the left and St. Catherine on the right, being set in aisles of the church, so giving an extension of the central space.

Two of the remaining dated pictures are even smaller, and must, like the Dresden altarpiece, have been painted for private devotions. *St. Barbara* (1437: Antwerp) (Pl. 19) is a brush drawing in monochrome on a chalk ground, and is usually thought to be the under-drawing of an unfinished painting. Some, however, think it was never meant to be coloured. The saint, holding her martyr's palm, is sitting serenely in the foreground, while behind

her the tower in which she is to be immured is being built. It would seem that the artist is here much less interested in pushing figures back in space and in giving them great solidity. Indeed, for the first time in any of the dated pictures he appears to be concerned with the shapes made, for instance, by St. Barbara's drapery fanning out on the ground. The tower, on the other hand, proves that his interest in detail has not slackened. All stages of the building operation can be followed. Men are bringing stone, others are carving it in the shelter of the lean-to shed, an overseer on the right watches more being hoisted by a crane to the men on the top of the tower, who are to set it in place.

The other little picture, the *Madonna of the Fountain* (1439: Antwerp) (Pl. 23*a*) also shows a turning away from the desire to set large figures in space which characterized the *Van der Paele Madonna*. The Virgin, who is turning towards the Child, thus giving the picture a new intimacy, is standing well forward, and the space behind her is deliberately cut off by the splendid brocade held up by two angels. It is therefore inherently less realistic and more supernatural than the earlier pictures, for though in one way it may be surprising to find the Virgin and Child sitting inside a church, the realism with which both figures and surroundings are treated makes it completely credible. Here the fluttering angels holding the brocade bring it into a visionary world. Even so, the Virgin stands firmly, the long straight folds emphasizing the fact that the weight is on her left leg; and the hedge of flowers set on the wall show, like St. Barbara's tower, that Jan kept his curiosity about the visible world right up to the end of his life.

The *Madonna of Nicolas Maelbeke* (at present exhibited at Warwick Castle) is much larger and was probably unfinished at Jan's death in 1441.[10] It also shows that his interests were changing. Although it is probably the first Flemish picture with a single vanishing point, it is not an exploration of depth. The figures, lightly modelled, are very close to the eye; they are linked, unusually for Van Eyck, by the linear method of a curling scroll, and while the arched loggia behind is filled with light and air, its interest largely lies in the patterns made by its ribs. It is, in fact, a background rather than a building enclosing the figures.

The most important of the unsigned pictures which by universal consent are given to Jan van Eyck is the *Madonna of Chancellor Rolin* (Louvre) (Pl. 22*a*). Nicolas Rolin (1376–1462), who is shown kneeling before the Virgin and Child, became Chancellor of the Duchy of Burgundy in 1422, and therefore must have been in constant touch with the painter at the ducal court. It is dangerous to date any picture on the apparent age of a donor, since men age at different rates, but Rolin might well be a man of between fifty and sixty;

and a comparison with the dated works suggests that this picture is earlier than the *Van der Paele Madonna* but perhaps later than the Ghent altarpiece — in other words, it might well have been painted in the first half of the 1430's. The pose of the Virgin is less clear than in Canon van der Paele's picture and her mantle does not show the sharp folds which help to define her knees; and the modelling of the Child's body is harsher. The figures are set under an open loggia, which looks out on to a garden with lilies and roses, enclosed by a castellated parapet over which two figures are looking. The recession here seems too sharp; even Jan van Eyck cannot yet quite control the problem of the middle distance. But beyond the parapet is one of his most astonishing creations, a river spanned by a bridge busy with traffic passing between the two parts of a town, each with splendid churches, and behind a richly-wooded landscape running back to blue distant mountains. No other artist of the century had so sure and all-pervading a vision, for this landscape is not a collection of isolated objects, but a unified and utterly convincing reality.[11]

The donor portraits in the Ghent altar and the *Rolin* and *Van der Paele Madonnas* have already indicated that Jan van Eyck had great gifts, as might be expected, in this field. There are, however, a small number of separate portraits which prove that he introduced a new phase in European portraiture. Such fourteenth-century portraits as exist are all of princely patrons, and they are of two types, either frontal like the Richard II in Westminster Abbey, or pure profile like the King John of France (Louvre). The *Portrait of a Man* (1432: National Gallery) (Pl. 17), inscribed: *Timotheos* and *Leal Souvenir*, shows a rather plain young man holding a roll of manuscript, his head being in three-quarter view against a dark ground. This cannot be a prince or even an aristocratic sitter, but is evidently a friend of the painter's, perhaps a fellow-servant at the ducal court.[12] Both the three-quarter view and the unpretentiousness of the sitter are new. For perhaps the first time since antiquity the features of an ordinary man are recorded as a portrait, and this new emphasis on the dignity of man links Jan van Eyck with the Renaissance, though unlike his Italian contemporaries, his insistence on the importance of man had nothing to do with the revival of classical learning.

In this portrait he appears still to be having some difficulty with the fore-shortening of the eyes and mouth in the turned head, but this is entirely overcome in the *Man in a Turban* (1433: National Gallery) (Pl. 20*b*). Here the sitter is older, the face less smooth, and the looser wrinkled skin gives the artist far more opportunity for recording detailed effects of light. The head is arranged with the shadowed cheek nearer the spectator's eye, and a careful scrutiny of the shadow reveals the same accomplishment that has been seen

[54]

in the larger pictures, for every half light within the shadow has been observed and set down to give complete verisimilitude to the face.

The height of Jan's achievement can be seen in the *Marriage Portrait of Giovanni Arnolfini and Giovanna Cenami* (1434 : National Gallery) (Frontis.). The painter may indeed have acted as a witness to the marriage, since he signs on the back wall : *Johannes de eyck fuit hic./.*1434. Arnolfini was a silk merchant of Lucca living in Bruges, who had sold Italian silks to the Duke of Burgundy as early as 1422. He stands in his room, joining hands with his young wife, and though there is no doubt that this picture records a special occasion, it looks forward in its theme of figures in an interior, to Dutch *genre* painting of the seventeenth century. Everything in the room is in its place — the bed with its looped-up curtains, the chair-back beyond it with the figure of St. Margaret, the chest under the window on which rest three oranges, the splendid brass chandelier with one candle burning, the round mirror (its frame decorated with scenes from the Passion) which reflects the backs of the figures, and the rosary hanging beside it, each bead glinting in the light.[13] It is light which gives the objects their value and makes the room over-whelmingly real. An analysis of the linear perspective shows that even yet there is not a single vanishing point, but so convincing is Jan's handling of the fall of light that this is at first sight hardly perceptible, and a comparison of this picture with the *Mérode Annunciation* (Pl. 6) is proof enough of the way Jan has outstripped his fellow-artist.

There is another unsigned half-length portrait of Arnolfini in Berlin, a firmly modelled one of the goldsmith, *Jan de Leeuw* (1438 : Vienna), and an uncompromisingly direct *Portrait of the Artist's Wife* (1439 : Bruges) (Pl. 20a). In this late work, as in the *Madonna of the Fountain* of the same year, Jan seems less occupied with solid form and more with pattern, for it is the shape of the face, with its triangles of hair silhouetted against the frilled head-dress, rather than the modelling, which gives the picture its character.[14]

It is not known whether Jan usually painted from the life or from a drawing, but on one occasion at least he used the latter method. A magnificent silver-point drawing in Dresden (Pl. 21a), formerly called *Cardinal Albergati*, was certainly made from life, for at the side are notes giving the tints of the face.[15] If the drawing did not exist, the unsigned painting in Vienna (Pl. 21b) would be regarded as one of the finest of Van Eyck portraits, but a comparison of the two shows how much has been hardened in the painting. The quality of the drawing, both in its modelling and in its immediacy, is indeed so remarkable that none of the other drawings attributed to Jan can be by his hand.

4. THE POSSIBLE EARLY WORKS

Jan van Eyck's achievement between 1432 and his death in 1441 is clear enough. The problem of his earlier works, and still more that of possible works by Hubert is very great, and can only be touched on here.

One picture, the *Three Maries at the Sepulchre* (Boymans Museum, Rotterdam) (Pl. 18*b*) is almost universally accepted as an early Eyckian picture, and many believe it to be by Hubert. The figures have less solidity than in any certain work by Jan, indeed, the Three Maries themselves with their small heads and long trailing garments are nearer to the International Gothic of the beginning of the century than anything except the group of Virgins, which has been suggested as the most archaic part of the Ghent altarpiece. The perspective of the tomb, with the lid on which the angel sits laid across it, is more audacious but less successful than the Fountain and the Altar in the *Adoration of the Lamb* panel (Pl. 13), and the fantastic sleeping guards are almost in the spirit of those in Count Seilern's Campin triptych. Moreover, the work shows an interest in narrative which is strangely absent in any certain work by Jan. Only the City of Jerusalem in the background is in Jan's manner, and it is conceivable that he painted, or repainted this part of the picture.

A much more teasing problem, which probably now can never be solved, was presented by a number of miniatures in the *Hours of Turin*. This manuscript, which was begun for the Duke of Berry, passed out of his possession unfinished, and part was acquired about 1414 by William of Bavaria, Count of Holland (the brother of that John of Bavaria in whose service Jan was working in 1422). William did not live long to enjoy his new possession, for he died in 1417. The manuscript was unknown until 1902, when it was discovered in the Turin Library by Count Durrieu. In the next year it was carefully studied by the great Belgian scholar, Hulin de Loo, who found further leaves from it in the library of Prince Trivulzio in Milan. In 1904 the Turin Library was burnt, and no one therefore studied the whole manuscript in the original except Hulin de Loo. All subsequent judgments (except those concerning the Trivulzio pages, which have since been given to Turin) are based on the plates in Hulin's publication, some of which are very blurred. Hulin himself quickly decided that the miniatures were Eyckian, but he thought they were by more than one hand, and assigned the best group to Hubert and another group to Jan. It would be impossible to trace the long arguments concerning them and indeed unwise, since they rest on evidence which is now insufficient.

One of the burnt leaves, according to Hulin by the best hand, showed William of Bavaria on the sea-shore accomplishing a vow on his return from

the peace negotiations after the Battle of Agincourt, an episode which took place in 1416, and which gives a possible date for the manuscript.[16] Among the surviving miniatures perhaps the most revealing is the *Birth of the Baptist* (Pl. 22b). Here, in an Eyckian room, integrated, though not very securely by light, small figures with thin limbs and trailing garments hurry about their duties. As in the *Three Maries at the Sepulchre* there is a keen sense of narrative, and there is also an anxiety to show figures in movement which is almost completely absent from the known works of Jan.[17] These and other deductions drawn from remaining miniatures such as the *Mass of the Dead*, would seem to make a case for regarding the chief master of the Turin Hours as Hubert, and for supposing that he came out of the world of manuscript painting, whereas Jan may well have been a picture-maker from the beginning of his career. Other manuscripts also reveal that their painters were beginning to experiment with the problems of setting figures in space. In the *Très Riches Heures* (Pls. 1a and 1b) the de Limbourg brothers made great strides in the representation of landscape, but were unable to integrate their figures into it. The unknown master, probably a Fleming, who illustrated the *Hours of Marshal Boucicault* (Jacquemart-André Collection, Paris)[18] was daring in his attempt to place figures convincingly in an interior, and his setting of the back wall of the room parallel to the picture plane, with the side walls retreating to different but centralized vanishing points, to some extent heralds the work of both Campin and Jan van Eyck. In neither of these manuscripts, however, is there any sustained attempt to unify the scenes by the fall of light; and it is in this, above else, that the Turin Hours proclaims itself 'Eyckian'.

If the Turin Master, with his sense of narrative, is perhaps Hubert, then the *Madonna in a Cathedral* (Berlin) (Pl. 23b) must certainly be an early work by Jan. The design of the picture is carefully planned to fit the rounded top of the frame, and though the Virgin is a tall, slender figure with a slightly swaying stance and the drawing of the Child somewhat immature, it has nothing of the additive quality of manuscript painting, with tiny figures in an unreal world, but is the work of a man who conceives a picture as a separate entity and not as part of the decoration of a page.[19]

Whatever the solution of the many problems surrounding the Van Eycks may be, their position remains supreme. It is, indeed, a tribute to the greatness of their art that scholars cannot rest in their search to explain it. All later Flemish artists learnt much from it, and even if some experiments had already been made by Campin, and some later artists, more passionate in temperament, were to turn from the calm detachment of Jan's style, the Ghent altar remains as one of the major landmarks of European painting.

CHAPTER IV

ROGER VAN DER WEYDEN

Roger van der Weyden is one of the few fifteenth-century Flemish artists whose birth and death dates are secure. He was born in either 1399 or 1400, his father being a master-cutler in Tournai; he died in Brussels in 1464. He was town-painter to Brussels by 1435, living there for the rest of his life, though he almost certainly made a journey to Italy in 1450. On the other hand, no signed picture remains, and none which can now be identified is ascribed to him before the sixteenth century. Nevertheless, starting from these sixteenth-century attributions, a considerable body of work can reasonably be regarded as his. It suggests that he was a very great master, building at first upon the work of Campin and Jan van Eyck, but adding his own tender sense of colour, his interest in line as well as in mass, and above all, his profound feeling for religious drama.

In the discussion of Robert Campin it has been shown that in 1427 Campin received two apprentices, Rogelet de la Pasture and Jacques Daret. The style of the chief and probably early picture ascribed to Roger van der Weyden, the *Descent from the Cross* (Madrid) (Pls. 24 and 26), shows so much knowledge of Campin's work that it strengthens the supposition that Rogelet de la Pasture and Roger van der Weyden are the same. If this is so, the painter was not apprenticed till he was twenty-seven, which is unusual, but by no means impossible. In 1426 the town of Tournai had given a present of wine to 'maistre Rogier de la Pasture', but the document recording it does not say he was a painter. If he was the same man he must have matriculated in another profession, but perhaps disliked it, and decided to turn to painting.[1] It is, at least, certain that the painter of Brussels was born in Tournai, and that he retained some connection with that town, for in 1435, three years after he would have left Campin's studio, 'Maitre Rogier de la Pasture, peintre', then living in Brussels, invested a considerable sum of money in Tournai.

Before he received his appointment in Brussels he must have done something to prove himself worthy of it, and perhaps also to produce the money which he invested in 1435. It seems possible that the work which made his name was the *Descent from the Cross* (Madrid), painted for the Guild of Archers

[58]

of Louvain. Since no one has ever seriously doubted the sixteenth-century attribution of this work to Roger, and since it was unquestionably in existence by 1443, when a small copy, still in Louvain, was made for the Edelheer family, it is a reasonably safe work on which to base a discussion of Roger's early style.[2]

The picture is fairly large, about seven feet high in the centre, the figures therefore being rather under life-size. To an even greater extent than Campin's *Entombment* (Pl. 5) it recalls a sculptured altarpiece, for the group appears to be set in a shallow niche, the small pieces of tracery painted in the corners deliberately increasing the illusion. The figures are tightly packed within the niche, but they have great force and reality, and the whole group is knit together by strong linear rhythms. The abrupt verticals and horizontals of Campin have been replaced by a series of carefully planned curves. Roger is, indeed, most daring in his composition, for the dominant lines of the arms and body of Christ are echoed in those made by the fainting figure of the Virgin. It would have been easy, in the hands of a lesser master, for this device, introduced partly to stress the tragedy, to throw the composition out of balance, and leave it sliding away to the left. Roger avoids this. He frames the group by the St. John on the left and the Magdalen on the right, both bowed in grief towards the centre, but in order to strengthen and steady the left side he adds another, more upright figure of a mourning woman. This assured method of composition, based on curves, though with every figure performing a natural and almost necessary action, with no awkward gaps between the figures, and with none seen from the back is surely proof that Roger and Campin are two different personalities. None of the works ascribed to Campin suggest that he could ever have thought in such terms, or solved the problem of grouping a number of figures together with such skill. Even though his design of the *Descent from the Cross*, recorded in the Liverpool copy (Pl. 9b), must be earlier than Roger's picture, the whole approach is fundamentally different. One is the work of a man who, in his anxiety to move away from the Gothic world to a new reality, abhors curving patterns; the other, younger painter is able and willing to take something from both the old and the new styles.

It can easily be seen that Roger has borrowed from Campin. Many of his figures, above all the women with their large faces and heavily lidded eyes, are very close to Campin. And though the drawing is everywhere more refined, the same firm line and slightly chiselled forms appear. The head of Nicodemus, for instance, can well be compared with those of the figures beneath the cross of the Frankfurt *Dying Thief*. The latter, too, as well as Count Seilern's

Entombment, show that Campin was not incapable of conveying drama, but nowhere in his work is there the profound sense of grief which fills Roger's picture. It is this deeply-felt religious emotion, which runs through all his works, which separates him so sharply from Jan van Eyck. Jan is an all-seeing spectator, detached and cool, with a marvellous ability to set down what he sees; Roger is an infinitely more subjective painter, who is passionately involved in the content of his pictures. Though we have no proof beyond the pictures, he must surely have been a deeply religious man.

There is one further aspect of this work in which Roger differs from both Campin and Van Eyck, and that is in his handling of colour. The strength of the older masters lay in their brilliance, strong reds, blues and greens foiled with white. Roger is much more subtle. In the *Descent from the Cross* he uses colour to strengthen the drama. The figures on the left of Christ are relatively sombre, St. John in dark crimson, the Virgin in plain blue, the woman behind her in soft green. On the right, where the grief is more clamorous, the colours are more broken and excited, Nicodemus in gold and red brocade, and the Magdalen in a multicoloured dress with scarlet sleeves, a yellowish bodice and a pale mauve skirt. Mauves, and later a rich plum colour, reappear constantly in Roger's work, and his use of them in contrast to blues, or of green with silver grey, give his work a variety and indeed a tenderness of colour which is absent in Van Eyck.

The *Descent from the Cross* has been discussed in some detail since it is the epitome of Roger's early style, but there are a number of other works which probably date from before about 1440. The *Annunciation* (Louvre) (Pl. 28), much more gentle than Campin's experimental picture of the same subject, is a little immature in the drawing of the heads, but the careful study of light falling into the room suggests that by the time he painted it Roger had seen and studied works by Van Eyck. The room also has some relation to Campin's *Werl wings* of 1438 (Pls. 11a and 11b), but the drawing of the figures is very different. Neither of Roger's figures rests very firmly, but both have a slight swaying movement resulting from the long curve running from their heads to the ground.[3]

The same swaying movements appear in another semi-documented early work, the *Retable of the Virgin*, which exists in two versions, neither apparently entirely by Roger himself. This is a triptych with three equal panels showing the *Holy Family*, the *Lamentation* and *Christ appearing to His Mother* (Pl. 25b), one version (now Berlin) of which was given to the Charterhouse at Miraflores in Spain by King John of Castile in 1445.[4] Each scene is set under a traceried, sculptured arch, the figures being so close to the eye that they

project in front of the arch. Although there is a carefully limited space or else a landscape behind them, Roger is in no way concerned with placing his figures in depth, but is more interested in the narrative content, and in the decorative design as a whole. The device of setting figures under, though hardly behind, a traceried arch evidently pleased him, for he used it on several other occasions. The small seated and standing Virgins of this pattern (Thyssen Coll. Lugano : Vienna) are clearly early works, for in both cases the face is Campinesque in type, though the Virgin wears an Eyckian crown. Later in life, Roger was to paint a triptych with three scenes from the *Life of the Baptist* (Berlin). Here the architecture is stronger than in the Miraflores altar, there is no tracery to confuse the eye, and the rooms or landscapes behind the arches are more fully realized. But even here the main figures are very close to the eye, and the narrative is far more important than in any picture by Van Eyck.

Perhaps the most striking demonstration of the difference between Roger van der Weyden and Jan van Eyck is provided by the former's *St. Luke painting the Virgin* (Boston, Munich, Leningrad, etc.) (Pls. 25a and 27),[5] the design of which is unquestionably derived from Van Eyck's *Rolin Madonna* (Pl. 22a). Van Eyck's picture is almost square, the Virgin and the donor making two triangular blocks, hardly connected with each other. Roger's picture is a tall rectangle, so that the proportions of the figures to the frame and to each other is necessarily different, and the figures are connected, partly by the linear rhythms of the Virgin's mantle. Van Eyck's Virgin is the Queen of Heaven; an angel brings her a magnificent crown, the Child holds an orb, and raises his right hand in blessing. Roger's Virgin, like Campin's *Madonna of the Firescreen* (Pl. A), is a mother giving the breast to her child, and the Child himself, helpless and naked, wriggles his hands and feet in anticipation. It is true that Roger's mother sits under a cloth of honour and has a fine gold brocade dress and a rich fur-lined mantle, but Roger conceives his holy figures in human terms while Van Eyck does not. The tall, slightly swaying figure of St. Luke is again characteristic of Roger, for the curves which he loves run right through his body and make it, indeed, impossible to know how his position is sufficiently steady for the act of drawing. The change of proportions, naturally, runs right through the picture, for the two figures looking over the parapet at the back are tall, both swing a little sideways, whereas Van Eyck's are two small sturdy blocks. The poverty of Roger's landscape compared with his pattern is again revealing. He has not the desire, and probably not the ability, to reproduce the wonderful teeming world beside the river. He is contented with a more summary suggestion of the landscape

beyond; his real interest lies in his figures and in what they represent.

This beautiful design, which has less of Campin in it than the Madrid *Descent from the Cross*, is generally dated about 1440, but the development of Roger's style about this time cannot be followed with certainty, since the panels showing stories of justice and retribution, painted for Brussels Town Hall by 1439, were destroyed in the bombardment by Marshal Villeroy in 1695.[6] The fine, assured triptych of the *Crucifixion* (Vienna) (Pl. 30), however, suggests that Roger gradually freed himself from his dependence on Campin and Van Eyck, and worked out his personal style in which the modelling remains firm but increasingly subtle, and linear rhythms are used with great dramatic effect.

In 1450 Roger went to Rome, perhaps because it was proclaimed a Jubilee Year by Pope Nicholas V. Our authority is the Italian, Bernardo Facio who, writing in 1456, states that Roger had greatly admired the works, now lost, of Gentile da Fabriano in St. John Lateran. It would be natural for a Northerner to find Gentile's work congenial, for in its love of a rich decorative effect it would seem less alien than more monumental Italian painting. What other Italian cities Roger visited is less certain. Until recently it was thought he had visited Ferrara, and painted the portrait of Lionello d'Este (New York). This portrait is now, however, known to be not of Lionello but of Francesco d'Este, a member of the family who had been to Burgundy.[7] A triptych of the *Pietà* by Roger was seen in Ferrara by Cyriac of Ancona in 1449, but the Este's had their agents in Bruges, and the picture may have been ordered through them. Nevertheless, there are two pictures which show knowledge of Italian, and above all of Florentine art, and it may well be that one or both were painted in Florence on Roger's way to or from Rome.

The first is a *Madonna and Child with Saints* (Frankfurt) (Pl. 32a) often called the *Medici Madonna*, since on a shield on the parapet it bears the red lily which was both the arms of Florence and one of the badges of the Medici family. The Virgin stands on a hexagonal flight of steps under a tent-like canopy, the latter a device which may come from Campin. Two saints stand on each side of the steps, St. Peter and the Baptist on the left and Sts. Cosmas and Damian on the right, and there is no donor. The picture is, in fact, a *Sacra Conversazione* in the Italian manner, and though the type was not completely unknown in the North, no dated example exists before 1456. Sts. Cosmas and Damian were the patron saints of the Medici family, but they were also the patrons of the Guilds of Physicians all over Europe and their presence alone would not suffice for a direct link with Italy.[8] The figure of St. Peter on the left, however, is strangely un-Flemish. He stands motionless, his cloak

falling in almost unbroken vertical folds from shoulders to feet. Indeed, except for the Baptist, all the saints are arranged to stress verticals, and give the impression that the artist must have seen Florentine works of the 1440's, the St. Peter being especially reminiscent of Fra Angelico.

The *Entombment* (Uffizi) (Pl. 32*b*) makes even a stronger case. This is almost certainly a picture which was in the Medici collection at Careggi in 1492, and is completely un-Flemish in conception. There are two main Flemish patterns for this subject, the one showing the Dead Christ being lowered into a large coffin-like tomb (as in Count Seilern's triptych), the other, frequently used by Roger, and represented in the National Gallery by the picture from the Earl of Powis' collection, with the Dead Christ on the ground or on a sheet, mourned over by his Mother and St. John. No other Flemish picture shows the sepulchre hewn out of a rock, with the body of Christ seen frontally, supported by Nicodemus and Joseph of Arimathea, with the Virgin and St. John bending over the limp, outstretched hands. The authority for this design is Fra Angelico's panel (Munich) which is part of the predella which he had painted for the altarpiece commissioned by the Medici for the convent of San Marco in Florence. It is impossible to believe that Roger had not seen this work. Fra Angelico might, indeed, have been even more attractive to him than Gentile da Fabriano, for his deep piety matched his own. The Northerner has elaborated the design, altering its frontality and its moving simplicity, adding figures to stress the narrative and giving the landscape greater importance, and filling the foreground with careful detail. The result is one of the most interesting examples in the whole century of a northern variation on an Italian theme.

Perhaps Roger's most original composition, and one of his largest, is the altarpiece of the *Last Judgment* in the Hospice at Beaune (Pl. 31). The Hospice had been founded by Chancellor Rolin in 1442, the chapel being dedicated in 1451, though it is not known if the altarpiece was then in place. The outside of the wings shows Rolin as a shrivelled old man, kneeling opposite his wife, while between them are two saints specially invoked in cases of plague, St. Sebastian and St. Anthony, with above them, in grisaille like the saints, is the Annunciation. The design is a simplification of that of the outside of the Ghent altarpiece, and is, in fact, the only place in fifteenth-century painting where the influence of this can clearly be seen. Rolin himself might have known it or, since Roger seems to have known something of the work of Jan van Eyck very early in his career, he might possibly have visited Jan's studio before the altarpiece was set up. Apart from this, the interest lies chiefly in the difference. Roger's saints are far more slender and it is hard to

know, especially in the Annunciation, whether his grisaille figures, with their lively movement, are stone or flesh.

The inside, which covers nine panels, has an amplitude of conception which far surpasses that of the Ghent altar. The tall central panel shows Christ as Judge, seated on a rainbow, and below him St. Michael weighing souls. To right and left, at the end of the rainbow, are the Virgin and the Baptist interceding for mankind, and behind them, seated in a great half-circle in the sky, are Apostles and Saints. Below, the dead rise from their graves, are led on the left by an angel to the portal of Heaven, and on the right they fall into the fires of Hell. The divisions into panels do not break up the design of the altarpiece, for it is conceived as a unity, and the ring of Apostles and Saints, as well as the landscape with the dead, runs on from one panel to the next. The germ of this idea had appeared in the lower row of the *Ghent altarpiece*, but there the scale is much smaller, and the panels could be read separately, whereas in the *Beaune altar* the whole must be regarded as one great composition, tied in design as well as in theme to the central figure of Christ. It is arguable that Roger could hardly have conceived so monumental a design before his visit to Italy, for though there is no immediate echo of any specific Italian composition, the new amplitude of conception might well be the result of seeing large fresco paintings.[9] This work shows Roger at the height of his powers. The slight harshness of some of his early works, derived from Campin, has disappeared, the modelling of, for instance, the Virgin's head and of all the praying hands, is full of perception, and in the drawing of the nudes, especially of the terrified figures condemned to Hell, he reaches a height of dramatic expression which far outstrips any earlier work.

Three altarpieces, none very large, must date from the period after 1450, and all show the mellowing of his art. The *Bracque Triptych* (Louvre) (Pl. B) must have been painted between 1450 and 1452, for it bears on the back the arms of Jehan de Bracque and his wife. They were married in 1450, and he died in 1452. It may be a memorial picture, but it cannot be much later, or his arms would not appear. The painting shows five half-length figures, Christ flanked by the Virgin and St. John the Evangelist in the centre, the Baptist and the Magdalen on the wings, all very close to the eye, but with a spreading landscape behind. The subject demands no narrative treatment, but the figures themselves are of superb quality, the Magdalen in her rich dress and grave expression being one of Roger's most beautiful creations. The landscape, too, is much finer than in his early works, but it may well be that by this period in his life Roger had learnt something from a younger painter, Dirk Bouts, whose work will be discussed in the next chapter.

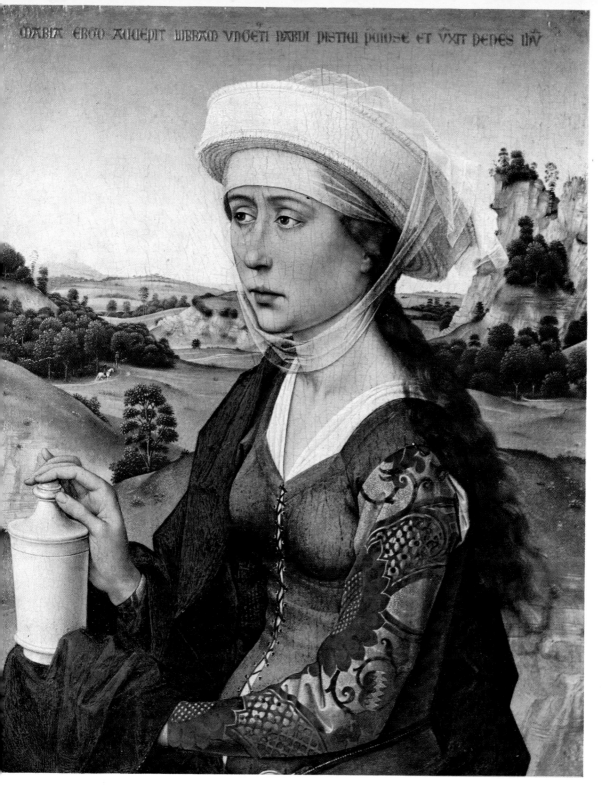

B. Roger van der Weyden: *The Magdalen (right wing of Bracque Triptych)* (1450-52)
Paris, Louvre

The *Bladelin altar* (Berlin) and the *St. Columba altar* (Munich) (Pl. 34) must be even later. The former was painted for Peter Bladelin, financial controller to the Duke of Burgundy, who built the town of Middelburg between 1446 and 1450, the church being dedicated in 1460. The other was for the church of St. Columba at Cologne, the enlargement of which was begun in 1456, and it may well be Roger's last important work, perhaps indeed left unfinished at his death in 1464. The *Bladelin altar* is a peaceful Nativity scene, beautiful in colour and filled with simple piety, but far more skilful in its arrangement of figures, stable and landscape than Campin's much earlier Dijon picture.[10] The *St. Columba altar* is far more splendid. The centre panel shows the Adoration of the Magi, the wings the Annunciation and the Presentation at the Temple. In the Adoration panel Roger introduces a new form of composition, with the stable no longer set diagonally but turned so that it is parallel to the picture plane, and greatly increased in size. The Virgin is almost in the centre, with the train of the kings coming from the right and St. Joseph and a kneeling donor on the left. The composition is more crowded than in earlier pictures, but the three kings, very richly dressed, are still tied together by linear means, though the line is less crisp and more complex than in the Madrid *Descent from the Cross*. Both in the central panel and in the wings the figures are tall and slender. This in itself would proclaim this to be a late picture, for elegant figures, with an emphasis on decoration, are characteristic of art in many parts of Europe round about 1460. But Roger's main interests have remained constant. Although in all three panels, and particularly in the *Presentation* scene, there is a beautiful development of space behind the figures, the figures themselves are very close to the eye and their action in the narrative is of far greater importance to the artist than their placing deep in their setting. These nervous elegant figures, intent on what they are doing, are far indeed from the monumental detached saints and donors of Jan van Eyck.

There are many other aspects of Roger's art which could be discussed. His great popularity led to the repetition of his designs, sometimes with a variation of the donor or the patron saint, and for such work he must have had a large studio with several competent assistants.[11] Sometimes only part of a design was repeated. There are, for instance, half-length panels of the Virgin and Child which are based on figures in *St. Luke painting the Virgin*. Such half-length Virgins were frequently the left-hand panel of a diptych, the right panel being given to a portrait of the praying donor. Most of these have now become separated from each other, but several pairs can be identified, since they correspond in both size and style. The portrait of *Laurent Froimont*

(Brussels) belongs to a Virgin and Child at Caen; the *Jan de Gros* (Chicago) had a Virgin (formerly Renders Coll. Brussels) close to, but later than the *St. Luke painting the Virgin*, and the slightly longer portrait of *Philippe de Croy* (Antwerp) (Pl. *33b*) belongs to the Virgin with the Child playing with a book at San Marino, California (Pl. *33a*). All these portraits, even if Virgins of the same size had not survived, could safely be identified as donor-portraits, for all show the hands joined in prayer. But Roger also certainly painted many portraits which were works in their own right; and these, like his altarpieces show the development of his personal style. Early examples such as the *Bishop Guillaume Fillastre* (Sir Thomas Merton Coll.) or the *Portrait of a Woman* (Berlin) are crisp and a trifle hard in drawing. The light is allowed to fall directly on to the face, so there is little occasion for the subtlety of a shadowed nearer cheek which is one of the triumphs of Jan van Eyck. Eyes and mouth are firmly and correctly drawn, but the outlines of the forms are more important than their modelling. Later, as Roger moved further from Campin, the drawing is less emphatic, though as in all his work, clear drawing remains crucial to his style. His modelling becomes softer, and the decorative quality of the work, in addition to the good likeness, is now of greater importance. This is most strikingly displayed in the *Portrait of a Lady* in a white headdress (Washington; and with variations, National Gallery (Pl. 29)). Here the placing of her head with its falling transparent linen frame is most carefully planned, and the delicate, serious young face projects from the flat planes on either side of it with full reality, but with a stillness, a slight melancholy which characterizes all Roger's work. This, and the later portraits, show a further departure from Jan van Eyck in the colouring of the background. It is usually a subdued colour, a dull green or blue; but even so, it is less neutral and more decorative than the plain dark background from which Van Eyck's heads emerge. In the very late portraits, the *Grand Bastard of Burgundy* (Brussels) or the *Charles the Bold* (Berlin), the features are much more broadly modelled, though the decorative quality remains.[12] The Grand Bastard wears a plum-coloured cap, and is set against a dark blue ground; his arrow and his Golden Fleece shine against his dark dress, and give the portrait a certain opulence without detracting from the breadth and strength of the face.

The same breadth in modelling a head appears in one of the last of Roger's religious paintings, the grand *Crucifixion* in grisaille (Escorial) which in 1574 was recorded in the Chartreuse in Brussels.[13] Long and curling draperies are still used, in contrast with straighter folds, to convey the agony of the shrinking Virgin, but the head of St. John, his hands raised in pity and amazement, who looks up to the Cross, is painted with a breadth and assurance

that brings it closer to the monumental vision of the Italians than any of Roger's other works.

Roger's art is perhaps the epitome of all that is best in Northern art of the fifteenth century. He can be tragic or tender, he can present a story or portray a face, and leave no doubt as to what he thinks of it. A beautiful colourist and a fine draughtsman with a keen sense of form, he is not afraid of decoration, though he uses it almost always for pictorial reasons and not just for show. The background of wealth and also that which sometimes led to religious hysteria were used when he needed them, and discarded when he did not; and his strength of personality enabled him to take what he required from his great predecessors, but to add to it so much of his own that, within the limits of his intention, he becomes their rival, and sets a permanent mark, inventive, pious and sincere, which served as a standard for many younger men.

CHAPTER V

PETRUS CHRISTUS AND DIRK BOUTS

1

The careers of Petrus Christus (d. 1472/3) and Dirk Bouts (d. 1475), the two major artists who with Roger must have been working about the middle of the century, are each so confused that discussion of the development of their styles must largely be based on conjecture. Christus has left a number of dated pictures from 1446 to probably 1457, a period which seems likely to have fallen about the middle of his life; Bouts' documented works are all between 1464 and 1475, when he was growing old. Nevertheless, Bouts' contribution to Flemish painting is easier to assess, for though he, like Christus, borrowed from other masters, his own deep feeling for landscape was to stimulate even greater masters such as Roger.

Christus was also a painter of considerable talent, but his signed works suggest that his talent was limited, and consisted largely in a conscious simplification of the detailed Eyckian vision, though the Eyckian interest in light and in setting figures in space was retained and even enlarged. Some of his pictures show, however, so strong an influence of the works of Robert Campin and Roger van der Weyden that Christus' own personality tends to disappear.[1] He certainly, however, enjoyed some fame outside Flanders, for Lorenzo de' Medici owned a portrait said to be of a French lady 'by Pietro Cresti da Bruggia'.

Petrus Christus became a Master in Bruges in 1444, about three years after the death of Jan van Eyck, having probably been born at Baerle near Limbourg. He is not recorded as working in any other city, and he was living in Bruges at the time of his death.[2]

One of the major points of controversy is whether Christus was taught by Jan van Eyck, and whether he completed the master's unfinished works, especially the *St. Jerome* (Detroit) and *The Virgin with St. Elizabeth of Hungary, St. Barbara and a Carthusian* (Frick Coll. New York). The former, as has been suggested, is a highly puzzling picture, but the latter is possible, since the female figures have the rather doll-like face which appear in some of Christus' later pictures;[3] on the other hand, the signed and dated portrait of

Edward Grimston (1446: Earl of Verulam Collection) (Pl. 35a), though it shows a knowledge of Eyckian lighting, is closer to Roger in drawing. It also shows one of Christus' real contributions to Flemish painting, for the figure is not seen against a plain background, but in the angle of a room — in other words, the question of the setting has here become part of the art of portraiture, a feature which had not occurred before, except in Van Eyck's *Marriage of Giovanni Arnolfini*, where it had a special significance. The modelling of the head is considerably simplified, and the same characteristic appears in the *St. Eligius with two Lovers* (1449: Lehmann Coll. New York) (Pl. 35b). Here again there is strong influence of Van Eyck, for St. Eligius is shown in his goldsmith's shop, weighing the wedding rings of the bridal couple, and the many objects of his trade are described precisely through the fall of light. Jan van Eyck had painted a half-length portrait of two men in an interior, and it is possible that Christus was building on this. The rendering of the gradation of light is, however, harsher than in the works of Van Eyck, the forms are harder, and the drawing of, for instance, the hands is weak and unexpressive.

From his earliest working years, therefore, Christus knew something of the harder drawing of Campin and Roger, and preferred it to the softer modelling of Van Eyck; by 1452 he was openly borrowing from both schools. Part of an altarpiece of that year (Berlin) has a tall oblong panel of the *Last Judgment* based on the Eyckian picture in New York, but with the design simplified and weakened, and two smaller panels of the *Annunciation* and the *Visitation* directly derived from Roger's Louvre picture. The *Madonna with St. Francis and St. Jerome* (Frankfurt) (Pl. 36) is apparently dated 1457 (though the third figure is hard to read) and is in some ways a dull version of an Eyckian type (the small *Lucca Madonna* also at Frankfurt is perhaps the closest), with the addition of two standing saints. But again, as in the *Edward Grimston*, there is something that is new. There is no donor, so it is perhaps the first true *Sacra Conversazione* to be painted in Flanders.[4]

Christus' experiments in simplifying the work of other masters had also evidently led him towards a clarification of the problem of rendering the space in which his figures are set. This is abundantly clear in two undated pictures. The *Nativity* (Washington) (Pl. 37), which has been dated *c.* 1445, though largely on its relation to works by other masters which are also undated, is curiously clumsy and even immature in the handling of the figures, for there is no sense of the structure of the body beneath the draperies. On the other hand, the placing of the stable in relation to the figures is of considerable interest. Christus has borrowed but transformed a device used by Roger in the central panel of the *Miraflores altar*, where the tau cross from which Christ

has been taken down stands behind the foreground group.[5] Christus changes the arms of the cross to a horizontal beam at the back of the stable, parallel to the picture plane and clearly related in depth to the sculptured arch which frames the composition, thereby giving a firmer spatial setting to his figures. An even more ambitious picture is the *Death of the Virgin* (San Diego, California), which may well date from the end of the 1450's.[6] It was in Sicily from at least the early sixteenth century and was at one time ascribed to Antonello da Messina. The confusion is, to some extent, easy to understand, for the Virgin's room is constructed with great clarity and with an obvious knowledge of the laws of mathematical perspective. Definition of the interior space by the fall of light is also a weapon employed by the artist, though the light is harsh and its effects are, compared with Van Eyck's *Arnolfini Marriage*, much simplified. The figures, however, are stiffly and indeed clumsily constructed, and are not welded into a group, but are scattered somewhat loosely about the room. Moreover, though one man displays exhaustion and some of the others a mild curiosity, the gestures are timid and there is no dramatic concentration in the scene. The picture owes nothing to Campin or Roger, but the vertical figure with a censer in the foreground, and the landscape seen through the window and open door, suggest that Christus was aware of the art of Dirk Bouts. The lack of coherence between the figures, and the limited range of colours — red, brown, dull blue and white — make indeed a sharp contrast to the work of Roger van der Weyden; on the other hand, Roger would never have attempted the daring and successful experiment of placing figures in so clearly defined a setting.

Christus' position and the development of his art remain hard to assess. The problem would be easier if dated works had survived from the last fifteen years of his life. His early dated works, such as the *Edward Grimston* and the *St. Eligius with two Lovers*, reveal a keen and experimental mind and are difficult to reconcile with a picture such as the *Lamentation* (Brussels), which is entirely dependent on Campin and Roger in the figures, and on Bouts in the landscape. Whether this represents his final style is still a matter of argument; if it does, he became less inventive towards the end of his life.[7]

2

Dirk Bouts was almost certainly born in Haarlem, at that time one of the poorer parts of the Burgundian dominions. It is not known if he was trained there, but since there was probably less opportunity there for a painter than in the richer south, he moved down to Louvain, where he probably married

about 1448.[8] He is not, however, actually recorded in Louvain till 1457, and he seems to have been continuously there from 1464 till his death in 1475.

Although there are certainly earlier works, it will be best first to consider Bouts' earliest fully documented work, the altarpiece of the *Last Supper* (Pls. 38 and 39), painted between 1464 and 1468 for the Confraternity of the Holy Sacrament in Louvain, and still in the church of St. Pierre. The contract for it states that he was to paint no other work at the same time. From it all the strength and weaknesses of Dirk's art will quickly be apparent. The central panel shows the Last Supper, and the wings certain meals of the Old Testament, which were regarded as types, foreshadowing the central theme. Each wing has two panels, placed above each other; on the left Abraham and Melchisidek and the Gathering of Manna, on the right Elijah in the Wilderness and the Passover. The colours are strong and rich, red, white, black, dark green and brown being dominant, though the mood is crystallized in the dull violet robe of Christ. The jewel-like brilliance of Van Eyck does not appear, but there is, above all in the central panel, a great feeling of light and air, a sudden hush caused by the words of Christ — 'One of you shall betray me' — but none of Roger's drama. The figures seated round the table are pushed back into the room, which is constructed accurately with a single vanishing point, set high on the overmantel above the head of Christ. Each person and every object in the room is touched by light, and it is light, rather than the drama of the moment, which gives unity to the whole. The figures are spare, and extremely restrained in their gestures, but each is an individual, and the evil intentions of Judas, sitting twisted and arrogant, the hand which will receive the silver hidden behind his back, are not hard to understand. Movement in heads and hands is very slight, but all have meaning. The draughtsmanship is clear and full of expression, and in this way related to that of Roger, but the delicate perception of the fall of light, above all on the hands, suggests that at some time in his life Bouts had seen works by Van Eyck, and had taken from them what he needed.

The construction of the central panel, so different from that of Roger, in which the main figures are always close to the eye, has been planned not only because Bouts wishes to exploit the spaciousness of the upper room, but also because these figures must not completely dwarf those on the wings. In the smaller panels they are brought forward, and so are as large as the narrative allows; had the Apostles at the Last Supper been so close to the eye, they would have made those on the wings seem uncomfortably small. Three of the Old Testament scenes show figures in a landscape setting. Bouts' landscapes owe nothing to the rich wooded hills of the Ghent altarpiece; they are bare

but rocky, sometimes with slender trees silhouetted against the sky. In each case a winding road leads the eye into the distance, and on the road, carefully placed, are smaller figures which help to articulate the landscape. Only the Passover is seen in an interior. Here the still, tall figures are typical of Bouts; elsewhere, notably in the angel bringing food to Elijah or the women gathering Manna, he takes his pattern from Roger, though the forms become a little stiffened in their transformation.

From 1468 till his death in 1475 Bouts is known to have been painting for the Town Hall in Louvain which had been finished in 1459. His *Last Judgment*, which was completed and framed in 1470, is now lost, but the two large panels of the *Justice of the Emperor Otto* (Pls. 40, 41, 42a), in fact a story of injustice and retribution, are now at Brussels. The first panel shows the infidelity of the Empress while the Emperor was on a journey, her seduction of an honourable Count, her false accusation of him on the Emperor's return, and his execution. The other shows the defence by the widowed Countess. Kneeling before the Emperor, she undergoes, unscathed, the ordeal by fire and convinces the Emperor of her husband's innocence. The guilty Empress is therefore condemned to death, and in the background is shown being burnt at the stake.[9] Such moralizing histories were considered appropriate for Town Halls in both the fifteenth and early sixteenth centuries — they run from the lost series by Roger in Brussels to a series by Holbein for Basle — and were no doubt intended as exemplars for judges. Only the second panel was completed by Bouts in 1473; the other was probably designed by him, though the poorer quality suggests he did little work on it himself.[10]

Although the story is a dramatic one, Bouts' treatment, as would be expected, is singularly undramatic, though that does not mean that the *Ordeal by Fire* panel is unimpressive. The panels are about six and a half feet high, and the tall, slender figures with their long, thin legs and high caps make them seem even longer. The central group of the motionless kneeling widow carrying her husband's head in one hand and the red-hot bar in the other, and the immensely tall seated Emperor, leaning back in amazement, is framed by quiet, vertical figures, set under a loggia whose depth and recession is very clearly defined, partly by the repetition of the painted tracery. As in the painting of the *Last Supper*, Bouts handles the problems of air and light with complete assurance. The drawing is remarkably fine, the modelling firm and crisp, the colours, black, gold, red, brown and plum against the pinkish stone are sufficiently rich and complicated to add interest to the picture without confusing the eye, and the quality of the heads, which must be portraits, is superb. The weakness of the other panel is now easy to see since the recent

cleaning, and it is not surprising to learn that its poor quality early became apparent, and that much of it was over-painted, probably early in the seventeenth century.

Two other works, also fairly late, can be attributed to Bouts with some certainty. The *Portrait of a Man*, dated 1462 (National Gallery) (Pl. 42b) is not signed, but it is so close in style to the *Last Supper* of 1464 that there can be no doubt that it is his. The head is shown against the angle of a room, thus carrying on the idea first used by Christus in his *Edward Grimston* (Pl. 35a), but it goes beyond Christus in the opening of the window on to a landscape. Moreover, the modelling is not hardened and simplified as in the work of Christus; light, shadow and half-light on the nearer cheek are most carefully rendered, as is the fall of light through the strands of hair.

The triptych of the *Martyrdom of St. Erasmus* in St. Pierre, Louvain, is also a reasonably certain work by Bouts and was probably finished soon before the *Last Supper altarpiece*.[11] Here again the artist shows his reluctance to deal dramatically with a theme of horror — St. Erasmus endured martyrdom by having his intestines wound out — but he composes a peaceful arrangement of horizontals and verticals, with a group of richly dressed onlookers set in a fine spreading landscape. Again the colours are interesting, but not Eyckian, for the use of plum and yellow as well as scarlet, blue and green suggests a knowledge of the work of Roger, though there is nothing of Roger's passion in the calm reserved composition.

All of these works fall fairly late in the artist's life, and all display a style of great maturity, very accomplished in its handling of light and colour, and deliberately restrained in its treatment of dramatic narrative. It is, however, necessary to ask if anything can be deduced about Bouts' earlier style, and in particular about how this mature style was formed. We do not know when Bouts first came south to Louvain, but if he married there about 1447 it may well have been in the mid-1440's. At that time the two leading painters were undoubtedly Roger, in Brussels, and Christus, in Bruges. Louvain is very close to Brussels, but there is no proof that he did not visit Bruges, which must have been widely known since the time of Van Eyck as a great centre for artists. It is, indeed, possible that when Bouts first came south he worked in Bruges, perhaps under Christus, and learnt something from him of Eyckian lighting, though there seems no trace in his work of the influence of Christus' dated pictures of the 1440's. On the other hand, it would appear to be certain that he must have had some immediate contact with Roger van der Weyden. He freely borrows types and to some extent methods of design (though not his sensitivity to light) from the latter, and some reverse influence of Bouts'

approach to landscapes can be seen in Roger's work, first, perhaps, in the Vienna *Crucifixion* (Pl. 30), with its bare countryside, and more strongly in the rocky hills of the *Bracque Triptych* (Pl. B). It must, however, always be remembered that, with the exception of the Bracque picture (*c.* 1450–52) none of the works concerned can be precisely dated, and that caution is needed in conclusions concerning them.

An important altarpiece in Spain, which exists in two versions, has been attributed to Bouts since 1523, and seems to offer conclusive evidence of his knowledge of Roger's work. The larger and finer of the two versions is the triptych of the *Deposition* with the *Crucifixion* and the *Resurrection* on the wings, in the Royal Chapel at Granada (Pl. 43*a*); a smaller version, probably an early copy, is at Valencia.[12] Much has been borrowed from Roger. The main scene, like all the episodes in the *Miraflores altar*, is set under a sculptured arch, but the figures are pushed back behind the arch, suggesting, tentatively, that interest in depth which Bouts was to bring to fruition in his later dated works. The *Resurrection* in the right wing is closely based on the small representation of the scene in the background of the panel of *Christ appearing to His Mother* in the *Miraflores altar* (Pl. 25*b*), while other figures are borrowed from Roger's Vienna *Crucifixion*, or from the Madrid *Descent from the Cross*, and some suggest that Bouts must have known Campin's lost *Descent from the Cross*, of which only the Frankfurt *Dying Thief* and the Liverpool copy remain (Pls. 8 and 9*b*). The grouping of the figures is, however, more abrupt than in designs by Roger, the linear rhythms are less strong, there is more emphasis on verticals, and while in Roger's figures an angularity of pose usually reflects the agitation of their feelings, Bouts' figures are calm, and their angularity seems the result of a deliberate stiffness to increase this calm. Similar characteristics may be seen in many other paintings attributed to Bouts — the four panels showing *Scenes from the Life of the Virgin* (Madrid), also under sculptured arches, the beautiful *Entombment* (National Gallery) in tempera on linen, and to some extent in the vividly coloured *Pearl of Brabant* altarpiece (Munich) (Pl. 43*b*).[13] The last, with the *Adoration of the Kings* in the centre, and *St. John the Baptist* and *St. Christopher* on the wings, both set in remarkable landscapes, has been a subject of much controversy, but the technical quality is so high that it cannot be a studio work. The narrative element in the centre panel is very close to that in, for instance, the *Abraham and Melchisidek* or the *Gathering of Manna* wings in the *Mystic Meals altarpiece*, and the tall, spare figures, awkwardly posed, reserved in expression, but filled with quiet devotion, are entirely characteristic of Bouts' work.

It is, indeed, in this stillness that Bouts' art is eternally impressive. His

sense of tragedy is less passionate than that of Roger, but he has not the complete detachment of Jan van Eyck, for he compels the spectator to contemplate the meaning of his themes. At the same time, he is more concerned than Roger with the beauty of the world which he sees, a world full of cool light, wide spaces in which his figures barely move, and deep, unpeopled landscapes. His characteristics of quiet and reserve, and indeed his awkwardness, may be inherently Dutch rather than Flemish, and come from his background. On the other hand, they link him with the outlook of the Brethren of the Common Life, a Dutch confraternity with which no connection is known, but who shared his contemplative approach to the sufferings of Christ, expressing this by silence, but also by an imitation of his example.[14] Many other works than those discussed can reasonably be attributed to him, and his influence, both as a master of light and of landscape, was to be strongly felt by younger men.

CHAPTER VI

HUGO VAN DER GOES

All Flemish painters working after 1460 found themselves, inevitably, building on the foundations laid by the Van Eycks, Campin and Roger. They drew on them both for types and for methods of composition, but they are rarely purely derivative, for they add something personal to the styles they found. Of no artist is this more true than of Hugo van der Goes (worked *c.* 1467–d. 1482). A man of passionate temperament, during his short working life he amalgamated many of the discoveries of the older masters, but pushed them to new heights of expressiveness. He was a great colourist, a superb draughtsman, and he explored new methods of composition which were still to interest painters some thirty years after his death.

His biography is short. He was probably born in Antwerp, where nothing is known of painting in the mid-fifteenth century, and in 1467 he became a Master in Ghent. The painter Joos van Wassenhove, known as Justus of Ghent, stood surety for him (this was necessary since Hugo was not a native of Ghent), having himself been a Master of Antwerp in 1460, and having bought his freedom in the Ghent Guild in 1464. Between 1467 and about 1474 there are a number of payments to Hugo by the town of Ghent, which show that he was employed in decorations for the entry of Charles the Bold in 1468/9, and also for the funeral of Philip the Good in 1473/4. At the time of the marriage of Charles the Bold to Margaret of York in 1468, he worked on decorations in Bruges, but his pay for these was not high. His reputation in the Ghent guild no doubt grew, and in 1474 he was appointed Dean. He was probably at this moment recognized as the most talented artist in the Netherlands (Bouts, whose fame must have been greater, was probably by now an old and perhaps sick man), and about the middle of the decade he received an important commission from Tomaso Portinari, the Medici agent in Bruges. Soon, however, his restless spirit drove him to join his brother in the Augustinian monastery of the Rode Kloster near Brussels, though he retained some contact with Ghent until about 1478. Moreover, in 1479 and again in 1480 he was called to Louvain to value the Bouts *Justice Scenes*. Nor did he cease painting in the cloister; he employed assistants and received

[76]

visitors, the Archduke Maximilian recently married to Charles the Bold's daughter Mary, being among them. In 1481 he went on a journey to Cologne, but on his way back the melancholia from which he suffered completely overcame him, and he died insane in his monastery in 1482.

Although there is no certainty that Justus had any hand in Hugo's training, for his support of Hugo in 1467 may have been due to personal friendship only, a brief statement about this puzzling master can conveniently be made here. Nothing is certainly known of his work in the Netherlands, but a large and striking painting of the *Crucifixion* in the Cathedral of Ghent may well be his. Its style proclaims it to be a work of the 1460's, the figures being relatively small and having a certain elegance, though they are easily disposed in a convincing but rocky landscape. Naturally, the painter is aware of the still greater picture in the same church, and has drawn something from Van Eyck's *Adoration of the Lamb* altar in his treatment of the horsemen, but a far stronger influence seems to come from Bouts, and perhaps going back through Bouts to Campin for some of the types. The figures are spare and angular, they are not linked by Roger's linear methods, and though their movements are more forceful than those of Bouts, their relation to the landscape, and indeed the landscape itself, seems to echo his work. No other known master working in either Ghent or Bruges can be the author of this picture, but its accomplishment, and the mixture of influences it displays, makes the problem of Justus all the more difficult.

That he had some knowledge of Bouts is certain, for in his only documented work, he copies a figure from the *St. Erasmus* altar. In one sense this work is outside the history of Flemish painting, for by 1473 Justus had gone to Italy, and never returned. In that year 'Giusto da Guanto' was paid by the Confraternity of the Holy Sacrament at Urbino for an altarpiece showing the *Communion of the Apostles* (Urbino, Palazzo Ducale) (Pl. 45). This has certain tricks of composition, notably a line of figures sloping down from the left, which link it with the *Crucifixion* in Ghent; the man on the right in the brocade dress is a direct borrowing from Bouts, and the heads of the Apostles recall the modifications that Hugo van der Goes was about to make on types drawn from the *Adoration of the Lamb* altar. Elsewhere, and notably in the fall of Christ's garments, there is evidence of Italian influence. Justus undertook other work, including a series of *Heads of Famous Men* for Federigo da Montefeltro, Duke of Urbino, but his chief importance lies in the fact that he was one of the channels through which a knowledge of Flemish oil technique was carried to Italy.[1] Hugo's most famous picture, the *Portinari altar*, was also to serve as a disseminator of style.

Since the birth dates of Tomaso Portinari's children, the three eldest of whom are shown in the altarpiece are known, it is certain that the work was painted before 1476, when the third son, who does not appear, was born.[2] It therefore falls shortly after the middle of Hugo's brief career, and stylistic evidence seems conclusive for placing certain pictures before and others after this great work. The whole span to be considered is brief, from about 1467 to about 1481, and the most important paintings will therefore be discussed in what seems a logical order, instead of by the more scholarly method of taking the dateable works first.

As might be expected, Hugo is at the outset deeply influenced by his predecessors. The small diptych of the *Fall of Man* and the *Lamentation* (Vienna) (Pls. 44a and 44b) shows that he had looked with attention and admiration at the works both of the Van Eycks and of Roger van der Weyden. His Adam and Eve and the garden in which they stand owe much to their prototypes on the *Adoration of the Lamb* altar. The figures are, however, rather more slender in build, the Eve and the serpent both have a new charm, and the colours, especially the greens and blues, are even more brilliant than those of Van Eyck. The drawing is more nervous, and the perception of light very great. The companion panel, the *Lamentation*, is far closer to the styles of Campin and Roger. Strong and sombre in colour, it is filled with violence. The figures, Rogerian in type, plunge downwards in a strong diagonal, which is only steadied by the seated figure on the right. Already Hugo is showing his power.

The large *Monforte altar* (Berlin) (Pl. 46) is perhaps the most serene of his compositions, and is one of the grandest of the pictures in which the styles of Van Eyck and of Roger are given a new direction. The subject, the *Adoration of the Magi*, owes much to Roger's *St. Columba altar* (Pl. 34), with the rich train of the Kings approaching from the right, though the treatment of individual features, above all of the hands (always a special beauty of Hugo's work), would have been impossible without a study of Van Eyck's exploitation of light. The figures, serene and rational, are easily placed on a deep stage, but the invention of the artist is shown first in his moving of the Virgin and Child from the centre to the left, so that the homage of the Kings has great weight, and secondly, by devising a new kind of architecture. Instead of the dilapidated hut, set back behind the Virgin, she now sits in a much larger ruined building, which runs on beyond the frame, and so gives a totally new sense of scale to the picture. The colour is very splendid; the old King is in scarlet and white, with gold and green brocade sleeves, the bearded king, whose hand makes a most telling gesture, is a foil to him for he wears black with rich

brown fur, and the dark young king is in multi-coloured dress, olive green in front, crimson and gold at the back, with strong blue at the neck. Hugo has used his blues as a thread which binds the picture together. Starting with the iris on the extreme left, the blues are varied from mauve to brilliant blue in the Virgin, they are picked up in the almost turqouise cloak of the kneeling servant with the cup, and in the cap of the man behind the standing king, and are echoed, more dully in the men behind the parapet at the back. In this immensely skilful handling of colour, in the accomplishment of his drawing and modelling and in his control of the narrative elements Hugo has moved far beyond the small Vienna diptych, which appears immature compared with this great picture. This must be a work of his first maturity, painted perhaps in the early 1470's, carrying on the central Flemish tradition, but giving it a new power.

The *Portinari altar* (Uffizi) (Pls. 47, 48, 49, 51a) is even more inventive, but the approach has changed. It is more dramatic but less rational, and the colours are somewhat cooler. It is Hugo's only documented work, for it is described by Vasari, who knew it in the church of St. Maria Nuova, Florence, for which it was painted, as the work of 'Ugo d'Anversa'. One of the great masterpieces of Flemish painting, it is also one of the largest, for the centre panel is about ten feet wide. The impression it created in Florence was clearly immense, and even to-day, on a first visit to the Uffizi, it is the only picture after the long line of great Italian masterpieces, that pulls one up short, and demands attention.

The main panel shows the Nativity, the left wing Portinari and his sons Antonio and Pigello with their patron saints, St. Anthony and St. Thomas, and the right Maria with her daughter Margharita and St. Margaret and St. Mary Magdalen. The centre panel is filled with figures, large and small, some of them in swift action; the framing wings are very still for, though there are small figures in the distance, the tall saints stand quietly against the winter sky, presenting the Portinari family to the Virgin. The scene of the Nativity takes place on a very deep stage, covered, it would seem, by a not quite clearly explained shed, and closed at the back by the ruined palace of the Ancestors of Christ, which under the New Order begun by the Nativity, was no longer needed.[3] The Virgin, a figure of great size, kneels before the Child lying on His back on the bare ground, with rays springing from Him. These two figures are, to a great extent, isolated from the rest, for they are sur-rounded first by an expanse of empty ground, and then by much smaller, but adolescent angels on both sides and at the back. Between the angels are flowers, lilies, iris and columbines, symbols of the Sorrows of the Virgin,

and grain to show that Christ is the Bread of Heaven.[4] St. Joseph timidly kneels on the left, while on the right are the shepherds. The story of the last is shown in two stages. On the hill at the back they keep their sheep, but are blinded by the vision of the angel. In front are shepherds who have rushed forward in answer to the message, but are brought up short by what they find. The contrast between these wonderfully observed, earthy figures, and those in the central scene is overwhelming. Hugo has exploited to the full the dramatic value of their arrested movement, the silence that falls on the two front men who kneel before the Child, the breathlessness and impatience of those behind who cannot yet make out what they have come to see. These figures, and St. Joseph, are in dark brown or red; the centre is cool, the tall, sad Virgin in chalky blue, the angels in bluish white or gold. There is little joy in the picture; even the angels, though some wear the splendid robes of Van Eyck's music-making angels in the *Adoration of the Lamb* altar, are slender (and therefore unlike Van Eyck's sturdy figures) and anxious, seeming already to know the fate of the Child. This is a new personal interpretation of the Nativity theme, full of uneasiness, which the disparity in the size of the figures does little to allay.

The dignity of the tall framing figures in the wings is unforgettably increased by the beauty of the landscape, especially in the wing with the female saints (Pl. 49). Campin had placed his Dijon *Nativity* in front of a winter landscape, but both Roger and Bouts had retained the foliage on their trees. Hugo sets tall, bare trees, like his tall saints, against a winter sky, and so devises perhaps the most beautiful and most personal landscape in fifteenth-century art. The incidents in the background of the wings are also unusual. Over the rocks on the left come Mary and Joseph journeying to Bethlehem. Mary does not ride, but is stumbling down the steep path, supported by Joseph, the ass and also the ox following quickly behind. In the right wing the Magi approach through the distant landscape, but the foremost figure is a dismounted groom, asking the way from a group of peasants. The contrast between the poverty of the peasants and the richness of the travellers is one which must often have been seen on fifteenth-century highways, and it is set down with passionate sympathy by Hugo. And further, the brooding grief of the central panel and of the still branches against the sky, reappears in his treatment of the backs of the wings. These adopt the traditional habit of showing figures, here the Virgin and the Angel of the Annunciation, in grisaille.[5] But Hugo's figures are hardly simulated sculpture; they appear to be alive, and the Angel is troubled at the tidings he must bring and the Virgin shrinks from the words she must hear.

It is not entirely easy to account for the change of style between the glowing splendour of the Monforte altar, and the tragic overtones of the Portinari painting. Part is, no doubt, due to the increasing melancholy of the artist. This, however, does not entirely explain either the change to a cooler and more chalky colour scheme, or the difference in types. Hugo's Virgin has no real antecedents in Flemish painting. She is not derived from Van Eyck or from Roger, and though the extreme delicacy of modelling, as well as the use of still framing figures may owe something to Bouts, neither the Virgin's head, nor that of St. Mary Magdalen would seem to rest on patterns set by Bouts. It has recently been suggested that some of these elements, notably the chalky blues, and the type of female head with a very small mouth and chin are most closely paralleled in France, and especially in the work of Jean Fouquet. Hugo had taken part in the funeral services of Philip the Good at Bruges in 1473. Was he perhaps among the large train of mourners who accompanied the corpses of the Duke and Duchess to the family burying place at Dijon, and did he then see something of French style? The answer is only conjectural; but it is an indubitable fact that the only Northern master whose work suggests that he knew the *Portinari altarpiece* is a Frenchman, the Maître de Moulins. It would appear that the work was immediately sent to Florence. It is nonsense to suppose that it was unpacked on the way, so that the Maître de Moulins could copy the back of the wings on his chief altarpiece, still at Moulins, nor is there any reason to suppose he travelled to Florence. There is other evidence that he knew the work of Hugo van der Goes, and the only explanation of this would seem to be that he worked in Hugo's studio. He is unlikely to have done so unless Hugo had had some direct connection with France, and if the Fleming went to Dijon the French artist may have returned with him as his pupil.[6]

It is not known with certainty when the Portinari altarpiece was finished, though it seems to have been in Florence before the end of the 1470's.[7] The most important remaining pictures attributed to Hugo van der Goes must presumably have been painted in his cloister, and all have a strangeness which suggests the increasing disturbance of his mind. The *Nativity* (Berlin), a long narrow panel, repeats the theme of the Portinari centre panel, but the figures are crowded into a small, ill-defined space, which should be clarified by the lines of the manger in which the Child now lies, but is not. The shepherds on the left are toppling into the stable in their violent agitation, and lack the impressive quality of rough men struck silent by the sight of the Child which is an unforgettable feature of the Uffizi painting. The angels grouped round the manger are at once confused in their positions and weakly

drawn; but it is known that Hugo was allowed assistants in the monastery, and it may be that not the whole of this picture is by his own hand. The design is further complicated by the device of two large half-length figures of prophets at the sides, staring into space, but pulling back curtains as if to reveal the New Dispensation shown on a stage within. The colour is much cooler than that of the Monforte *Adoration of the Magi* in the same gallery, and the contrast between the serenity of the one and the confusion of the other is very great. The *Portinari altar* and the entry into the cloister must lie between them.

The *Bonkil wings* (H.M. the Queen: deposited in National Gallery of Scotland) (Pls. 52*a* and 52*b*) can hardly be before 1479 or 1480. The donor, who appears on one panel, was Sir Edward Bonkil, Provost of Trinity College, Edinburgh, whose brother was a merchant in Bruges, and they were given by him to Trinity Church, Edinburgh. Whether they form part of an altarpiece of which the centre panel is lost, or were intended as organ wings, perhaps for the organ which had been given to the church by King James III of Scotland in 1466, is unknown. They are painted on both sides, the inner sides bearing royal portraits, James III and a young prince with St. Andrew on the left, and Queen Margaret with St. George on the right. The portraits are feeble, and may well have been added by another hand, perhaps even in Scotland, but the prince, who was born in 1473, appears to be a boy of six or seven years old, and this provides a probable date for the work. The tall saints are, on the other hand, clearly by Hugo himself, the St. Andrew being close to one of the saints on the left-hand wing of the *Portinari altar*, and the other a more slender, nervous version of the St. George from Van Eyck's *Van der Paele* altar at Bruges.

The outside of the Wings is more interesting and more impressive. The left (Pl. 52*b*) shows the kneeling figure of Bonkil, while behind him an angel is seated at an organ with another angel peering round the side. The figures are set in the front of a deep Gothic room, though this is cut by the plunging diagonal of the organ. Bonkil is a superb portrait, the modelling of his head by light most carefully studied, but rather more loosely painted than in Hugo's earlier work. It is worth comparing the angel at the organ with her prototype on Van Eyck's *Ghent altarpiece* (Pl. 12), which Hugo so clearly admired. Van Eyck's angel, broadly built, and dressed in rich brocade, sits firmly on her stool, her small hands resting easily on the keys. In Hugo's work the figure is much taller, as one would expect in a work of this date, but its pose is full of tension, there are no rich garments, and the large nervous hands, much more bony than those of Van Eyck, but most beautifully drawn, seem un-

certain what they will do. The same uneasiness is apparent in the angel with the strange long face, who looks round the edge of the organ.

The outside of the right wing shows the Trinity (Pl. 52a), and is one of Hugo's most memorable and most personal inventions. God the Father, enthroned before a rainbow, holds the naked, broken body of Christ in front of Him, the Dove making a sharp, white horizontal between the two heads. The design was traditional, and probably goes back to Campin, but the version of his painting in the Hermitage shows the Father with a triple tiara, and the Dove perched on the shoulder of Christ. By eliminating the tiara, and giving the heads of Father and Son the same features, Hugo has added enormously to the poignancy of the theme. Moreover, greatly daring, he steadies the angular lines of the body of Christ, running down to the globe beneath his feet, with a long straight fold made by the cloak of the Father. Again the modelling is masterly. The hard edges and sharp drawing of the prototype is replaced by a modelling, broader than that of Van Eyck or of Bouts, looking forward in its liquid quality to much later painting; yet at the same time the underlying drawing is immensely firm.

Hugo's last picture is perhaps the *Death of the Virgin* (Bruges) (Pls. 50 and 51b). In this large panel, packed with figures, the artist abandons all attempt at clarity of space. The dying Virgin lies diagonally on her bed, the vision of Christ floating above her, and the Apostles disposed around her. But the room has no depth, and the group has no common emotion. The Apostles do not see the vision, few of them look at the Virgin, or communicate with one another. Instead, they stare out of the picture, or across the bed with nothing to meet their gaze. The colours are bright but harsh. Individual features, the new curling drapery of Christ moving above, the firm drawing of the Virgin's head, the modelling of the hands, are masterly — but the whole is immensely disquieting. That it is a great picture no one, especially if they have seen it in a mixed exhibition where it kills most other works of its century, can doubt. The artist had beyond question the most powerful personality of the second half of the fifteenth century in Flanders. This picture makes his death from melancholia in 1482 at once understandable and all the more sad.[8]

CHAPTER VII

HANS MEMLINC

No greater contrast could be found than that between the passionate art of
Hugo van der Goes and the contemplative spirit of the leading Bruges artist
of the time, Hans Memlinc. The two must surely have met, but Hugo's
powerful style seems to have had no effect on Memlinc, whose placid art is
derived almost entirely from Roger van der Weyden and Dirk Bouts. Memlinc
was neither Dutch nor Flemish by birth, but German, for he came from
Seeligenstadt near Frankfurt-am-Main. His birth date is unknown, but he
became a citizen of Bruges in 1465 and apparently lived there till his death in
1494. Nothing is certainly known of his early works, but his style has little
connection with Germany, and it is more probable that he was trained in
Flanders. His close familiarity with the later works of Roger van der Weyden
suggests, indeed, that he may have worked in the Brussels studio, perhaps
until Roger's death in 1464, and then set up in Bruges on his own account.
Although, however, he borrows both types and on occasions whole designs
from Roger, his spirit is very different. His religious pictures have not the
same intensity of feeling, and his methods of composition are more abrupt
and less flowing. In many ways, therefore, he is close to Dirk Bouts, though
his perception of light is less delicate and his modelling rather more summary.
This amalgamation of the styles of Roger and Bouts seems, however, to have
been much to the taste of Bruges patrons in the last quarter of the fifteenth
century. Even in the city in which Jan van Eyck had worked for the last ten
years of his life, his style was no longer dominant; and though nothing is
certainly known of the late works of Petrus Christus, who was still active in
Bruges when Memlinc first appeared, it looks as if his example was not strong
enough to withstand the overwhelming influence of Roger and Bouts.

Memlinc undoubtedly had a very large practice. He has left a number of
signed or dated works, none of them very early, which show that his style did
not change much, and he certainly had a number of assistants. Because his
style does not vary, he is sometimes regarded as a dull master; but his tech-
nique is superb, and a visit to the museum devoted to his work, the Hôpital
de St. Jean at Bruges, reveals that within his own range he had very great

gifts. These were clearly recognized in his own day, for commissions came
to him from foreign as well as from Flemish patrons. At some time before
1473 he painted an altarpiece of the *Last Judgment*, based upon Roger's
Beaune altarpiece, for the Florentine, Jacopo Tani. Like Hugo's *Portinari
altarpiece*, it was probably shipped to Florence soon after it was painted, but
it never arrived, since in 1473 the ship was captured by pirates and taken to
Dantzig, where the altarpiece still remains. The design is less lucid than
Roger's, the figures being crowded together in three tall panels, the spacious-
ness of the prototype therefore being lost. Moreover, Roger's impressive
central accent made by the vertical St. Michael with the seated Christ im-
mediately above his head is weakened by the separation of the figures, and
the substitution of armour for the saint's straight white robe, which brings an
unsatisfactory restlessness to the centre of the picture. The nudes also are
much less firmly drawn.[1]

Another work, now in the National Gallery (Pl. 53), was commissioned by
an Englishman, Sir John Donne. He is known to have been in Bruges in 1468,
for the marriage of Charles the Bold to Margaret of York, and was there
again in 1477. The lack of development in Memlinc's style makes it impossible
to say with certainty on which visit the work was commissioned, but the figures
are slightly more predominantly vertical and the drapery patterns a little more
rigid than in two dated works of 1479, the *Marriage of St. Catherine* and the
Floreins altar (both Hôpital de St. Jean, Bruges) (Pls. 54a and 56). The
Donne altarpiece is a picture of great serenity. The Virgin sits with the Child
on her lap before a cloth of honour set on an open loggia. At the sides kneel
the donor and his family being presented to the Virgin by tall female saints,
and between them kneel music-making angels. Behind the loggia is a pleasant
landscape, neither too empty nor too full of incident. There is little movement
in the group, only the gentle gestures of the saints, and a slight turning
movement in the Child who stretches out one hand to take an apple from an
angel and ruffles the pages of the Virgin's book with the other. Beyond this,
it is a nearly symmetrical composition in which the balance of the figures and
the patterns made on the picture plane by the outlines of the whole group, seem
to have interested the artist more than any question of placing the figures
in space. A similar interest in surface pattern rather than in mass appears in
Italy about this time in, for instance, the works of Botticelli, and with the
increased love of slender forms makes one of the great differences between
the pioneer work, earlier in the century, of Masaccio in Florence and Van
Eyck and Campin in Flanders. The wings of the *Donne altarpiece*, each showing
a single, still figure, St. John the Baptist on the left and St. John the Evangelist

on the right, standing in extensions of the loggia, are in the same quiet mood as the centre panel, but their emptiness makes a perfect frame for its more crowded design.

The triptych of the *Marriage of St. Catherine* (Pl. *54a*), dated 1479 but probably ordered before 1475, was painted for the Hôpital de St. Jean, where it remains.[2] To a great extent the design is an elaboration, on a much larger scale, of the central panel of the *Donne altarpiece*, but the curling lines of the draperies of the seated female saints, St. Catherine and St. Barbara, give it a little more animation. The wings, too, are far more complex. The left shows the *Beheading of the Baptist*, ideas for the design being taken from Roger's *St. John altarpiece* (Berlin), and the right the *Vision of St. John the Evangelist on Patmos*. This last breaks sharply with the space in which the central scene is set, for St. John sits on a rock in the foreground, and beyond him, across the river is a miniature-like Vision of God enthroned with the Lamb, the Four Beasts and the Elders, and below this the Four Horsemen and the explosion of war.[3] This wing is one of Memlinc's most dramatic designs, and has passages of great beauty of colour, but the conception of the altarpiece as a whole is less firm than when he works on a smaller scale.

The *Floreins altarpiece* (Pl. 56), given by Jean Floreins to the Hôpital de St. Jean in 1479, which like the *Marriage of St. Catherine* is both signed and dated, is a further example of Memlinc's dependence on Roger. The central panel, showing the *Adoration of the Magi*, is a simplification of Roger's *St. Columba altar* (Munich), with the Virgin in the centre of the picture, the shed parallel to the eye, and the Magi entering from the right. There are fewer figures, however, and less opulence of dress. The *Presentation* on the right wing is also borrowed from the same altarpiece, but the figures have far less elegance, and their relation to the building in which they stand is less interesting. The *Nativity*, on the left, though less directly derived, is Rogerian in type.[4]

Memlinc was, on occasions, given commissions which required skill in narrative. The earliest, perhaps, was the altarpiece, now at Munich, showing the *Seven Joys of the Virgin*, painted in 1480 for the Chapel of the Tanners' Guild in Brussels.[5] Here, in a large landscape (the picture is nearly six feet long), much broken by rocks, with the city of Jerusalem in the middle distance, and a harbour in the background, the seven episodes are shown, sometimes with a rich extension of narrative before or after the main event. It is, indeed, the enchanting pastoral of the Annunciation to the Shepherds, rather than the Nativity itself, which catches the eye; and the journey of the Magi, coming from distant lands, and moving with a flurry of pennons and a jostle of horses,

or the groom watering horses while the Magi worship the Child, give the picture an immediacy, a vivid reality which must have been immensely satisfying to the donors. It must, inevitably, be read, detail by detail, and can hardly be judged, as for instance Roger's *Beaune altar* can be judged, as a unified composition, but the welding together of so many different incidents by means of the landscape is by no means unskilful. Moreover, the great panoramic landscape foreshadows developments in Flemish painting of the sixteenth century.[6]

The artist's most famous narrative cycle, the *Shrine of St. Ursula* (1489: Bruges) (Pl. 54b)[7] is, however, a series of separate panels, each showing a single episode from the story of St. Ursula and her eleven thousand Virgins. The story demands a considerable use of boats, and the representation of so many figures, princes of the church as well as virgins, crowded into a boat is beyond the artist's powers and borders on the ridiculous; and in the martyrdom scenes there is no sense of drama or tragedy, only a slightly surprised resignation. But in all the backgrounds with their churches, often identifiably those of Cologne, there is a quiet beauty of lighting, and in the scene of the arrival at Basel, where the virgins who have disembarked walk into the country along a winding road, there is a feeling for everyday life which is more within the artist's range than a story of violent death.

Memlinc and his studio also produced a number of small altarpieces, probably chiefly for private devotion, of the Madonna and Child enthroned with music-making angels or donors kneeling at the sides.[8] In all the Virgin is close in type to the quiet central figure in the *Donne altarpiece*, and though the poses of the angels may vary a little, as do the buildings set in the peaceful landscapes seen behind the throne, the main pattern remains the same. In two of these pictures, however (Vienna and Florence, Uffizi), there is an interesting intrusion of Italian detail, for the arch under which the Virgin sits is hung with festoons of fruit and flowers held at the ends by little naked boys. These are the *putti* of Italian art and not part of the Flemish tradition. To insert them, Memlinc must have seen and been attracted by some Italian work perhaps in the house of one of the Italian merchants in Bruges, either a painting by the Paduan artist, Squarcione, who made frequent use of such festoons, or just possibly a piece of coloured Della Robbia ware from Florence, in which festoons and *putti* often appear. But whatever he may have seen, his eye was caught by a decorative detail only, for there is nothing Italian in his composition or in the treatment of his figures.

Memlinc also carried on the tradition established by Roger van der Weyden, of the diptych with the Virgin and Child in the left panel and a donor in the

right. Fewer examples are known than is the case with Roger, but fortunately in one important instance the work has survived intact, whereas in all Roger's diptychs the two panels have been separated and are now in different galleries. Memlinc's *Diptych of Martin van Nieuwenhove* (Hôpital de St. Jean, Bruges) (Pls. 57*a* and 57*b*) is still in its original frame, which bears the date 1487, and states that the donor was twenty-three years of age. This work, which is in very good condition, breaks away from the Roger pattern of figures against a plain ground. Instead, both figures are shown in a room, the far corner of which must be read as being behind the frame dividing the two panels. The Virgin and Child are shown full-face in the left panel, with the donor in three-quarter view in the other panel against the wall at right-angles to them. This disposition is made quite clear by their reflections in the mirror hung on the wall behind the Virgin's right shoulder, for the back of the Virgin is seen silhouetted against a window which must be on the invisible wall in front of her (that is to say, on the side of the spectator), and beside her Martin van Nieuwenhove appears in profile. The device of allowing a single space to run, as it were, behind the frame, and appear on more than one panel, goes right back to the beginnings of Flemish painting, for it was used by Robert Campin in the centre and left wing of the *Mérode altar* (Pl. 6), and by the Van Eycks in the *Ghent altar* (Pls. 12 and 15). In no earlier example, however, is the space so clearly defined, and in none is the frame made to play so vital a part in the articulation of the room. Memlinc may not have the originality of Hugo van der Goes, but he is not purely an imitative artist, and at several points — and this is one of them — he adds something new to established tradition.

In addition to the skill in planning, this diptych has great beauty of colour. The left-hand panel is gay, for the Virgin wears a blue dress enriched at the front with jewels and gold brocade, and a red cloak over her shoulders, and she offers a red apple to the Child. In contrast, the donor panel is sombre, for Martin van Nieuwenhove wears a dark brownish dress trimmed with black fur. The bright colours of the other panel are, however, echoed in the stained glass panel behind his head, which shows his patron saint, St. Martin, dividing his cloak with a beggar. Both Bouts and Roger have contributed something to the type and handling of the Virgin and Child, but in the donor portrait the modelling is softer than in any portrait by Roger, the forms are less sculptural, and the quality of the soft flesh of the rather plump young man is well conveyed. Both panels, indeed, show Memlinc at the peak of his achievement, quiet, accomplished, especially in technique, and resourceful.

In his religious paintings, as has been seen, Memlinc drew much from the

work of other masters, above all from Roger, but he is nevertheless a distinct and by no means negligible personality. In the field of portraiture his borrowings are less obvious and his own contribution is greater — indeed, at one point it was sufficient to influence artists outside Flanders. Unfortunately none of his portraits is dated or precisely dateable, but a sufficient number remain to prove that he had many commissions.

It is perhaps reasonable to suppose that those which are closest to Roger, and which use, as he did, a plain ground, are fairly early in Memlinc's career. The portraits of *Tomaso and Maria Portinari* (Metropolitan Museum, New York), both with hands joined in prayer, may well date from shortly before 1470, for the sitters seem a little younger than on the donor panels of Hugo van der Goes' *Portinari altar* of about 1475. In both the figure is set against a dark ground, with the light falling in such a way that the further cheek is slightly in shadow; in both there is a painted frame within the real frame, and the figure is given greater bulk by its projection in front of the former. The *Man with the Arrow* (National Gallery, Washington) (Pl. 55) uses a different device to create a feeling of depth, for the hand holding the arrow, its fingers sharply foreshortened, seems to rest on an unseen ledge within the frame. The handling of the features in the two Portinari portraits is fairly close to that of Roger, for they are firmly drawn. In the *Man with the Arrow*, however, the drawing is less incisive and the modelling softer.

As well as using the traditional type, Memlinc devised an entirely new pattern for portraits, in which the figure, with the head as usual in three-quarter view, is shown in front of a landscape. Such portraits, generally of youngish men in dark clothes, set against a brilliant green landscape, often with one hand resting on a parapet, and with the cap silhouetted against the strong blue sky and frequently running right up to the frame at the top, are extremely striking and are, indeed, among the finest products of Flemish art. Even in a gallery such as the Accademia in Venice, which is filled with masterpieces of Italian art, the Memlinc *Portrait of an Unknown Man* (Pl. 58b) not only holds its own, but compels attention. It would seem as if the type had an especial attraction for Italian patrons, for the sitters in several examples including the *Man holding a Medal* (Antwerp),[9] the portrait in Venice and that formerly in the Corsini Collection, Florence, are palpably Italians. Flemish art was much admired in Italy in the late fifteenth century, and such works as these, which give a more complete account of man and the natural world than any Italian portraits of the time, interested not only Italian patrons but also Italian artists, for it seems certain that gifted painters such as Giovanni Bellini and Perugino saw and were influenced by them. In other Memlinc

portraits, the *Guillaume Moreel* and his wife *Barbara van Vlaenderbergh* (Brussels),[10] or the *Young Man*, perhaps an Italian, in the Lehmann Collection, New York, the landscape is framed by columns, so that the sitters appear to be within a building. The effect is, however, very different from, for instance, the Bouts *Portrait of a Man* in the National Gallery, for the light does not fall from the window sideways on to the face, but as in the *Nieuwenhove diptych*, the head is lit from the front and is silhouetted against the open sky behind.

In portraiture, therefore, Memlinc adds much that is new to Flemish art, though in religious art he makes a synthesis, quiet and idyllic, of what had already been done. His accomplishment should not, however, be underrated. That he enjoyed great success in his own day is proved by the facts that in 1480 he owned four houses in Bruges, and his name is included in a list of the two hundred and forty-seven richest citizens. He also had many followers. The unidentified masters known from their most important works as the Master of the St. Ursula Legend and the Master of the St. Lucy Legend, both apparently working in Bruges towards the end of the fifteenth century, are deeply influenced by him. But a very quick glance at their work reveals his superiority. Memlinc may borrow from other masters, but he absorbs his borrowings into his serene, personal style. His followers create doll-like imitations with no individuality behind them.

OUWATER AND GEERTGEN

All the painters so far discussed appear to have lived for most of their working lives in the prosperous cities of the southern part of the Netherlands, Bruges, Ghent, Brussels, Tournai and Louvain. They clearly knew each other's work and in some cases must have met each other, though no such occasions are recorded. Moreover, almost all of them were born in the territory which is now Belgium. It is true that Memlinc was born in Germany, but he seems to have become completely acclimatized in Flanders, to which he may have come when he was very young. The one important exception is Dirk Bouts, who was born in Haarlem and therefore Dutch; though we only know of his activities in Louvain after 1457.[1]

Little is known of painting in Holland in the first half of the century. The fact that Jan van Eyck worked in The Hague in 1423/4 for John, Count of Holland was probably due to a contact at the Burgundian court rather than to local circumstances. There is no reason to suppose that his work led to any further developments in the area. Nor is it possible to say if Bouts, who must have been trained in the second quarter of the century, learnt the rudiments of his art in Holland or whether he was trained in the south. His interest in the fall of light and in landscape have already been discussed, and these may well not be accidental. Men who grow up in flat country are likely to have a special feeling for light, for it is the changing light alone that gives interest to their surroundings. While it would be unwise to push the analogy too far, light and landscape were to be among the over-riding factors in the development of the great Dutch painters of the seventeenth century, and they may well have played a parallel role in the work of their ancestors in the fifteenth century.

For, after the middle of the century, there appears to have been a school of painters in and around Haarlem whose interests were, to a large extent, those of Bouts. Indeed, the first known Haarlem master, Aelbert van Ouwater, must surely have had some contact with the Louvain painter, but how and when can only be conjectural. The sole contemporary record of Van Ouwater shows that he was a painter living in Haarlem in 1467. Van Mander, who is more likely to be well informed about Dutch painting than about Flemish, for he wrote his

book in Alkmaar, recorded two pictures by Van Ouwater. The first, which is
lost, was an altarpiece in the Groote Kerk at Haarlem, and showed St. Peter
and St. Paul, in an interesting landscape with many pilgrims. The other, the
Raising of Lazarus, was only known to Van Mander in a copy, the composition
of which he describes; for the original had been looted and taken to Spain
after the siege of Haarlem in 1573. It is in all probability a picture now in
Berlin (Pl. 59a), which conforms to Van Mander's description.[2]

The painting, rather surprisingly, shows Lazarus rising from his grave in
the apse of a church. He is not wrapped in grave-clothes, as in earlier represen-
tations of the scene, but is seated half-nude on the lid of his tomb, with his
shroud falling over his thighs. On the left is the still figure of Christ, with one
hand raised, commanding him to come forth from the tomb, while round
Christ are grouped solemn figures of Mary and Martha and some Apostles.
On the other side, in contrast to this quiet group full of controlled emotion,
is a more agitated group of Jews in fantastic clothes, turning in disgust from
the revived corpse. A link between the two groups, essential to the com-
position though not to the story, is provided by the figure of an old man,
probably St. Peter, who stands behind Lazarus demonstrating the miracle to
the reluctant Jews. The verticals which play so strong a part in the com-
position are strengthened by the tall pillars of the apse, that above the head
of Christ being lighter than the others and so acting both as a visual accent
and as an indication of holiness. Behind the screen which joins the pillars a
crowd of inquisitive spectators peer through the bars of the door, but the real
beauty of the background of the picture lies in the light which falls on the
arches and vaults of the ambulatory which surrounds the apse.

There is much in this picture which is reminiscent of the art of Bouts. The
grouping of figures with a stress on verticals, the setting of them firmly in a
space which is clarified by the recession of the tiled floor can be paralleled in
the *Last Supper altarpiece* (Pl. 38) of 1464–8 in Louvain. Ouwater's figures
are a little less slender than those of Bouts in his late, dated works, but the
Lazarus may well be before 1460. The methods of composition are the same,
and though the setting of a religious subject within the apse of a church may
derive ultimately from Van Eyck, the spirit of Ouwater's picture is far closer
to the *Last Supper altar* than to Van Eyck's *Madonna of Canon van der Paele*
(Pl. 18a). The head of the kneeling Mary is near in type to that of Bouts'
Madonna and Child (National Gallery), and though some of the other heads
are rather wider than in his documented works, they are in general much the
same. Moreover, the brilliant use of light behind the screen is much in the
spirit of Bouts.

Whether Van Ouwater had come south, either for his training or to widen his experience cannot be said with any certainty. If so, it would be likely that he would have got into touch with his fellow-citizen, or perhaps even have worked for a time in the Louvain studio. Many theories have been put forward and many attempts have been made to trace further works, both in painting and engraving, by the master; but unless further documents should come to light, all must be regarded as conjecture.[3]

One point, however, is clear. The painter of the *Raising of Lazarus* was a mature artist, and as such might well have attracted pupils. According to Van Mander he was the teacher of Geertgen tot Sin Jans, who was born in Leyden. In Geertgen's case there is an even greater dearth of fact on which to build, for no certain contemporary records of him are known. Van Mander's statement that he was only twenty-eight when he died may be true, but if so he was both a precocious and a prolific artist. He appears to have died at some time between 1485 and 1495, which would give him a birth date of between 1455 and '65. Towards the end of his life he seems to have been a lay-brother of the Brotherhood of St. John in Haarlem (from which he takes his name of Little Gerard of St. John), and one wing of an otherwise lost triptych of the *Crucifixion* which he painted for the Brotherhood and which is described by Van Mander, remains at Vienna. This wing was painted on both sides, the inner showing the *Lamentation over Christ* (Pl. 61) and the outer the unusual scene of the *Burning of the Bones of St. John the Baptist by order of Julian the Apostate* (Pl. 60).[4] It has now been sawn in half and exists as two separate pictures. These are certainly mature works, perhaps the last in Geertgen's short life; but since they are the best documented they must be considered first, since all other attributions depend on them.

Both are striking compositions, the *Lamentation* being the more lucid and coherent of the two. In the foreground the figures are arranged in a great triangle above the dead body of Christ, the group being steadied by vertical accents at each side. The heads, especially of the female figures and of the young St. John, are large and egg-shaped, smoothly modelled and with little pointed noses that jut sharply forward, almost as if they were cut out of wood. On a hill behind soldiers, clumsy in their movements, are taking down the bodies of the thieves from their crosses and making sure they are dead; and behind again is a most beautiful wooded landscape. This landscape is more advanced in its handling of the problems of recession, and more varied in its use of different kinds of trees interspersed with bare ground than any landscape by Bouts. It is therefore all the more tantalizing that Ouwater's picture, which showed St. Peter and St. Paul and an interesting landscape, has disappeared;

for it is now impossible to know how much of landscape painting Geertgen may have learnt from his master and how much is a personal development.

The *Burning of the Bones* panel, though less impressive as a composition than the *Lamentation*, is by no means lacking in interest. In the foreground the Emperor and his court, fantastically dressed, are superintending the burning which is being carried out by three men, lively and grotesque in pose and expression. Behind the desecrated tomb is a group of the Brethren of St. John, some of whom are salvaging bones before they are shovelled on to the fire. These figures are almost certainly portraits, and most of them take no part in the action. A further group of Brethren stand farther back, half-way up the hill, at the top of which is a church with a procession of yet more Brethren issuing from it. In the more distant landscape, again of great beauty, the funeral of the Baptist, more than three centuries earlier than the desecration, can be seen. In one place a group of mourners are laying his headless body in his tomb, and in another a figure kneels before a cave which contains his head.

The *Lamentation* panel, for all its originality, makes it almost certain that before he painted it Geertgen had been south to Ghent or Bruges; for one figure, the dark bearded man in a rich dress kneeling with his right hand on his breast, is closely modelled on that of the second of the kings in Hugo van der Goes' *Monforte altar* (Pl. 46).[5] Moreover, the device of piling up figures in a triangle which is steadied by vertical figures at the sides had been used by Hugo in the *Lamentation* panel of his small diptych at Vienna, and could have provided the source for Geertgen. The circumstances of his visit are unknown, though it has been suggested that he is identical with Gheerkin de Hollandere, whose name appears in 1475/6 as an apprentice in the books of the Guild of Illuminators and Bookbinders at Bruges.[6] This is not conclusive, and most of his work has a breadth not usually associated with illumination. On the other hand, there is one enchanting tiny picture in the Boymans Museum, Rotterdam (Pl. 58*a*), which could be the work of a miniature painter. It shows a half-length Virgin, crowned and holding the Child, above a crescent moon with Satan in the form of a dragon writhing beneath it. The Virgin is in red and is surrounded by a golden glory, the outer rings of which, pink, grey and almost black, are peopled by a shadowy host of angels. Most of them are joyfully making music, but those in the pink ring bear Instruments of the Passion. This could well be an early work of the master's, for it has his special type of egg-shaped head; but though it has great charm, the drawing of the Child is immature, and the oval of the Virgin's head is modelled with much greater simplicity than are the female heads in the *Lamentation*.

[94]

It is not easy to trace the development of Geertgen in what was almost certainly a brief career, because none of his pictures is dated. His style is unmistakable, but it may have been imitated by followers of whom we know nothing. His contribution can best be seen in the two halves of the Vienna wing already discussed, but there are other pictures which have some of the same characteristics. The *Relations of the Virgin in a Church* (Rijks museum, Amsterdam) (Pl. 59b) has little connection with painting in the south, but is completely understandable as the work of a pupil of Ouwater, though one with a strong and independent personality. St. Anne and her daughter the Virgin Mary with the Christ-child on her lap, with Joachim, the Virgin's father and St. Joseph behind them are on the left. Opposite are St. Anne's daughters by her previous husbands, who were the mothers of the apostles, James and John, Simon and Jude and James the Less. All the women are stiffly posed and all have the long, unexpressive oval heads typical of Geertgen. Farther back in the church, the pillars of which are very similar to those in Ouwater's *Raising of Lazarus* (Pl. 59a), though they carry pointed rather than round arches, are incidents which are both lively and symbolical. Behind the altar is a dark screen with sculptured reliefs of the Fall of Man, and on the altar stands a group of the Sacrifice of Isaac, one of those Old Testament scenes which were thought of as parallels to the sacrifice of Christ. Beside the altar are Jewish priests, but in front of it an acolyte is extinguishing the candles on the screen, and so implying that the old order is at an end and with the Birth of Christ a new order begins. The boy is a grotesque little figure, seen from the back and surely observed from the life. Between him and the foreground groups are three more small boys, perhaps indeed belonging to the family of St. Anne, pouring wine into a metal cup. The action is symbolic but the boys are naturalistic, small clumsy children intent on what they are doing. There is here something of the same freshness of observation which gives vigour to the executioners in the *Burning of the Bones of the Baptist*.

The *St. John the Baptist in the Wilderness* (Berlin) (Pl. 64) is much smaller and is surely later in Geertgen's life. It must have been painted for the Brotherhood of St. John, but can hardly have been an altarpiece but might perhaps have hung in the Prior's cell. St. John, a weary figure resting his head on his hand, is seated by a stream with his symbol, the Lamb of God, beside him. Behind, the landscape, in which are many birds and animals, recedes gently towards woods with a city in the distance. The landscape is far more complete and convincing than in any earlier picture; the teasing problem of the middle distance, never quite mastered by Bouts, is here handled with skill, for the transition from the foreground is masked by the weighty

figure of the saint. Behind him it would be possible to walk with ease over the little hillocks straight into the woods beyond.

Yet another powerful picture is the *Christ as the Man of Sorrows* (Utrecht) (Pl. 63). Here the effect depends on the figures alone, for they are silhouetted against a plain background. The design is complex, for the harsh diagonals of the Cross and the Instruments of the Passion held by angels form a kind of mesh to support the large angular figures, placed very close to the eye. In spite of the profound and pious grief conveyed in this unusual presentation of the subject, the figures, especially the Virgin and the St. John, have an earthy simplicity in their homely faces which is entirely characteristic of Geertgen's art.

This master, who at all times seems less sophisticated than men who spent their lives in the rich cities of the south, has a very real originality, and his contribution especially to landscape painting is very great. His simplicity, his sincerity and his freshness of observation were not overwhelmed by his undoubted knowledge of south Netherlandish art. Untouched by the sweetness of Memlinc, whose work he might well have known, though excited by the imagination of Hugo van der Goes, his figure style finds its closest parallels in the wood-sculpture of Holland in the late fifteenth century.[7] On the other hand, as will be seen, his brief life was not without effect on the painting of his day.[8]

JEROME BOSCH

1

Jerome Bosch (*c.* 1450–1516) stands somewhat apart from the main stream of Flemish painting. He is, moreover, one of the most elusive of all great artists. Something is known of his life, but nothing of his training or his contacts, if they occurred, with other artists. Some of his pictures are signed, but as early as fifty years after his death it was already known that not all signed pictures are necessarily authentic, for his style and his signature had been copied by imitators.[1] No picture is dated, or even approximately dateable on external evidence, and there has been much disagreement about the sequence in which they were painted. Finally, though many of his works have great beauty both of colour and design, his subjects were rarely the normal biblical ones of his day, and the imagery he uses is so strange, so inventive, but also on occasions so horrible that the meaning is far from clear. That all his pictures had a meaning, and that the meaning was of paramount importance is beyond question. Moreover, it was probably for their meaning that they were greatly prized in the sixteenth century, above all by Philip II of Spain, who collected a number of the finest of them and hung them in the Escorial.[2] It is impossible to believe that Philip, who was an intensely religious man and a fervent upholder of the church against heresy, would have admired the works so much unless he understood them and believed them to have a Christian meaning. The charges of hidden heresy which were levelled against Bosch in the seventeenth century and which have recently been revived,[3] can therefore surely be dismissed. A more difficult theory to refute entirely is the supposition that the strange monsters who fill Bosch's picture were the outcome of dreams, and that they should therefore be explained only in the terms of Freudian psychoanalysis.[4] Some, indeed, have gone so far as to claim that Bosch was the first Surrealist painter. It is true that, as early as 1521, an Italian writer described a painting by Bosch which he had seen as 'a picture of a dream',[5] but he was in Venice, far from the Netherlands, and may not have had the clue which a Northerner would have possessed about the intention of the picture. No one can say with certainty whether Bosch's monsters, and the

strange happenings in his pictures did or did not haunt his dreams, but it can be proved beyond question that some of the curious groups, and in one case at least the subject of a whole picture, illustrate known proverbs or doggerel verse, or even sayings in common use in the Low Countries. Many other sayings, well known and widely understood in Bosch's time, have no doubt been lost, for they were not of a kind to find a place in literature. Some of the images, however, have been traced in late mediaeval poems or visions, and though many are still unexplained, it seems safe to suppose that the sources were largely literary, though transformed into something more lively, more immediate and often more terrifying by Bosch's powerful imagination.

Moreover, as will be seen, Bosch lived for the whole of his life in a city, s'Hertogenbosch (also known as Bois-le-Duc) which took little share in the active commercial and political life of the Netherlands at the end of the fifteenth century. It had, however, been a great centre of Gothic art, and still possesses the finest Gothic church in Holland. It was also a centre of intense religious activity. Religious thought in s'Hertogenbosch was dominated by links with societies such as The Brethren of the Common Life, that is by men who despised monasticism, and felt that evil could best be fought by disciplined Christian lives within the world. To such, the Devil and his works were very real and the need to expose his machinations was great. All mediaeval thought was translated into a system of symbols, often complex and to-day unintelligible without a key; but it is noteworthy that at the end of the Middle Ages, a period of troubled minds which, in the North, heralds the Reformation, the symbols of evil were more lively and less stereotyped than those of celestial love.[6] This is the background against which the works of Bosch should be seen. He appears obsessed with the folly and depravity of the world around him, and in a spirit of profound melancholy he conjures up monstrous images in which this is displayed. Some, though by no means all, are developments of known mediaeval symbols — the swan, the stag and the strawberry of lasciviousness, the owl and the toad of evil, and all the manifestations of the Seven Deadly Sins play their part. Moreover, many of the monsters are composite, part man, part beast, and so the horror is increased. While, however, many of Bosch's strangest images appear to be the creation of his own vivid imagination, it should not be forgotten that grotesques had freely peopled the borders of late mediaeval manuscripts, and that in some cases at least Bosch may have borrowed a fantastic creature and by transforming it from a flat to a solid figure have given it a new and more hideous reality and a lively activity which is sometimes shocking.

Bosch's interests and aims are therefore far from those of his Flemish

contemporaries such as Memlinc and David, who were content for the most part to paint traditional subjects, and whose designs are static rather than filled with rapid movement. They were still concerned, as Van Eyck and Roger had been before them with the placing of figures in a space rendered convincing by the fall of light; they loved to attempt realistic representation of different textures, and above all of richly patterned stuffs; and their technique, with its careful slow building-up of an enamel-like surface through the use of transparent glazes, still follows the example of Van Eyck. Bosch, on the other hand, had no interest in texture, and little in the disposition of figures in space. It is true that he was to become a remarkable landscape painter, but his deeply spreading backgrounds have little coherence with the figures set right in the foreground, and in some cases he returns deliberately to the International Gothic method of allowing his landscape to run up the picture space rather than back into depth.

His technique, too, is far more rapid and less painstaking than that of other Netherlandish painters. The brush-strokes, generally thin, but sometimes thick, are often easily to be seen, which is seldom the case with earlier Netherlandish masters, and in some of the more complicated pictures the small figures, modelled rapidly and directly in bright colour, add much to the sense of lively movement. Indeed, for all his beauty of colour Bosch, unlike his contemporaries, is a draughtsman rather than a painter. He draws freely but incisively with his fine brush and the sheets of pen drawings which have survived prove that he also had considerable mastery in that medium.

2

Jerome (or Hieronymus) Bosch was born at s'Hertogenbosch in the province of North Brabant — that is to say, in the south of what we now call Holland — about or soon after 1450 and died there in 1516. His father, Anthonis van Aken, was a craftsman in carving and gilding wood, and probably also something of a painter. His grandfather may well have been the Jan van Aken whose name appears in the cathedral records, and who was probably the author of a wall-painting of the *Crucifixion* dated 1444 and still to be seen there.[7] Nothing is known of Jerome's training, though many suggestions have been put forward. It seems certain that there were no panel painters of any accomplishment in s'Hertogenbosch from whom he could have learnt, but the technique of what appear to be his earliest pictures is somewhat crude, and it may be that he at first picked up what he could in the general cathedral workshop. On the other hand, he might conceivably have learnt in some other Dutch

provincial centre such as Utrecht. He seems to have had some knowledge of fifteenth-century illuminated manuscripts, though chiefly of a style already out of date by the 1470's, and he certainly knew early Dutch and German woodcuts, notably those of the Rhenish Master E.S., for he borrows figures directly from them. In his early works some scholars have seen links with other Dutch masters, especially with Geertgen in the latter's least sophisticated works, and with the painter called by Max Friedlaender The Master of the Virgo inter Virgines, whose facial types and love of rather gaunt heads in profile (Pl. 62) seems on occasions very close to those of Bosch.[8] Since, however, the dates of all the relevant works are unknown, no firm deductions can be drawn. It also seems possible, though nothing can be proved, that Bosch made a journey to the Southern Netherlands, where he saw and admired Bouts' *Last Supper* at Louvain, and that he also knew, either in the original or in copies, works by Robert Campin, Roger van der Weyden and Jan van Eyck. What is, on the other hand, certain is that the impression made on him by such works was not very deep and that he quickly evolved his own personal style. If he saw the work of contemporary Flemish painters, it meant nothing to him, for there is no echo at all of the serene elegance of Memlinc or the passionate splendour of Hugo van der Goes.

From the 1480's onwards there are many references to Bosch's personal and professional life in his own town. He married a girl of good family in 1480 and two years later moved to a fine large house on the Great Market Place. In 1486 he became a lay-member of the Brotherhood of Our Lady, and much of his recorded work was done for the Confraternity. Not all of this was painting, and it is clear that he also worked in metal and in wood. In 1504 he painted a *Last Judgment* for the ruler of the Netherlands, Philip the Fair, and before his death in 1516 the Regent Margaret, who with Philip will be discussed in a later chapter, owned a painting by him of the *Temptation of St. Anthony*.[9] Since neither of these are now certainly identifiable, there is nothing in his life which helps to date any of his works.

Almost every painting by Bosch raises arguments over dating, meaning and sources used, so it is clearly impossible to discuss his work in any detail here. A few characteristic works have therefore been chosen, from which the difficulties and the fascination of the study of the artist will perhaps become evident.

The Cure of Folly (Madrid) (Pl. 65) must be an early design.[10] The figures are stocky, are clumsily placed in relation to each other and the colours are sharp and hard. The content of the picture, however, shows that right from the beginning of his career, Bosch followed an individual and

[100]

indeed a new road. It shows a fat, foolish man seated on a chair undergoing an operation to his head, which is being performed by a man in a fool's cap. Beside him is a monk holding a flagon of wine and beyond, leaning on a table and gazing into space, is a nun balancing a book on her head. Above and below the roundel is an inscription in fine Gothic lettering which can be translated as: 'Master, cut the stone out. My name is Lubbert Das.'[11] The key to the picture lies in the fool's cap on the head of the doctor, for the patient who comes to be cured of his folly is in fact trusting a fool. The theme is therefore primarily that of stupidity, credulity and fraud. But since medicine in the Middle Ages had been largely dispensed by the church, the presence of the monk and the nun, the latter perhaps with a book of science on her head, may be a satire on the ignorance and the pretentiousness of religious Orders, a theme which occurs again and again in the artist's works. But in spite of the crudeness of design, there is a freshness of observation which is new. Bosch must have watched quack doctors and their patients, probably at the fairs which played so large a part in mediaeval life, and he is already able to set down what he saw.

Some other early paintings by Bosch, among them the *Seven Deadly Sins* (Prado) and the *Marriage of Cana* (Rotterdam) imply some slight knowledge of earlier Flemish painting — mainly of Van Eyck or Bouts — and of illumination, but they also reveal observation of contemporary life, and the satirical twist which runs through all the artist's work.[12]

The pictures so far mentioned are regarded as 'early', but whether the period falls within the 1480's or extends to the 1490's is an open question. On the other hand, there can be little doubt that the first large surviving triptych, the *Hay-wain* (Madrid) (Pl. 66), marks a new phase and is a far more mature work. Moreover it appears to be the first of the known works in which Bosch gave his imagination full rein. It is signed on the left wing, and is just under six feet high. The subject is without parallel in earlier or contemporary Netherlandish painting.

The centre panel shows a cart loaded with a vast mound of hay, with a pair of lovers seated on the top, while below men and women snatch at the hay with such frenzy that they fall beneath the wheels, and others attack those who have already gained a handful. The cart is drawn by devilish creatures, half man and half beast, and behind it rides a sumptuous train of the rulers of the Church and State. Above, in the sky, is Christ displaying His wounds. The left wing represents the Garden of Eden, with the Creation of Eve, the Fall and the Expulsion, with God the Father enthroned in the sky beneath a rainbow, and the Rebel Angels falling like a swarm of bees on the earth.

The right wing shows Hell, alive with horrors and set against a flaming sky.

Up to a point, therefore, the picture follows a normal Last Judgment pattern, with the Fall of Man on one wing and Hell on the other. But instead of the usual Judgment scene in the centre, the panel illustrates the weakness and indeed the depravity of man. The source may be in a Flemish proverb, only known, however, in modern form: 'The world is a haystack, and everyone snatches what he can from it', though an even closer parallel is provided by a contemporary ballad:

> *'Each wight to snatch and pluck is fain*
> *He sees a fortune in the wain.*
> *He'd rather take than give, I'll swear*
> *So long as he can get his share.*
> *The fun to-day seems fine and fast*
> *But hay's a stuff that will not last.'*[13]

As in all Bosch's larger pictures, every group has its meaning, which adds to the main theme. For instance, the lovers on the top of the hay are themselves a symbol of lust. They pay no attention to the guardian angel playing behind, but their music echoes that of the Devil dancing on the right. In the right foreground is one of Bosch's condemnations of religious orders — the monk drinking while the nuns stuff a huge sack with the precious hay. One of the nuns, however, turns towards a man with a bagpipe, which was known as a symbol of lust. It reappears in this sense in other of Bosch's works. Beyond the nuns is a woman being attended by a quack doctor, once again a symbol of folly and credulity, while the latter vice reappears on the left, here more strongly censured since it entails a belief in magic, for the woman in the dress of a respectable bourgeoise is having her hand told by a gipsy. In the right wing all the Deadly Sins appear in the foreground — Gluttony, for instance, is shown by a man being swallowed by a monster and Pride by the woman with a toad in her lap, while the figure riding the cow has a chalice in his hand, and represents sacrilege.

It is easy before a picture such as this to become so intent on making out the meaning of every part that the brilliance of the whole is forgotten. In the centre panel the action is set in what is perhaps the first of Bosch's splendid spreading landscapes, with blue hills, some crowned by towers and water between them, stretching far into the distance. The figures, smaller in scale than in most of the earlier works, are drawn with great economy but with sure observation. They flutter round the great golden mass of hay dressed in strong, bright colours — scarlet, yellow, pink, blue and black, and by their

brightness add to the sense of turmoil. In the Creation wing it is easy to see that Bosch found some of his inspiration in the International Gothic art of the very beginning of the century, for both the design and the slender figures have much in common with manuscript painting, and the angel with the sword is very tall, with sharp tossing draperies which contrast with the broader, simpler treatment of the foreground figures in the centre panel. The flaming landscape of Hell, though it was to be surpassed in Bosch's later works, is a most remarkable invention, for the whole world seems on fire, and there is no escape left for man. This work, perhaps of the 1490's, seems to have revealed to Bosch the true possibilities within him; thereafter his art reaches a new spiritual level, and his range of subjects, though never to be very wide, seems to have been enlarged.

One of the themes which was to fascinate Bosch, apparently for the rest of his working life, was the special temptations which beset hermits and holy men seeking strength through contemplation. A much damaged, signed triptych in the Doges' Palace, Venice, shows the legends of the hermit saints, Jerome, Anthony and Egidius, which perhaps reflect the writings of the Dutch mystic, Johannes Ruysbroeck;[14] and two single paintings of *St. John the Baptist* (Lazaro-Galdeano Mus., Madrid) and *St. John the Evangelist on Patmos* (Berlin) are expressions of the same theme. The Baptist, more strongly modelled than any figure so far discussed, is shown in deep meditation in front of a Geertgen-like landscape; but some of the plants and trees have rioted into hideous, evil objects, covered with huge thorns and bearing strange fruits which have an almost animal quality. This transformation of nature into an instrument of evil was to reappear, even more horribly, in other works. *St. John the Evangelist on Patmos* is a calmer, and indeed a most beautiful picture. The saint writes the *Book of the Revelation*, undisturbed by the creeping devil behind him, and with an angel above pointing to the vision of the Virgin and Child in the sky. The source of the composition here may be engravings by the Master E.S. and Martin Schongauer, but the superb landscape, with a great church set in the distance on the banks of a wide river, is surely a record of Holland as Bosch knew it.

The series culminates in the large signed triptych of the *Temptation of St. Anthony* (Lisbon) (Pls. 68 and 69), which appears to have been the master's most popular work, and is also one of his most beautiful.[15] It is even more complicated in theme than the *Hay-wain*, and must be several years later, for it is far more incisive in drawing and in its handling with rapid brush-strokes which can quite easily be seen. The story of the hermit, St. Anthony, who retired into the desert, fought with demons and organized a community

of hermits, was well known throughout the Middle Ages through the *Vita Antonii* of St. Athanasius and through the *Golden Legend*. Bosch knew the story in Dutch versions, for he shows incidents which occur in P. van Os's *Vaderboek*, issued at Zwolle in 1490, but which do not occur in the original of St. Athanasius. He begins with traditional scenes in the left panel, where the saint is carried off by demons, whose onslaughts he meets with prayer. The fierce and horrible creatures, bearing or attacking the horror-stricken saint, swoop through the air, and are among Bosch's most brilliant achievements. The temptation overcome, he falls senseless to the ground, and is carried away by his friends. The whole panel is alive with symbolism — the 'man-house' probably representing a brothel, and the demons wearing monks' clothes yet one more expression of Bosch's contempt for religious orders. The right wing, too, is fairly easy to decipher, for it shows the incident related in the *Vaderboek* of the saint in the desert coming upon a beautiful queen bathing near her city. But since she is the Devil in disguise, she is surrounded by obscene creatures, typifying lust.

The central scene, which is far more advanced and coherent in composition than that of the *Hay-wain*, is filled with groups, often made up of fearsome creatures, half-man, half-beast, for which many interpretations have been found. The main subject, however, is clear enough; for St. Anthony crouches in the centre, calling upon the Lord and raising his hand, probably in the act of exorcism. So constricting, however, is the press of evil creatures led by the fantastically dressed queen, that he is unable to raise his eyes to the figure of Christ, standing by the altar within the ruined tower and pointing to the crucifix. Symbols of lust and of evil abound, and even where the full meaning may be obscure, the malevolence of the Devil's crew is clear enough.[16] Though, however, the saint appears to be almost overwhelmed by evil and the sins of humanity are given first place, the outside of the wings point the way to salvation, for they show, in grisaille, scenes from the Passion.

The figures in this triptych have less weight than those in the *Hay-wain*, the forms are sharper, there is more interest in sweeping Gothic line, and far less sense of reality. This is increased by the introduction of water in the foreground of the centre panel, for above it the buildings and the figures seem to float with no sure foundation. The colour, too, grey in the centre but with luminous spots of brilliant colour playing against it, adds to the fantastic unreality. The return to Gothic methods of drawing is, beyond doubt, deliberate, and must have been chosen by Bosch at this moment in his life as the best means of achieving a new intensity of expression. That the picture is a mature work, perhaps indeed as late as 1500, is evident, for it shows an assurance, a

complete mastery over design, modelling and symbolism (whatever it may be) which is far beyond the stage represented by the *Hay-wain*.

The small *Temptation of St. Anthony* (Madrid) (Pl. 67) is far simpler, both in design and content, and is generally thought to be among the artist's latest works. The saint, placed very near the eye, sits on a hillock by a stream, and the very beautiful landscape is closed at the back by churches behind woods and hills. Although within the landscape there are small devils, some engaged in the normal occupations of peasants, the saint takes no notice of them, but sits gazing into space, having attained the last degree of wisdom when he can contemplate the perfection which is not of this world. The colour also is quiet — yellows, browns and greens with a clear blue — and the handling is broader, each object being more softly and more fully modelled than in earlier works.

It is perhaps strange that Bosch, who was so active a member of the Confraternity of Our Lady should, so far as is known, have painted no picture of the Virgin and Child. His temperament obviously drove him to more anguished subjects. He did, however, paint two versions of the *Adoration of the Magi*. The first is an immature work in Philadelphia, the second (Madrid) (Pl. 72) is probably the most beautiful of all his paintings.[17] The work is a triptych, rather smaller in size than the *Hay-wain* or the *Temptation of St. Anthony*, the proportions of the panels being more Gothic, for they are narrower in comparison with their height, and they run up to a rounded top. The Adoration occupies the centre panel, and the wings show a donor and his wife kneeling, with their patron saints, St. Peter and St. Agnes, standing behind.[18] Near the foreground in the main panel is set a dilapidated hut, a motive which goes right back to Robert Campin's Dijon *Nativity* (Pl. 7a), but which had by this time been superseded in Flanders by the large ruined building introduced by Hugo van der Goes, and used by both Geertgen and David. The Virgin, in a plain blue mantle, sits motionless on the right, the Child held in front of her. Here again there is an echo of the art of the first half of the century, for the pose is closer to Van Eyck's *Madonna of Chancellor Rolin* (Pl. 22a) than to any later work.[19] Before her kneel the old king in scarlet, the middle-aged king in blue, while the young king, a Moor in a fantastic white dress with his Negro page in scarlet, makes a strong vertical accent on the left. There is much of interest in the details, though here the details do not overshadow the whole. For instance, the offerings or dress of all three kings show Old Testament scenes which were in the Middle Ages regarded as anti-types to those in the New Testament. The old king has offered a gold group of Abraham sacrificing Isaac, which foreshadows the Crucifixion; on

the collar of the middle king is the Queen of Sheba before Solomon, a parallel to the Epiphany, and on the sphere held by the young king is the Pelican in her Piety, a symbol of the sacrifice of Christ. The shepherds also appear in the scene, climbing on to the roof of the hut and peering in at the windows; and St. Joseph is included in the left wing, seated by a fire and drying the swaddling clothes of Christ. All these figures are normal to the subject, but the crowd of men with hideous faces inside the hut are peculiar to Bosch and have given rise to much speculation.[20] Whatever they may mean, they are clearly evil, and so must fall within Bosch's obsession with the conflict between evil and good.

Behind and running through all three panels is the most magnificent of Bosch's many landscapes. The horizon is high, so that the spectator has a bird's-eye view, and sees a great panorama of the world. In the centre is the city of Jerusalem, the way to it being pointed by an idol surmounted by a crescent, for neither at the moment of the Epiphany nor in Bosch's day, when it was ruled by the Turks, was it a Christian city. Many of the tiny figures seem to be harmless peasants about their daily life, but there are also fierce groups of armed men, and on the right wing evil again appears, for a bear and a wolf attack travellers. None the less, the picture has a greater serenity than any of Bosch's other works. There is a new dignity and stateliness in the figures, the colour is more luminous and the handling more deliberate than in the triptych of *St. Anthony*, and though evil may be present, the frenzy of both the earlier triptychs has gone.

The luminous technique and the more deliberate handling reappear in the fourth of Bosch's important triptychs, *The Garden of Delights* (Madrid) (Pls. 70 and 71), but the monumentality in the figures and the serenity of mood are notably lacking. It is, indeed, the most difficult of all Bosch's pictures, both in subject and style, and though on similarity of handling most scholars would now place it near in date to the *Adoration of the Magi*, there are some who regard it as an even later work.[21] It is the largest of all Bosch's pictures, being over seven feet high, but it teems with small figures and monsters perhaps more hideous than any others Bosch devised.

The general plan is close to that of the *Hay-wain*. The left wing is easy enough to read, for it shows the Creation of Man with the Fountain of Life and the newly-created beasts in the background, though the tone of the picture is set by the eagerness with which Adam regards Eve. The right, full of unredeemed horror, and including some of the most complex of Bosch's images, has been variously interpreted as Hell or Purgatory. The centre, though there is much argument about it, seems once more to represent the

depravity of mankind. In the *Hay-wain* the symbolism of the hay was used to show the covetousness and anger of man; here the enjoyment of soft and luscious fruits, strawberries, raspberries, cherries and grapes, reveal the lust and carnal appetites of humanity.[22] The picture is divided into three zones, running sharply upwards, for Bosch has here abandoned all attempt to represent normal space and there is no real recession, though the figures in the upper zones are smaller than those in the lower. The first zone is crowded with groups of small nude figures, intertwined with monsters and monstrous fruits, almost all being explicable (where they can be explained) only in erotic terms. Next comes a zone in which naked men ride on a variety of beasts, some naturalistic and some fantastic, and all probably related to mediaeval Bestiaries, in an ever moving circle round a pool in which stand groups of nude women, both white and black. Beyond the circle are groups of desperately active figures, indulging in strange antics with monsters which they support by standing upside-down, or nourish by pressing themselves into their empty shells. The top zone is stranger still, for in the middle of a lake floats a vast blue globe, with a fantastic obelisk above it — interpreted by some as the Fountain of Youth — and surrounded by four castles composed partly of rocks and partly of monstrous vegetable growths. On the lake and in the landscape behind are many other figures, one group surrounding a vast strawberry, all of which are, again, erotic in intention.

The horror of the picture is increased by the beauty of its colour. The mother-of-pearl tints of the many nudes are combined with pink and blue animals and more brilliant notes of the same colours are used for the castles. And everywhere, spotted all over the design, is the scarlet of the fruit.

In spite, however, of the richness of image and the remorseless activity of the figures, this picture has less sense of reality than any other work by Bosch. The figures are small and boneless, like figures in mediaeval manuscripts, and have little modelling. Indeed, they are not individuals but symbols. The first impression is of a superb piece of decoration, flat and tapestry-like in its general effect; it is only upon closer investigation, group by group, that the nightmare horror of Bosch's view of evil humanity achieves the impact he intended.[23]

One remaining group of paintings, easier to understand, but filled with tragedy, must be discussed. These are the half-length paintings showing the Passion of Christ. All present the maximum contrast between the humility of the suffering Saviour and the bestiality of the soldiers around Him. All, perhaps, were painted late in his life, though the *Christ Mocked* (National Gallery) (Pl. 73), which is lucid in design, fairly light in tone and subtle

rather than bold in modelling, must certainly be the earliest of the group. The picture of the same subject in Madrid is more brutal in action and in the types used, and more forceful in modelling. It has, nevertheless, an unexpected element in the setting of the figures in a circle with a gold ground, the circle being surrounded by grisailles of angels fighting devils. Most haunting of all this group is the *Christ carrying the Cross* (Ghent), perhaps the last known picture by Bosch. Here there is no attempt to dispose figures lucidly in space. The head of Christ near the centre, accentuated by the diagonal line of the cross, is surrounded on all sides by grimacing faces emerging from a dark ground. The modelling, like the heads, is now much more violent, with strong contrasts of light and shadow; and though the general colour is dark, there are passages of brilliant red, and the head-dress of St. Veronica, who is crushed in a corner showing her handkerchief with the image of Christ, strikes a note of bright emerald green which reappears among the rainbow tints of a fool's cap worn by a man on the right.

These pictures, though of traditional themes, have little that is traditional in design or handling. They stand on the threshold of the sixteenth century in their force and concentration; and if they epitomize the victory of evil over good which is so constant a theme in Bosch's works, they are less over-whelming in their pessimism, for they admit the possibility of the Christian way of salvation.

It is doubtful if the exact meaning or the precise chronology of the works by Bosch will ever be proved. That he stands apart from the main stream of Netherlandish painting is clear, but his influence may be seen in the works of other masters of the early sixteenth century. Patinir must have looked with admiration at his landscapes, and Quentin Matsys, in his *Christ presented to the People* (Madrid) imitates but softens the grotesqueness of his types. Above all, though it is outside the scope of this book, the effect of Bosch on the art of Pieter Bruegel was profound. No master, however, carried on the complex symbolism and none was so haunted by devils. Bosch's art is, indeed, more personal than that of any other Flemish master, for it seeks and finds a new means of expressing in visual terms his immense unhappiness at the state of the world.

CHAPTER X

GERARD DAVID

Gerard David's place in the history of Flemish painting is much easier to assess than that of Bosch, for he is the last major painter in the Bruges tradition. Nevertheless, it seems certain that early in his life David learnt something from the art of Geertgen. He was born at Oudewater in Holland, which is not a great distance from Haarlem, and had earlier been the birthplace of Aelbert van Ouwater. We know neither the date of his birth nor any details of his training, but in 1484 he appears as a foreign master in the Guild of Painters at Bruges. He was paid for work in the Justice Room of the Town Hall of Bruges between 1488 and 1498, but his first work there, a *Last Judgment*, is now lost, and his earliest remaining dated work is the *Judgment of Cambyses* (now transferred to the Bruges Musée Communale) (Pl. 74a) of 1498. Other dated or dateable pictures were painted in Bruges in the first decade of the sixteenth century. In 1515 'Meester Gheraet van Brugghe, scildere', who is almost certainly identical with Gerard David, was admitted to the Antwerp Guild, but he was back in Bruges in 1521 and died there in 1523. He possibly also worked as a miniaturist, and though this rests on a somewhat dubious statement in Vasari's *Lives of the Painters* (1550), it is by no means impossible, for by his time book illumination had lost its individual character and consisted simply of naturalistic paintings on a very small scale. Some of these are close to David's known style, and have reasonably been attributed to him.[1]

David's work therefore spans roughly the last twenty years of the fifteenth century and the first twenty of the sixteenth. These years were to see great changes, political, economic and stylistic, which will be discussed in Chapter XI. The new Italianism resulting from these changes made no deep impression on David's art, though in some of his works of the early sixteenth century he moves, apparently independently, towards a grand and monumental style, which turns sharply away from the languid elegance of Memlinc, whose art must have dominated Bruges on David's arrival in 1484.

Since David first appears in Bruges as a foreign master, it is evident that he had already been trained elsewhere. The dates of both Van Ouwater and

Geertgen are too uncertain for it to be possible to say in which studio he worked; but it seems probable that his first training was in Haarlem, and that he knew something of the work of both artists. The *Christ being nailed to the Cross* (National Gallery) is generally accepted as an early picture, painted perhaps before he came to Bruges. The composition is immature, but the soldiers carrying out their task are close in type to the men burning the bones of the Baptist in Geertgen's Vienna picture and have the same lively brutality. Geertgen's picture is almost certainly the later of the two, so there can be no direct influence, but merely a common liking for grotesque, forceful peasant types. Moreover, David frames his composition with vertical figures and shows an incipient interest in landscape receding towards woods, both features which can be paralleled in the work of Geertgen. The wings of David's picture are in Antwerp, and again the compositions are built on verticals, and in the group of mourning women in the left wing both the St. John and the Magdalen are closer to figures in Van Ouwater's *Raising of Lazarus* than to anything by a southern master. That David knew Van Ouwater's picture seems certain, for in a fragment of *Christ taking leave of his Mother* (Dublin), he repeats exactly Van Ouwater's Christ. His colours are, however, from the first richer but more sombre, and his modelling is bolder and indeed more perceptive than that of the other Haarlem masters.

David's activities in the 1480's and 1490's are still largely a matter of speculation, though it is likely that the *Sedano triptych* (Louvre), which carries on the Memlinc theme of the Virgin between music-making angels, but is also strongly influenced by Van Eyck's *Madonna of Canon van der Paele*, is characteristic of his style soon after he came south. It is not until 1498 that firmer ground is reached. This date appears on the *Judgment of Cambyses* (Bruges) (Pl. 74a), one of two pictures formerly in the Town Hall. It is not signed, but David was paid for a large picture of an unspecified subject in that year, and there can be little doubt that this is it. The companion picture, the *Flaying of Sisamnes*, is not documented, but the Bruges records for 1499 are lost.

The *Judgment of Cambyses*, like Dirk Bouts' *Justice of the Emperor Otto*, tells a tale of injustice and retribution, and so was appropriate to the Council Chamber of a Town Hall. In the first panel the Persian king, Cambyses, stands before an unjust judge, Sisamnes, enumerating the list of accusations against him. Sisamnes, whose expression betrays his guilt, is still on his judges' chair, but is being arrested by one of the soldiers of Cambyses. In the second panel his fate is shown. The king decreed that he should be flayed, and that his skin should be hung on the seat of justice, on which his young son, Otanes, should be compelled to sit.

It is possible that for the first panel, with the judge enthroned on the right, David had in mind Bouts' similar composition of the *Justice of the Emperor Otto* (Pl. 41). The differences between the two are, however, very revealing. Bouts' tall, slender figures are sharply defined, each separated from the next and set in a room filled with light and air. David is also aware of the importance of the fall of light, but his figures are much heavier in build, and behind the king they are packed in a crowded group which cuts the foreground scene from the street and buildings behind. Bouts left the centre of his composition open, so that the eye is led from the kneeling countess to the guilty empress being burned on the hill behind. David's composition also contains two episodes, for in the background Sisamnes is seen at the door of a house receiving a bribe; but the mass of men crowded across the panel separates the two incidents completely and helps to make it clear that they are not happening at the same time. The characterization of many of the heads is so vigorous that they have the air of portraits, and it is strange, therefore, that David is not known to have practised as a portrait painter. Above the judge's throne is Italianate detail, reminiscent of the festoons and *putti* used by Memlinc, but there are also representations of two antique cameos, that on the right which shows *Apollo and Marsyas* being one in the Medici collection. How David knew of it is obscure, but someone in the Italian colony may have owned a drawing or perhaps a cast of it. The most striking thing about the picture, however, is the rich, sombre colouring — dark and glowing blues, browns and reds with a good deal of black — which seems to match the bulk of the figures. Though David had by now absorbed much from earlier Flemish painting, he is introducing a new feeling of solidity which is his own contribution, and which was from now onwards to be constant in his works. The companion piece, the *Flaying of Sisamnes*, is similar in composition, with the grisly execution in the foreground, and behind the line of impassive spectators the shrinking figure of Otanes on his father's throne.

In these two impressive works, David established his claim as the leading master in Bruges, and his appointment as Dean of the Guild of Painters in 1501 set the seal on his achievement. He was evidently much in demand in the next decade, when his art shows an increasing nobility, though unfortunately few of his commissions can be precisely dated. The work on the large triptych of the *Baptism of Christ* (Bruges) (Pl. 75) may well have been spread over a number of years. It was painted for Jean de Trompes, who is shown kneeling with his young son, Philippe, in front of his patron saint on the left wing, while his wife Elizabeth, their four daughters and St. Elizabeth of Hungary balance him on the right. Elizabeth died in 1502, and it is likely that the work was

undertaken before her death. The outside of the wings are also painted, the Virgin and Child being on the left, and de Trompes' second wife, Madeleine Cordier, with the eldest of her children, on the right. Since Madeleine, who married in 1507, was to have two more children and die in 1510, this part of the work can hardly be later than *c.* 1508/9, or the younger children would be shown.[2] Whatever the precise date or dates, the whole work must fall within the first decade of the sixteenth century and is one of the last great masterpieces of Bruges painting.

Like so many of David's works, it looks both backwards and forwards. In the centre panel of the Baptism of Christ, the angel in the rich brocaded robe and the angular figure of the Baptist are direct descendants of fifteenth-century figures; but the Christ is more heavily built, the rounded torso and the legs having a broad sculptural solidity that was new in Northern art. The contrast between the Christ and the Baptist is indeed so great that some Italian influence must be suspected in the treatment of the former. This may be of a generalized kind, since knowledge of Italian art was rapidly increasing in Flanders. Moreover, contacts of the Italian colony with Flemish painters and indeed with David himself are confirmed by documents, so there was ample opportunity for the widening of knowledge.[3] In the setting of the scene, too, there is a certain dichotomy. The plants in the foreground are so detailed as to be easily identifiable, and the rings of water round Christ's legs are most closely observed. Indeed, these features are almost Eyckian in their precision. But behind the landscape spreads not only into the distance but sideways into the wings, and figures appear walking amongst the trees. It is as if Geertgen's landscape in his little panel of *St. John in the Wilderness* (Pl. 64) had been greatly enlarged and extended, so that the foreground scene becomes only an incident, though naturally a major one, in a much larger whole. On the outside of the wings the total composition is less lucid, for the figures in each half do not seem to be in one continuous setting. But the donor panel has an interesting novelty, for an arch behind opens on to a courtyard which is no longer Gothic in style, and shows that new ideas in architecture as well as in painting were alive in the Netherlands. Moreover, there is a change in the method of representing the Virgin and Child, for instead of the nude Infant which had been universal in Flemish fifteenth-century painting, David's Child is a little older and wears a nightgown which reaches almost to His feet. This clothed Child was to become the standard type in the early sixteenth century, but David appears to be the first artist to use the motive. The Virgin is traditional — an amalgam, as it were, of earlier types; so here again there is a combination of old and new.

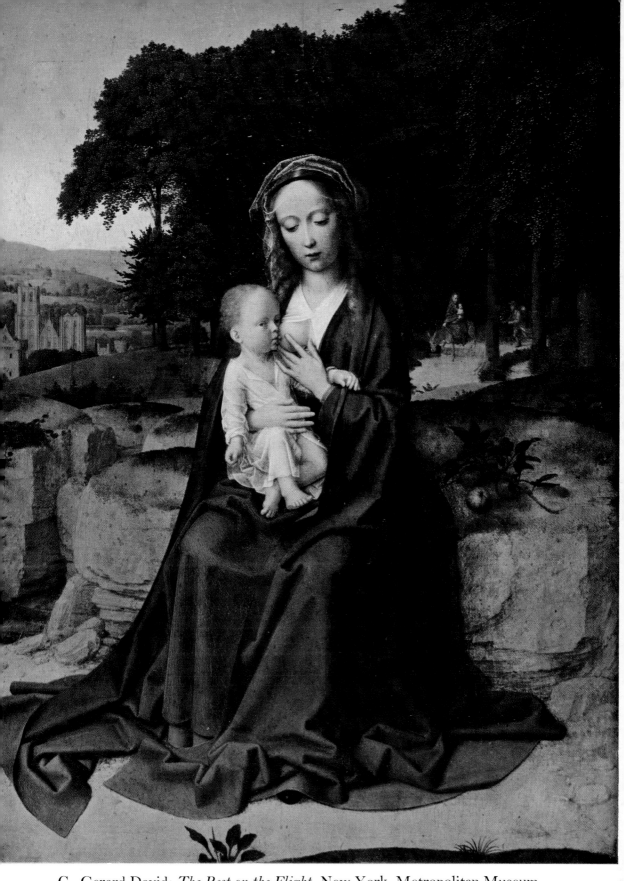

C. Gerard David: *The Rest on the Flight*. New York, Metropolitan Museum

It seems, judging from a documented picture of 1509 that David moved, during the first decade of the sixteenth century, towards a grander and more concentrated type of composition. The *Virgin and Child with female Saints* (Rouen) (Pl. 76) was given by the artist to the Carmelite Convent of Sion at Bruges, and his own portrait and that of his wife appear standing at the back as donors. The picture has been cut at both sides and top, and the wings, which showed the Nativity and the Death of the Virgin are lost; but it would seem that there can never have been any architectural or landscape setting. The whole interest of the picture, therefore, lies in the half circle of large seated figures ranged on either side of the enthroned Virgin, with two standing angels making music, all against a dark ground. The figures are closely packed into the space, overlapping each other, and there is nothing of the lightness or the surface patterning of Memlinc's *Donne altarpiece* (Pl. 53), which is close in theme. The Virgin, her throne draped with a scarlet cloth, is motionless and frontal, her plain blue dress falling in ample folds, and her long crimped hair recalling the central figure in Van Eyck's *Van der Paele altarpiece* (Pl. 18*a*). But the resemblance ends there; the Child, who holds a bunch of grapes (an emblem of the Passion) wears a little night-shirt, and though the modelling everywhere is firm and full, light and air and the placing of figures in space play a far smaller part than in earlier Flemish pictures. The colours are characteristic of David at this period of his life — dark rich greens, reds and blues, only St. Catherine in her red and gold brocade striking a lighter note. It is a grave and perhaps a slightly heavy picture, but the emphasis on figures alone gives it a special place in David's art.

He did not, however, entirely lose the characteristic Flemish interest in the every-day world. The *Marriage of St. Catherine* (National Gallery) is close in style, as far as the figures are concerned, to the Rouen picture of 1509,[4] but the scene is set in a walled garden (the mediaeval *Hortus Conclusus*) behind which is a sunlit town and woods. Again a comparison with Memlinc's rendering of the same subject (1479: Hôpital de St. Jean, Bruges) reveals the change that is taking place, for David's figures are far more massive.

David does, indeed, reject the slender figures common to most Flemish artists in the last quarter of the fifteenth century, and turn back to Van Eyck. On the other hand, he is far more than a mere copyist or an archaising artist, for his pictures have a new coherence in their combination of grandly conceived forms within a beautifully lit landscape. His feeling for landscape, which may perhaps have originated in his first training in Haarlem, is nowhere better displayed than in two fragments in the Rijksmuseum, Amsterdam, of woodland scenes with no figures, though one has a small ass and the other two oxen.

They may well, therefore, have once been part of a triptych of the Nativity. The loving care with which the deep forest with light falling through the trees and on to a little building on the left is shown, suggests a sympathy with nature beyond that of any painter of the time.

In the early years of the sixteenth century he was obviously a successful painter with a large practice, and probably many assistants. Some of his designs, the *Rest on the Flight into Egypt*, the *Adoration of the Magi* and the *Crucifixion* are known in a number of variants, by no means all of them from his hand. The *Rest on the Flight* (Metropolitan Museum, New York) (Pl. C), which shows the Virgin suckling the Child in the foreground and in the background the journey itself with the travellers emerging from a forest, has great tenderness of feeling. It was, moreover, something of a novelty, and the number of versions suggest that it was one of his most popular creations. His pattern for the *Adoration of the Magi* (Brussels, Munich, etc.) is less original, for it follows that introduced by Hugo van der Goes in the *Monforte altar*, though the versions vary considerably both in quality and in the number of figures which are included. In his paintings of the *Crucifixion* (Thyssen Coll., Lugano; Barnes Foundation, Philadelphia, etc.) he invariably uses a rigid figure of Christ, avoiding the angular, tortured lines of Roger's Vienna *Crucifixion*, which had been so influential in the mid-fifteenth century.

One representation of the *Crucifixion* (Palazzo Bianco, Genoa) (Pl. 74*b*) must be singled out for special mention, for it is the grandest of David's pictures. In all other Flemish Crucifixions the horizon rises high, often above the heads of the figures at the foot of the Cross and the landscape is full of incident. In this picture the horizon is low and the landscape bare. The motionless figures of the Virgin and St. John stand silhouetted against the sky. The forms are simple and strong and very broadly modelled; indeed of all Flemish pictures of its time this comes closest in feeling to Italian art, though neither the types nor the handling are in any sense 'Italianate'. Whether, as has been suggested, David paid a visit to North Italy between *c.* 1511 and *c.* 1515, when there is no record of him in Flanders, is non-proven, though perhaps it is easier to accept the possibility of such a journey and to regard this moving work as evidence of the impact of Italy on a mature and gifted artist.[5]

In spite of David's success in Bruges he was apparently attracted by the idea of the rich patronage rising in Antwerp, which will be discussed later, and moved there in 1515. Though nothing is definitely known of his work there, it is usually held that the *Virgin with a Bowl of Milk* (Brussels and elsewhere) (Pl. 78) dates from the Antwerp visit. It is certainly unlike traditional Bruges painting, both in the extreme intimacy of its conception

and in the tinge of sentiment visible in both heads, which suggest the influence of the Antwerp painter, Quentin Matsys. Moreover, the attempt to arrange the two figures in a new and more plastic grouping, might imply a knowledge of Italian painting. A quick comparison with Memlinc's Virgin from the *Diptych of Martin van Nieuwenhove* (Pl. 57a), painted a generation before, makes the change of mood immediately apparent. It is a tender picture, but in no sense a religious image.

The precise date of David's return to Bruges is not known, though he was certainly there for two years before his death in 1523. Moreover, there are no late dated pictures. It seems, however, likely that two panels, the *Adoration of the Magi* and the *Deposition* (National Gallery), probably originally part of the same altarpiece, are from the painter's last years. Both suggest a knowledge of the work of Quentin Matsys, especially in the heads, which was absent in David's earlier pictures, and both show a lightening of the palette which could well be the result of a stay in Antwerp, where pale colours were fashionable. Neither has any great novelty of design, though the figures, especially in the *Deposition*, reveal an interest in curling forms which do not appear in the grave and placid female saints in the Rouen picture of 1509. Both, on the other hand, prove that David retained his talent for landscape to the end of his life.

His main output, however, is that of an accomplished master who has digested the work of his predecessors and is content to work within the Flemish tradition. But he achieves a new and perhaps final synthesis, giving an added nobility and humanity which leads him to a style which is no longer fifteenth-century, but which has in itself something of the grandeur of sixteenth-century art.

His influence can be seen in the work of many other painters and was dominant in Bruges until well into the sixteenth century, his chief pupil being in all probability Adriaen Isenbrandt (Pl. 91), who became a Master in Bruges in 1510 and died in 1551.[6]

CHAPTER XI

THE EARLY SIXTEENTH-CENTURY BACKGROUND

In the late fifteenth and early sixteenth century the political, cultural and to some extent the economic situation in the Netherlands underwent a profound change. As has been shown in Chapter I, Charles the Bold, the last Valois Duke, was bringing disaster on his dominions even before he was killed at the Battle of Nancy in 1477. The marriage in the next year of his heiress, Mary, to Maximilian of Habsburg, and her death in 1482, created a situation of further political stress, for though Maximilian became Regent for his infant son Philip, not all the Flemish towns accepted his rule. Indeed, immediately after the death of Charles the Bold Mary had been compelled to sign a charter, known as the Great Privilege, whereby she undertook not to make war nor to raise taxes without the consent of the seven states, Flanders, Brabant, Hainault, Namur, Artois, Holland and Zeeland which comprised her dominions, for French Burgundy had been seized by Louis XI after the Battle of Nancy. Inevitably there were clashes between Maximilian and the States arising out of rivalries concerning the guardianship of the young Philip, of questions of peace or enmity with France, of support for the exiled Yorkists or the new Tudor dynasty in England, and above all of finance for Maximilian's wars. Indeed, in 1488, by which time Maximilian had been crowned King of the Romans, and was therefore clearly designated as the successor to his father, the Emperor Frederick III, he was imprisoned by the discontented citizens of Bruges.

The Low Countries were, indeed, reluctant to be drawn into European politics as a pawn (even if a rich one) in the hands of a foreign Regent, and they therefore welcomed the day in 1494 when Philip, known as The Fair, attained his sixteenth birthday, and was allowed to rule in his own name. Though, however, he pleased his subjects by a series of Pageant Entries in the various provinces and by his apparent willingness to accept Flemings as his advisers, it was clearly impossible for him to stand aside from European politics. The marriage of Mary of Burgundy had been of European impor-

tance; that of her son was to be no less crucial, for in 1496 he married Juana, eldest daughter and soon, owing to the death of her brother, heiress of Ferdinand of Aragon and Isabella of Castile, the monarchs who by their own marriage had united Spain.[1] Philip established his court at Brussels, but made little mark as a patron of the arts, and was compelled to spend much time in travelling, though he greatly preferred his northern dominions to Spain. His early death in Spain in 1506 at the age of only twenty-eight, is one of those events which give a new twist to the course of history; for his wife Juana had become mad, and his young son, Charles, then aged six, became heir to both his grandfather Ferdinand of Aragon and to his grandfather Maximilian, Holy Roman Emperor. Naturally, both claimed his guardianship, but Maximilian contrived that the child remained in the Netherlands, and appointed Philip's sister, Margaret, as Regent.

This appointment was probably the greatest benefit the Netherlands gained from their association with Maximilian. Margaret of Austria, already twice widowed (she had married Ferdinand's son, Juan, and after his death Philibert, Duke of Savoy) was an able and learned woman, deeply concerned for the prosperity of the Provinces under her charge, and determined to keep them out of her father's wars. Her court at Malines was moral, her religion sincere without being bigoted, and she was to prove a considerable patroness of learning and the arts. This slightly austere but secure and happy background was the training ground of Charles and his sisters for the next ten years, and it gave him an affection for the Netherlands which he was never to lose in spite of the fact that little of his adult life could be spent there. For in 1516 he succeeded his grandfather Ferdinand as King of Spain, and three years later he succeeded Maximilian and became the Emperor Charles V. He confirmed the Regency of his aunt, Margaret, and she held office till her death in 1530.

By the political results of a series of dynastic marriages Flanders was therefore, by the early sixteenth century, drawn into the area of European rivalries on a vast scale. Not all was loss, for inevitably it brought a widening of horizons, frequent movement of members of the court sent on embassies and returning with new ideas, and no doubt also increased opportunitites for trade. But the chief economic change was not the result of the new political situation of the Netherlands themselves, but was part of a change effecting the whole of Europe. The exploration of the west coast of Africa, culminating in the opening up of the Cape route to India in the late 1490's and the discovery of the Americas in the same decade meant, among other things, that the small ships which had carried merchandise round the coasts of Europe were no

longer adequate. New, larger ships which could cross the ocean were needed, and naturally they could not use the old small ports. For some time Bruges had been proving less and less convenient for the great body of trade it carried, for the Zwyn, the estuary which ran up to it, was gradually silting up. The ocean-going trade was its death-knell. Antwerp, on the other hand, a city of minor importance in the fifteenth century, offered excellent port facilities and could take the largest ships. Its rise was sudden and spectacular. It quickly became the most prosperous city of the Netherlands, only rivalled in Northern Europe as a port by London and Bristol. The pessimism expressed by Bosch had no place in the new, confident world of Antwerp, and when Albrecht Dürer visited the town in 1520 he was greatly impressed by the new houses and by the new furnishings (since destroyed) in the cathedral — 'But at Antwerp they spare no cost on such things, for there is money enough.' His *Diary* also makes it clear that Antwerp was far more cosmopolitan than other cities he visited, for he met Portuguese, Italians, men from the Baltic towns, as well as the representative of the great banking house of the Fuggers of Augsburg, who had 'newly built in very costly fashion'; and he was there given presents of curiosities from strange lands — coral, Calicut feathers, sugar-cane, a great turtle and a small green parrot.[2] None may be intrinsically of great importance, but they are sufficient to suggest the long voyages of ships in and out of the busy new port.

Though, however, Antwerp is chiefly notable for her great commercial prosperity, the city was not without intellectual life. The town-clerk, Peter Gilles, who liked to be known by the Latinized form of his name, Aegidius, was a scholar of considerable attainments. Like many men of his age, he was attracted to the world of classical literature which could now be much more widely and deeply explored owing to the invention of printing. Printing had first appeared in the fifteenth century in both Germany and Holland, and had spread rapidly. By the end of the century there were a number of presses in the Netherlands, and William Caxton, the first English printer, had learnt his trade in Bruges before he set up his press at Westminster in 1476.[3] Before the rise of printing, scholars had been dependent for their knowledge of classical literature, and also of the writings of the Fathers of the Church and of the Bible itself, on manuscripts which were themselves generally copies of older manuscripts into which many copyists' errors had crept. Now, in both Italy and the North, printers who were usually themselves learned men, sought the aid of scholars in the production of better and purer texts. Peter Gilles worked on proofs for the printer, Dirk Maertenz of Louvain, and it was probably his interest in pure Latin which gained him the friendship of the

greatest of Northern Humanists, Erasmus of Rotterdam.

In spite of the fact that Erasmus was a native of the Low Countries, little of his adult life was spent there, for he early fell out with churchmen, both in Holland and Louvain, who to his mind held too rigidly to the dogmas of mediaeval Christianity.[4] The impact of his mind on painting may not be at once apparent, but the prestige of his writings was very great and its effects were far-reaching. Erasmus was above all things a lover of pure Latin and Greek, but at the same time a devoted Christian. Although widely acquainted with pagan classical writers, whose style he honoured in his *Adagiorum Collectanea*, first published in 1500, but republished in a greatly enlarged edition by the famous Venetian printer, Aldus Manutius in 1508, he was much more deeply concerned with the purity of Christian texts. In 1516, after many years' work, he published a new version of the New Testament, which contained a purified Greek text, with a Latin translation in which the Vulgate, the Latin New Testament most widely used in Western Europe, was corrected. In the same year appeared his edition of the works of St. Jerome. He earnestly desired that the church should rid herself of errors and adopt a purer Christianity, and in his disgust at the abuses he perceived he, like Jerome Bosch, used satire as his weapon. Indeed the work by which he is chiefly remembered to-day is his *Laus Stultitae*, or *The Praise of Folly* (1509, enlarged edition, 1515). Such a man, though of most complex character, was not likely to concern himself much with either classical art or classical history, and it was not through him that classical subjects appear in Flemish painting. His work would, however, have strengthened the wish for simple and straightforward Christian themes, while the popularity of *The Praise of Folly* undoubtedly led to an increased taste for satire. Further, in spite of Erasmus' open criticism of abuses, his reverence for the church was such that the ideas of Luther were abhorrent to him. Had he broken with the church and become a Protestant, many of his countrymen might quickly have followed him. As it was, though the teachings of Luther and still more those of Calvin were, later in the century, to gain a strong hold on Holland, the rise of Protestantism around 1520 did not produce that immediate impact on Flemish artists which can be so clearly seen in Germany. Naturally, the writings of Erasmus were only one of several causes which prevented the spread of religious strife to the Netherlands in the first half of the century. The mild, wise rule of the Regent and the moderation of her councillors were also a stabilizing factor, and since the Netherlands were as a whole prosperous, they were not a fertile ground for extremists.

The new background of politics, trade and learning inevitably affected

patronage of the arts, though the break with the past was not so complete as might have been expected. The great fifteenth-century tradition of painting was still admired, and works by Jan van Eyck and Roger van der Weyden were still much prized.[5] Many paintings were still produced, notably in Bruges, which are little more than variations on well-worn themes, with only slight modifications of style. There seems, indeed, to have been some confusion in the minds of painters as to the road they should follow. This is partly, though perhaps not wholly due to new influences from abroad, few of which were completely assimilated. The new trade routes could rapidly be exploited because they only demanded an enlargement of methods already mastered and in use. The new art of the High Renaissance, on the other hand, was in its grandeur far more alien to the Netherlands than that of fifteenth-century Italy, and its meaning was never fully to be grasped.

Points of contact with Italy were, however, more frequent in the early sixteenth century than in the late fifteenth, and there were other channels of influence which were to prove of great importance. Journeys to Italy were more numerous, for there was naturally a constant exchange of embassies between the Habsburg rulers and the Papacy or the individual states of Italy. One leading painter, Mabuse, is known to have accompanied such an embassy. The effects of this journey on his style will be discussed in Chapter XIII. Other artists may perhaps have travelled on their own account, though there is little documentary evidence of this within the period of this book.

On the other hand, artists who did not travel had some chance of learning about the newest phases of Italian art. In 1518 a Lombard painter, Ambrosius Benson, settled in Bruges, and though he was not an artist of any great distinction, his works show a knowledge of Leonardo's *sfumato* (or softness of gradation from light to dark tone), and he may even have possessed copies of some of Leonardo's works. A more tantalizing figure is the Venetian, Jacopo de' Barbari, who was in the Netherlands from 1510 to his death in 1516, working first for the Regent and then for Philip, a bastard of the House of Burgundy. Jacopo, who had left Venice about 1500 to work for the Emperor Maximilian, had already had a profound influence on Dürer, who had learnt from him a Canon of (or system of ideal) human proportions. In other words, Jacopo, unusually for a Venetian, must have been concerned with the theory as well as with the practice of art. This search for ideal proportions, which was based largely on the writings of the Roman architect, Vitruvius,[6] was an integral part of Italian High Renaissance theory, and had indeed influenced some Italian artists in the fifteenth century. Though the works of Vitruvius were not unknown in the North, his theory had held no interest for Northern

artists, and it is indeed questionable if it made much headway during Jacopo's stay in Flanders. Jacopo's main importance as a channel of influence lies in another field. The rise of printing was parelleled by the development of engraving, both on wood and on copper. Engravings were easily portable, and from now onwards were to play a vital part in the dissemination of artistic ideas. Jacopo was himself an engraver, and though he was an old man when he entered the service of the Regent, he undoubtedly had examples of his engravings with him. Since these showed classical subjects with figures which have classical proportions, their significance as a source of influence was considerable. He may also have brought other Italian engravings, and perhaps even printed books with illustrations, such as the *Hypnerotomachia Poliphili*, a romance printed in Venice in 1499. And among the things which Dürer saw when he visited the Regent at Malines in 1521 was 'Jacob's little book'.[7] What was in it no one knows; it may have contained theoretical drawings, or composition designs, some perhaps of pictures Jacopo had seen before he left Italy. At least it must have been of great interest to artists, for Dürer coveted it so much that he asked for it, but was told that the Regent had promised it to her court painter, Bernard van Orley.

Another and intrinsically more important source should have brought knowledge of Italian High Renaissance art of the first rank to Flemish painters, but its effect was surprisingly small. In 1516 the Raphael cartoons of the *Acts of the Apostles* (now in the English Royal Collection and on loan to the Victoria and Albert Museum) were sent by Pope Leo X to Brussels tapestry workers, acknowledged to be the best in Europe, so that tapestries might be woven for the Sistine Chapel.[8] The cartoons or copies of them remained in the Brussels factory of Pieter van Aelst for many years, but though very occasionally knowledge of them can be sensed in the work of a Flemish painter, they do not seem to have had the impact which might have been expected. It may be that only a few favoured artists, such as the Regent's painter, were allowed to see them, or perhaps that their monumental grandeur was beyond the grasp of Northern painters. They did, however, serve in an indirect way to bring knowledge of Italian art to Flanders. For the Pope decided that a second set of tapestries should be woven and presented to King Henry VIII, together with the title of Defender of the Faith, in gratitude for his book on the Sacraments refuting the Theses of Martin Luther,[9] and Tomaso Vincidor, a Bolognese member of Raphael's studio, was sent to Brussels to superintend the weaving.[10] He must almost certainly have had with him drawings of compositions produced in Raphael's studio, perhaps those on which he himself had worked, for in the 1520's echoes of such compositions, strangely mis-

understood, can be found in Flemish painting. It is also just possible that he may have had engravings by Marcantonio Raimondi after Raphael, as well as other Italian works of art.[11]

It cannot, however, be held that in spite of increased opportunities, Flemish painters in the first thirty years of the sixteenth century showed much real appreciation of the style of High Renaissance Italy. They and their patrons were, on the other hand, alive to the fascination of classical subjects, especially of those which required the use of the nude; and they were also conscious of the fact that painting could represent the human form in a grander, broader and more sculptural manner than had hitherto been within the Flemish tradition. But on the whole they found it easier to learn this new solidity, not from Italy itself, but via the work of Albrecht Dürer. In his woodcuts and engravings, which quickly became known and admired all over Europe, Dürer, with his unsurpassed technical skill, was able even in a medium without colour, to give his figures a sculptural breadth and to place them in their surroundings in a way which must have had a peculiar appeal to Flemish painters, with their traditional interest in reality. The meagre forms and angular poses, originating with Campin and Roger van der Weyden and lasting till the end of the fifteenth century, were to be replaced, largely under the influence of Dürer, by figures with rounded limbs and in more flowing poses. Dürer's work, which retains many Northern elements, was no doubt less strange and austere than that of Italy, and prints are more easily portable than pictures or sculpture; and though to-day no one would mistake Dürer's work for that of an Italian High Renaissance artist, to sixteenth-century Flemish eyes it must have appeared equally impressive and equally new.

The first thirty years of the sixteenth century in Flanders present a strange, confused picture. The new influences already discussed are constantly at work, but they are only half assimilated. Antwerp and Brussels, the home of the Regent's painter, are the chief centres, but in neither was there so coherent a school as in Bruges in the fifteenth century. And in Bruges itself work continued, though painters seem uncomfortably aware that their tradition was dying, and that new things were being done elsewhere. The same religious subjects were still in demand, though sometimes they appear in a new dress; classical themes appear, perhaps for the first time, but with a certain uneasiness in presentation, and in Antwerp, as in other mercantile communities in other periods, there is an interest in *genre* (or everyday) subjects, often with a satirical twist. Here, perhaps, the direct influence of *The Praise of Folly* can be seen. None of these paths seem, however, quite sure where they are going. It is perhaps only in the art of the portrait that early sixteenth-century

Flanders was to hold its own, and was to make, indeed, a major contribution to European painting. In this field the Flemings had no need to borrow from elsewhere, but they built on the tradition which they fully understood, enlarging it so that here at least they were to give to, and not take from, other countries of Europe.

CHAPTER XII

QUENTIN MATSYS
AND OTHER ANTWERP ARTISTS

1

Quentin Matsys (or Massys) (1466–1530) was the most gifted painter to benefit by the new patronage of Antwerp. He has left a small number of dated or datable pictures, and many more which seem surely his. Most have a tinge of sentimentality which is new in Flemish painting, due perhaps chiefly to his own personality, reinforced by his undoubted interest in the art of Leonardo, but strengthened probably by the taste of Antwerp society. His work is uneven and his development not easy to follow. He was clearly affected by the generally confused situation already discussed, for until late in life he did not break entirely with the fifteenth-century tradition, though he was at the same time aware that it did not provide an adequate language for the expression of new ideas.

Not much, but perhaps just enough is known about his life.[1] He was born in 1466 in Louvain, that is to say when Dirk Bouts was still the leading painter in that city; in 1491 he was admitted to the Guild of Painters in Antwerp, being already a citizen, and he died there in 1530. There are no dated pictures before 1507, by which time as will be seen, he was already a painter of maturity. He had a large studio with many pupils, and towards the end of his life he was probably assisted by the sons of his second marriage, Cornelis and Jan, both of whom became Masters in 1531. It is also almost certain that at some time between 1515 and 1524 he collaborated with the landscape painter, Joachim Patinir. His reputation in his own time was clearly high, for Dürer hastened to visit his house when he arrived in Antwerp in 1520, and in 1526 Erasmus wrote to Peter Gilles asking him to introduce Hans Holbein to Matsys when he passed through Antwerp on his journey to England.[2] In neither case do we in fact know that the German artists met Matsys, but there can be no doubt that the example of his portraits meant much to Holbein.

When Matsys was a boy in Louvain he must constantly have seen two great

[124]

masterpieces of Flemish painting, Roger van der Weyden's *Descent from the Cross* (Madrid) (Pl. 24), and Dirk Bouts' *Last Supper altarpiece* (Pl. 38), both of which were then in the church of St. Pierre, where the latter still remains. The first would have shown him a dramatic theme, rendered more poignant by the discipline of its design, the boldness of its modelling and by its brilliant but controlled use of colour. The second, a great contrast in its lack of violent action, would have taught him the importance of the study of the fall of light. In other words, he could in the town in which he was born have absorbed all that was best in the tradition of fifteenth-century painting.

We do not know how long he lived in Louvain, though his first marriage took place there in 1486, or when he first went to Antwerp. It would, however, seem that he acquired some knowledge of Bruges painting, for he was to borrow themes from Memlinc and types from David. Both were working in Bruges at least from the first known record of David there in 1484 until Memlinc's death in 1495, when David became the foremost painter; and it is possible that Matsys worked for a time in Bruges before he went to Antwerp. His first dated work, begun in 1507, was painted after he was forty, but there are some pictures which can with confidence be assigned to an earlier date.

The Virgin and Child enthroned with angels (National Gallery, formerly Dyson Perrins Coll.) (Pl. 77a) and two paintings of the *Virgin and Child* (Brussels) are all relatively sombre in colour, and in this and in the heavy build of the Virgin with its soft, heavy modelling, they seem to show the influence of David. In all the Child is clothed and has little animation, and in two there is much interest in the intricate detail of late Gothic architecture. The National Gallery picture has music-making angels in long straight dresses standing on either side of the Gothic throne and others flying above with a crown. There is little that is not traditional, but the angels are younger and less formal than in earlier pictures, in spite of the stiffness of their pose. They have small, round faces with deep-set eyes, a mop of short fluffy hair and little pointed chins. In later works the type of face may change, but a pointed chin is constant in Matsys' work.[3] The two pictures at Brussels have a greater expression of melancholy in the Virgin's face, the smaller carrying this to the edge of sentimentality.

Since nothing is really known of Matsys' work before 1507, it will be best to consider next his two dated works of 1507–11, for one of them provides the proof that the group just discussed must be earlier. The *St. Anne altar* (Brussels) (Pl. 79) is signed and dated 1509, though it is known to have been ordered by the Confraternity of St. Anne for the church of St. Pierre, Louvain in 1507. This large painting, even though it has at some time been

much damaged, is still a most beautiful and impressive work. The broad centre panel, with a new form of triple-curved top, shows in the middle the Virgin and St. Anne seated, with the Christ Child on the Virgin's lap as the focal point of the whole picture. In front, with their children, are St. Anne's daughters by her former marriages — on the left, Mary the daughter of Cleophas, with St. James the Less, St. Simon and St. Jude, and a child who did not become one of the Apostles, known as Joseph the Just. On the right is Mary, the daughter of Salomas, with St. James the Great and St. John the Evangelist, constantly referred to in the New Testament as the sons of their father, Zebedee. Behind the groups of women and children is a wall, and on it lean four male figures, the husbands of the women in front — Alphaeus, St. Joseph, Joachim (the father of the Virgin) and Zebedee.[4] Behind again is a more ambitious and up-to-date piece of architecture than anything yet seen in Flemish painting, a construction of piers treated as an open loggia, the four central piers supporting a dome. Beyond the loggia, in the distance, is a mountainous landscape.

The subject is not new to Netherlandish art (it had been painted by Geertgen in the picture in the Rijksmuseum, Amsterdam), but there is a new monumentality and a new, inventive type of composition. The figures are large and kept relatively close to the eye, and the artist seems less interested in planning in depth than he is in a grandly balanced pattern, for the wall which separates the men from the women does not really serve as a space-defining element. It is not, indeed, until the middle distance, with its novel architectural device, that the picture acquires a sense of depth. The architecture is, in many ways, an epitome of the whole composition, for it is neither purely Gothic nor purely Renaissanse. The little cupola, the round arches, the half-columns in front of the piers and the coffered vaults at the sides, are of the Renaissance, and must be echoes of some Italian work known to Matsys, but the handling of the detail with its ribs and crocket capitals is entirely un-Italian and comes out of the Gothic world. So too in the figures, though the Virgin herself is linked with fifteenth-century painting, the flowing, rounded curves of the draperies are new.

Moreover, though the surface is now much rubbed, the painting must always have been novel in its colour harmonies. The whole of the middle group hinges on the Child in grey-blue, the Virgin being in white with blue shadows and a grey fur lining to her sleeves, St. Anne in plum colour holding grey-green grapes. The groups at the sides are in stronger, though not in harsher tints — blues, greens and pinks, and a characteristic feature appears in the handling of the turbans of the two Maries, one being pink veiled with

blue, and the other grey veiled with blue. These complex colours were dear to Matsys; the device of veiling one colour with another may have been part of the fashion of his day, but he seized on it for its effect of softness, and for the opportunity it gave of carrying his colour harmonies across a picture. The male figures are in stronger colours than the women, St. Joseph being emphasized by his scarlet clothes, and strong colours also appear in the wings, the left showing the *Annunciation to Joachim*, and the right the *Death of St. Anne*. The latter suggests that Matsys knew Hugo van der Goes' *Death of the Virgin* (Pl. 50), but his group of weeping, hysterical figures round the bed is very far removed from the strange power of Hugo's staring Apostles.

The other firmly dated picture of about this time is the *Emtombment* (1508–11), ordered for Antwerp Cathedral and now moved to the Gallery (Pl. 80). Though in far better condition than the *St. Anne altar*, it is a less impressive picture. Once more, much in the large group of figures spread right across the broad composition is a clear development from traditional painting; but there is a hysterical frenzy, conveyed partly by expression and partly by gesticulation which seems a little theatrical if compared with, for instance the bitter grief of Roger's Madrid *Deposition* (Pl. 24). But, as in the *St. Anne altar*, the complex colour has great beauty, for the whole group is built up in subtle harmonies of greys — grey-mauve, grey-blue, grey-pink, grey-green and some dull green — the only strong colours accenting the Virgin in blue supported by St. John in scarlet.[5]

An important series of panels in Lisbon are perhaps a little but not much earlier than these two documented altarpieces. They formed part of the *Retable of the Sorrows of the Virgin* in the church of Madre de Dios, and though subsequently scattered have now been reunited. Although the individual panels are not large they have an air of monumentality which proclaims them as sixteenth- rather than fifteenth-century works. The figures are disposed near the eye, in front of rather than part of the setting, which may be landscape, as in the centre panel of the seated *Virgin with the sword about to pierce her heart*, or in the *Three Maries at the Sepulchre*, or semi-Italianate architecture in *Christ among the Doctors* and the *Presentation at the Temple*. Matsys was clearly attempting to break away from traditional methods of composition and at the same time to emphasize the emotional content. In the *Presentation* the main group is surrounded by spectators pressing forward in curiosity, and the woman carrying the sacrificial doves bends forward in ecstasy at the recognition of the Saviour by Simeon and Anna. The intensity of feeling and the types of head are very close to the Antwerp *Entombment*, but the compositions, though slightly immature, are far more experimental. In colour,

too, this altarpiece points forward rather than back, for it has the soft light tints of the *St. Anne altar*, rather than the sombre colouring of the early pictures influenced by David. The work is also interesting as one of the first examples of a commission by a foreign patron for an altarpiece in the new Antwerp style, and it was to have a marked effect on painting in Portugal in the sixteenth century.

It is not possible to say how or precisely when Matsys obtained a knowledge of the style of Leonardo da Vinci. Some scholars have thought it possible that he made a journey to North Italy about 1512, though there is no documentary evidence for this; while others assume that he saw copies of Leonardo's drawings and perhaps also of his paintings in the north.[6] A number of Northern artists appear to have had some knowledge of Leonardo's drawings, particularly of his grotesque heads, and Leonardo's pupils are known to have made copies of his paintings. Matsys' knowledge seems to have been fairly extensive, but certain aspects of Leonardo's art would have had a great appeal for him, and having seen one example, he might well have sought out others.

The earliest dated example of clear Leonardesque influence is in a profile *Portrait of a Man* in the Jacquemart-André Collection, Paris (Pl. 83*a*), and is signed and dated 1513.[7] The profile portrait was not a traditional Flemish type, and this ugly face with its hooked nose and pendulous lower lip is very close indeed to Leonardo's caricature drawings, notably to one now at Windsor Castle. The Fleming has, however, shown great skill in the placing of the silhouetted head in the picture space, and the detailed modelling and precise study of gradated shadow is in the purely Flemish tradition.[8]

There are, however, other and probably later pictures by Matsys which reflect a different aspect of Leonardo's art. The *Madonna and Child with a Lamb* (Poznan) is a direct copy of two of the four figures in Leonardo's *Madonna and Child with St. Anne* (Louvre).[9] Matsys has, however, transformed the design, for instead of the figures towering in front of a distant landscape, the effect of the picture has been confused by the insertion of a straight horizon above the Virgin's head, and by the filling of the landscape with lively incidents.[10] Moreover, though the Virgin's limbs have rounded forms very different from those used in fifteenth-century Flemish painting, the arrangement of her garments shows that Leonardo's endlessly flowing lines have been entirely misunderstood.

Ideas taken from Leonardo have been more fully absorbed in one of the most beautiful of Matsys' smaller paintings, the *St. Mary Magdalen* at Antwerp (Pl. 77*b*). It is neither signed nor dated, but it is unquestionably from his hand, and must be a fairly late work, perhaps about 1520. The half-

length figure under an arched loggia is beautifully placed on the panel with its rounded top, the play of curves adding greatly to the distinction of the design. The face, with a small chin and half-shut eyes, is modelled with extreme delicacy, and is markedly Leonardesque in type. The colour is a lovely harmony of pinks and browns, and in the transparent veil over the dark golden hair, Matsys' craftsmanship is seen at its best. Whether in his choice and pose of a half-length figure, steadied and broadened at the base by a bent arm in a large enveloping sleeve, he was consciously echoing the *Mona Lisa*, is impossible to say,[11] but there can be no doubt that he has by now left the fifteenth-century tradition far behind, and in this quiet figure, at once solidly and delicately conveyed, he achieves a brief synthesis of Italian composition and Northern handling.

Unfortunately the dated pictures by Matsys do not provide all the clues needed for a firm analysis of the development of his style. *The Banker and his Wife* (Louvre) (Pl. 81), signed and dated 1514, with two half-length figures in an interior, goes back in its loving representation of the still-life which surrounds them, to such a work as Christus' *St. Eligius and two Lovers* (Lehmann Coll., New York) (Pl. 35b), and perhaps further back to a design by Jan van Eyck.[12] Moreover, Matsys' figures do not wear contemporary costume, but that of the fifteenth century. Nevertheless the picture has features which would not have appeared in an earlier work, notably the moral implications and the psychological contrast. For while the banker is intent on counting and weighing his money, his wife has in front of her an illuminated book of prayers. She is not, however, paying much attention to it, for her eyes are fixed on the riches of this world in her husband's hands, and the little heap of pearls on the table in front of him. And her face is not the oval of fifteenth-century masters, but the broader type with the small pointed chin already noted in Matsys' work.

This picture is the first datable example of a kind which was to enjoy great popularity in Antwerp in the next decades, though most are more blatant and nearer to caricature. *The Ill-Matched Pair* (Pourtales Coll., Paris) is usually accepted as a work by Quentin himself, though the theme seems also to have been painted by his sons. It shows a prostitute accepting the embraces of a leering old man while she steals his purse and hands it to an accomplice. The contrast between youth and age, beauty and ugliness, were part of Leonardo's many notes, and may have had influence in Antwerp, as they did in Germany. And the banker theme, twisted to include both misers and tax-gatherers, was to be taken up and exploited after 1530 in the satirical paintings of Marinus van Reymerswaele (National Gallery, etc).

Throughout his life Matsys received many commissions for religious subjects. It would, however, appear that a moment came when he was dissatisfied with calm and relatively serene figures, such as those in the centre panel of the *St. Anne altar*. As early as the *Entombment* of 1508–11 he had introduced more tortured poses for figures hysterical with grief, and the desire to show agitated figures in movement seems to increase in his later work. A *Temptation of St. Anthony* (Madrid) (Pl. 86a) was probably painted between 1515 and 1524, since an Inventory of the Spanish Royal Collection of 1574 states that the picture was by 'Maestre Coyntin' (i.e. Quentin) and 'M. Joachim'. The landscape is completely acceptable as the work of Joachim Patinir, whose art will be discussed later in this chapter, and who was a Master in Antwerp from 1515 till his death in 1524. He was certainly a friend of Matsys, since the latter became guardian to Patinir's daughter. The figures in this picture are, however, more exaggerated than in any work by Matsys so far discussed. Their bodies are slender, their gestures affected, and the eroticism of the female figures is reinforced by the swaying curves of their fashionable clothes.

The only other religious painting which serves as a guide to Matsys' late style is the *Rattier Madonna* (Louvre) (Pl. 85a), dated 1529, the year before his death. This palpably belongs to a different world from the *St. Anne altar*, for he has totally abandoned his native tradition, and is attempting something which he perhaps hoped would compare favourably with Italian art. The Virgin, a half-length figure, is seated behind a narrow ledge on which rests fruit and other still-life, and is being embraced by the Child, who is no longer an infant, but a curiously mal-proportioned young boy.[13] It is a disagreeable picture, both in its design and in its cloying sentimentality, which is increased by the ecstatic expression on the Virgin's face, but it is valuable because it is dated.

Judging by the last two pictures discussed, it is reasonable to suppose that a series of Virgin and Child paintings, of which the whole-length in Berlin is perhaps the most characteristic, which exploit the kissing theme, and also make use of contorted poses, were created late in Quentin's life. They lack the dignity of his earlier pictures, but are very revealing for the taste of Antwerp in the early sixteenth century, and also for the uneasiness of Flemish artists when they attempted something new.[14]

Though, however, Matsys may not in religious painting have achieved all that might have been hoped from the artist of the *St. Anne altar*, his contribution as a portrait painter is very high. Leaving aside the *Portrait of a Man* (Jacquemart-André Coll., Paris), which is an exceptional picture, alien to

Flemish art, it can be seen that he carries on the distinguished fifteenth-century tradition, but adds much to it. Few of his portraits are dated, but judging from what can be deduced from his dated religious pictures, it seems probable that his earliest portraits show the head against a plain ground and are relatively incisive in drawing and crisp in modelling (e.g. *Portrait of a Man*, Chicago).

In 1517, however, he created a pair of portraits of much greater significance, the *Peter Gilles* (Longford Castle, Wilts) and the *Erasmus* (Museo Nazionale, Rome) (Pls. 82a and 82b) which were sent to England as a present to Sir Thomas More.[15] The two scholars are seen seated in two halves of the same room, Erasmus at his desk, writing the opening passages of his *Paraphrase of the Epistle to the Romans*, and Gilles opposite to him with his right hand resting on Erasmus' newly printed *Antibarbarorum liber*, and holding in his left a letter addressed to him in More's handwriting.[16] He looks across to Erasmus and seems about to speak to him, so that the two panels are linked in action as well as in design. Behind, running across both panels are shelves with books, the titles reflecting the interests of the two men, a fine silver cup and a pair of scissors hanging near Erasmus' head. It is a quiet and serene picture, both men being in black, but it is not in any way austere, for their robes are trimmed with fur, the walls of the room and the still-life are in mellow golden tones, and a soft golden light plays over the figures.

This superb double portrait is a landmark in European art, and represents Matsys' greatest and certainly his most influential achievement. For the first time, men are shown at work in their everyday surroundings. Though, however, no portrait precisely of this kind had yet been painted anywhere in Europe, it is in a way the synthesis of much that had been seen in fifteenth-century Flemish painting. Jan van Eyck had painted *Giovanni Arnolfini and his wife* (Frontis.) in their own house, but on a special occasion. His other remaining portraits have the head set against a plain dark ground, with only slight indications of the interests of the sitter, though his lost picture of a *Banker and his agent* may have come nearer in intention to the work of Matsys. Christus' *St. Eligius and two Lovers* (Pl. 35b), probably influenced by Van Eyck, also shows figures in an interior, but like the *Arnolfini Marriage* group it seems to record a special occasion. Both Christus and Bouts had set a figure in the angle of a room, but in neither case is there any suggestion of the man at work. And though the portrait half of Memlinc's *Diptych of Martin van Nieuwenhove* (Pl. 57b) shows the donor in his room, it is not an entirely realistic work, for the Virgin and Child appear in the room with him, and his hands are joined in prayer. It is therefore in a different vein from the compelling

reality of Matsys' portraits. They are, indeed, a perfect reflection of all that was best in the new age of humanist scholarship, enforcing the idea that a scholar could be a man living in the world and not of necessity enclosed in a cloister. At the same time they are the ancestors of many fine portraits of character. There can be little doubt that since the first portraits of this kind painted by Holbein were those of Erasmus in 1523 (Louvre and Longford Castle), the idea was transmitted to the artist by the sitter, who had been well pleased with the form evolved by Matsys.[17]

One other type of portrait, that introduced by Memlinc with the head set against a landscape, was also developed by Matsys, though unfortunately in no case can the sitter be identified or the picture dated. It is, however, unlikely that he painted them very early in his career, and moreover by the time he painted them he must have seen some fine example of an Italian sixteenth-century portrait. The *Portrait of a Canon* (Liechtenstein Coll.) (Pl. 83b) shows the figure standing behind a parapet, with a spreading landscape behind framed by two tall trees. The major difference between this and any portrait by Memlinc lies in the increased bulk of the figure, seen as a broad triangle on a wide base. It has, indeed, curious affinities to Andrea Solario's *Portrait of Longono* (National Gallery), dated 1506, even to the framing trees, and it may well have been a North Italian work of this type that Matsys had seen. Two other portraits, both of scholars (National Gallery of Scotland, and Frankfurt) (Pl. 84a), are slightly different in pattern, for in both an arched loggia is set between the figures and the landscape. The Frankfurt picture is the more impressive, both in design and characterization; and the enormously accomplished modelling of the strong face shows that Matsys, for all the sentimentality of some of his late religious pictures, is worthy of a high place in the history of Flemish painting.

2

Many painters were working in Antwerp in the first third of the sixteenth century, but none of them have the personality of Matsys; in many cases they remain shadowy or indeed, anonymous figures. Moreover, while their styles betray in most cases a knowledge of Bruges painting in the late fifteenth century, combined with a striving for something new, the precise influences at work are not easy to define, and their work cannot be discussed in detail.

In some cases it would seem that their taste ran to a fantastic embroidering of the older style. A typical master in this manner is the painter known as The Master of Frankfurt, from his large and crowded *St. Anne altar* in the

Frankfurt Gallery. It has none of the dignity of Matsys' representation of the same theme, the types are to some extent an exaggeration of those of David, and there is a certain play with tossed and swirling draperies which appears in more fantastic guise in other works ascribed to him. Goswin van der Weyden, the grandson of the great Roger, has a fairly well-documented life, for he became a Master in Antwerp in 1504, was Dean of the Guild in 1514 and again in 1530, and was still working in 1535, but his style has little originality. Both artists, however, seem to have contributed something to the manner of younger and even more fantastic painters, still known by the name of 'Antwerp Mannerists' given them years ago by Max Friedlaender. Their many works must be regarded as evidence of the liking in Antwerp for bizarre costume, contorted poses, strangely proportioned semi-classical architecture and restless compositions.

A more accomplished, but extremely confusing painter is Joos van Cleve, who became a Master in Antwerp in 1511 and died in 1540, though it is possible that he was away from Antwerp for some years, probably between 1528 and 1535.[18] His triptych of the *Death of the Virgin* (Munich) and a simpler version of the same subject (Wallraf-Richartz Mus., Cologne) are both of 1515. They borrow much from older pictures, but are notable for their use of soft curling draperies which increase the agitation already introduced in the larger picture by twisted, gesticulating figures seen from the back. The many paintings of the *Virgin and Child* ascribed to the artist (e.g. Vienna and Fitzwilliam Museum, Cambridge) (Pl. 85*b*) show the influence of Matsys in the soft, Leonardesque modelling of the Virgin's face, and a certain element of prettiness which is perhaps an extension of the sentimentality of Matsys' late work. Joos, however, almost certainly worked for a time in France, where he would have come into direct contact with the art of Leonardo. He was probably chiefly employed there as a portraitist, for he seems to have been well known as a painter of royal portraits. Several versions exist of his portraits of Francis I and his Queen; that of *Henry VIII* (Hampton Court) cannot be earlier than about 1536, for the inscription on the scroll held by the King refers to the publication of Coverdale's English Bible in that year. It shows that by then Joos had mastered the international formula of court portraiture, with its emphasis on rich dress, but that he had not entirely lost the Flemish sense of character.

Joachim Patinir (or Patenier) is an artist of very different calibre from those who catered for the half-formulated desire for novelty. He was probably born in or near Dinant, that is to say in the deep, craggy gorge of the Meuse, so unlike the flat or rolling country of most of the Netherlands, but nothing is

certainly known of him beyond the facts that he became a Master in Antwerp in 1515, died there in 1524, and that Dürer spoke of him as 'a good landscape painter'.[19] This last is in itself of interest, for though all the pictures likely to be by Patinir himself, and not by other artists imitating his style contain figures, the landscape setting has become of far greater importance than in earlier works, and Dürer's statement suggests that, perhaps for the first time, an artist was known as a specialist in landscape. Pure landscape painting was hardly to arise before the seventeenth century, for even the landscape paintings of Pieter Bruegel in the second half of the sixteenth century have a theme and therefore include figures, so the place of Patinir is of some importance. Moreover, in most of his pictures the landscapes are of greater importance than the figures in them.

Patinir has left a small number of signed pictures, and others in which the landscapes are certainly his. How far the figures in any, even of the signed pictures, are from his hand is an open question, but it is not impossible that they are his. Unfortunately no picture is dated, though it is reasonable to suppose *The Temptation of St. Anthony* (Madrid) (Pl. 86a), in which he collaborated with Matsys, was painted in Antwerp and therefore after 1515. It seems possible that earlier in life he had come into contact with Gerard David, for his signed *Baptism of Christ* (Vienna) has some affinities with David's picture of the same subject (Bruges), probably painted between about 1502 and 1508. In Patinir's picture, Christ and the Baptist, placed well in the foreground, have some similarity to the same figures in David's work, though the Christ is less solidly modelled. Further, the group of figures in the middle-distance, listening to the Baptist preaching, could also be an idea taken from David. Moreover, the massed trees, with flecks of light on the leaves, echo the methods of older masters, notably David and Geertgen.

Two other signed works, the *Flight into Egypt* (Antwerp) and the *St. Jerome* (Madrid) (Pls. 86b and 87), are further from David, for the figures are much smaller, though his influence remains in the massed trees. In both the contrast between the jutting rocks in the foreground and the deep panorama behind is very strong, while in the middle distance the rural scenery of the Low Countries is lovingly displayed. In both, too, the tiny figures in the middle distance enlarge the narrative, for the Antwerp picture shows the Massacre of the Innocents in the fields round the farm, and in the other St. Jerome's lion can be seen joyfully recognizing the ass which had been stolen from his master.[20] Patinir tends to use brilliant greens and a very strong blue for his distant panoramas, so that his landscapes when seen in the original appear more fantastic and less realistic than they do in black and white illustration.

If the *Temptation of St. Anthony* can be taken as characteristic of the painter's work around or after 1515, it is probable that his interest in a far-spreading landscape increased with experience, for here the depth and the sense of a wide flat landscape broken by a river is far greater than in the more Davidian *Baptism of Christ*. Perhaps the most striking of all his pictures is *Charon crossing the Styx* (Madrid). On the left is a serene landscape, wooded in front and peopled by tiny angels, with barer country, a distant town and hills beyond. The whole of the centre of the picture, right back to the horizon, is filled with the broad shining river, across which Charon ferries a soul, and on the right is a hideous land inhabited by monsters and ravaged by the flames of hell. It is not, indeed, the subject which is new, for this is a Last Judgment picture, though presented as a classical legend to please the new taste; the real novelty of the picture, and that which is responsible for its sudden impact, is the tremendous spread of water, earth and sky.

With his flames of hell, his monsters, and indeed his distant landscapes with tongues of land running out into water, it is inevitable to ask if Patinir knew the work of Bosch. But the question cannot be finally answered, for too little is known either about Patinir's life before 1515, or about the whereabouts of Bosch's pictures before the later sixteenth century. It must, however, be regarded as a possibility that Patinir did borrow from Bosch, though his panoramic landscapes dwarfing the figures, which are his chief contribution to Flemish painting, are his own. They are surely a logical development for a man with a great gift for landscape, and who found himself living in a world the borders of which had suddenly been enlarged, and above all in a city where the strange new lands beyond the seas must have been a constant source of conversation.

CHAPTER XIII

MABUSE AND BERNARD VAN ORLEY

1

The work of Jan Gossaert, known as Mabuse, marks a further stage in the movement away from the fifteenth-century tradition. Indeed, to early historians of Flemish painting, it marks the beginning of a more enlightened epoch. Guicciardini, in his *Descrittione de' Paesi Bassi*, published in Antwerp in 1567 stated : 'He was the first to bring from Italy to this country the art of painting histories and poesies with nude figures',[1] and he is still to-day sometimes spoken of as the first of the Romanists. That he introduced new classical subjects and that many of his pictures are studies of the nude is true beyond question. How far his inspiration came direct from Italy must be investigated further.

Jan Gossaert was probably born about 1476, he or his family coming from Maubeuge in Hainault. His early life is obscure, but his style suggests that he may have been trained in Bruges, though he is probably the 'Jennyn van Hennegouwe' (Hainault) who became a Master in Antwerp in 1503. In 1507–8 he accompanied Philip, a bastard of Philip the Good, the last but one of the Valois Dukes of Burgundy, to Italy, where he was sent by the Emperor Maximilian on a mission to Pope Julius II. The party is known to have visited Verona and Florence as well as Rome. By 1514 Gossaert was in close touch with the court of the Regent Margaret and was patronized by the Chancellor, Jean de Carondelet. Up to 1516 his signatures are in some form of Jennin Gossaert, but from that time onwards he latinized his name, and signed: *Johannes Malbodius*. In the next year he was decorating the Castle of Souberg (or Suytborg) on the Island of Walcheren for his patron Philip, now Bishop of Utrecht. He continued to work for him there or in Utrecht till Philip's death in 1524, when he passed into the service of Adolphe of Burgundy, Philip's nephew, living at Middelburg till his own death about 1533.

No dated picture exists before the Italian journey of 1508, and there is some dispute about his early works. A small *Virgin and Child with Angels* (Lisbon) is usually regarded as at least partly from his hand, the angels being close to a drawing at Copenhagen certainly by him. The figures are, in the

main, those used in Bruges about the turn of the century, though there is a certain affectation in them which is similar to the work of Bruges painters such as Goswin van der Weyden, who are known to have moved to Antwerp.

A much harder problem is presented by the large signed *Adoration of the Magi* (National Gallery) (Pl. 88), a splendid and mature work. It cannot, however, be certainly decided if it was painted before the Italian journey or not.[2] The links with earlier Flemish painters are strong, and therefore many scholars date it *c.* 1507. The Virgin is close in type to works by David; the large praying angels floating above recall those of Hugo van der Goes; and the smaller, more contorted ones are near to the style of the group of painters known as the Antwerp Mannerists. The large ruined building is a development of that originated by Hugo van der Goes and used by David, though the fact that it has complete arches and that plants sprout from the top may suggest a borrowing from the prints of Albrecht Dürer.[3] On the other side is the somewhat negative argument that, as will shortly be seen, Mabuse's pictures painted immediately after the Italian journey do not show the strong Italian influence that might be expected. It can, indeed, be contended that some Italian ideas are visible in the design, for it is very unusual for a Flemish *Adoration of the Magi* to show the train of kings approaching from both sides. The centralization of the composition and the unexpectedly strong verticals apparent in the figures on either side of the Virgin might suggest a first-hand, but half-digested knowledge of Italian methods of composition, and so place the picture after Mabuse's return in 1509.

Fortunately it is possible to check fairly precisely the immediate impact of Italy on Mabuse. His patron Philip had a taste for the arts, and was deeply impressed by Rome — and also by Pope Julius II. He caused Mabuse to make drawings for him of antique sculpture. A few of these have survived and are extremely revealing. One sheet in the University of Leyden shows the well-known antique figure of the boy pulling a thorn from his foot (the *Spinario*). Many versions are known, but Mabuse's drawing was in all probability made from the figure given to the Capitoline Museum by Pope Sixtus IV soon after its foundation in 1471. The figure has been drawn with great care, but the Northern artist has been totally unable to grasp the essential character of antique sculpture. Instead of the broad generalization of form, in which the accidents of nature are suppressed, and the contours flow through and round the body, each part has been seen and exaggerated separately. The back becomes a succession of lumpy muscles, instead of a subtly modelled whole, and the figure has a curious effect, almost as if it had been inflated like a balloon. As well as the *Spinario*, the sheet has drawings of the ornaments

of antique dress, such as richly-wrought leggings, and these with their elaborate detail clearly proved easier to understand. In the same way, the drawing of a *Hermaphrodite* (Venice) shows the body broken up into small lumps of light and shadow, and a drapery which has been transformed into angular, Northern rhythms.[4]

The first works painted after Mabuse's return to Flanders show the same lack of understanding of the principles of classical or Renaissance art, though they display his knowledge of detail. None can be precisely dated, but the signed *St. Luke painting the Virgin* (Prague) (Pl. 90) must be after 1509, since the well-known group of the *Boy with a Goose* (Rome, Capitoline Museum) appears, though with wings added, above the Virgin on the left. Mabuse had no doubt made a drawing of it, though this has not survived. The setting of the scene is a strange mixture of misunderstood Italian architecture and Gothic detail, and though in his attempt to space his figures more widely, the artist may perhaps have been influenced by the Italian paintings he had seen, the figures themselves and their sharp broken draperies are wholly within the Flemish tradition.

The charming little *Malvagna Triptych* (Palermo) (Pl. 89), only some eighteen inches high and certainly Mabuse's most attractive work, also shows a mixture of styles. The Virgin and Child are still in the tradition of Gerard David, and incidentally are not far removed from the same figures in Mabuse's National Gallery *Adoration of the Magi*. They are seated under an open loggia of the most elaborate and fantastic late Gothic architecture.[5] But surrounding them are music-making *putti*, who reveal a complete break with the music-making angels used by Memlinc and his successors in Bruges, for they are purely Italian in style. Mabuse's Italian journey had taken him to Florence, and he may well have been attracted by the sculptured *putti* of Donatello and still more of Luca della Robbia on the Singing Galleries in the Cathedral. The outside of the wings suggests a different borrowing and gives some slight clue towards date, for they show figures of Adam and Eve in Eden, and the strange twisted action of the legs must be a direct copy of Dürer's woodcut in the *Small Passion* of 1511.[6]

It is not, in fact, till about 1516 that Mabuse began to produce the type of picture for which he is most famous. In 1515 Philip of Burgundy, after a period of service as Grand Admiral of the Netherlands, began to decorate his castle of Souberg. To execute his plans he summoned not only Mabuse, but also the Italian, Jacopo de' Barbari, then in the Regent's service. Jacopo was very old and died in the next year, but he must surely have had some of his prints and possibly also drawings with him. It is impossible to say if he or Philip

planned the decoration, or precisely what it was like, but two of Mabuse's pairs of nudes almost certainly record part of it, and one at least shows a strong echo of de' Barbari's known work.

The large *Neptune and Amphitrite* (Berlin) (Pl. 92) is dated 1516, and is the first known example of Mabuse's change to the signature: Johannes Malbodius. The pair of figures, nearly full-face, and strongly modelled with an almost metallic sheen, stand within an architectural framework which must have been thought highly classical by both patron and artist. It is, indeed, composed of Doric columns, though their capitals and abaci are decorated in an un-Doric manner and the entablature above them has been woefully mis-understood. The skulls of oxen (bucrania) which should be placed in the square panels between the triglyphs, have been dropped below them and look like Gothic corbels set normally at the springing of ribs. The cornice above is equally confused; it is not easy to understand how the building is planned, and it is certainly too small for the massive figures. The nudes bear much the same relation to classical sources as the architecture, and with their exagger-ated muscles and inflated bodies recall Mabuse's drawing of the *Spinario*. Nevertheless, they are a brave attempt at a new kind of painting in a classical style. It hardly seems, however, that Guicciardini was justified in saying that Mabuse 'brought the style from Italy'. Some time had elapsed since his Italian journey, and the sources can be found nearer home. One was certainly the prints of de' Barbari, above all his *Mars and Venus* in which the pose, especially of the legs, of the female figure is very close. But the proportions of the figures, the sloping shoulders of Amphitrite, the exaggerated width of the chest of Neptune and his unsteady stance are not Italian but German. Mabuse must surely have known and admired Dürer's great engraving of *Adam and Eve* of 1504 where, in spite of the fact that it is one of the most classical of his works, similar distortions occur. Further, the German type of female nude, which appears frequently in the prints of Hans Baldung, with sloping shoulders, high breasts and bulging thighs must have been known to him in the small figures, such as the *Judith* (Munich) by Konrad Meit, a German sculptor working at the Regent's court from about 1514–26.[7]

The *Hercules and Dejanira* (Barber Institute, Birmingham), signed and dated 1517, is much smaller and perhaps a reduced replica of one of the Souberg decorations. It is more coldly sensual than the *Neptune and Amphitrite*, more metallic in colour, and disagreeable in its strange design of intertwined legs. In its restless pattern it is a completely unclassical picture, but it no doubt added to Mabuse's reputation as a painter of the nude. Some patrons were to continue the demand for classical subjects, as may be seen in the

Venus and Cupid (1521: Brussels), or the *Hercules and Antaeus* (1523: Thyssen Coll., Lugano), the latter with strong echoes of Dürer; others, with perhaps fewer intellectual pretensions, found that their tastes could be titillated equally well by representations of *Adam and Eve*. Several such exist, the finest being that at Hampton Court, dating probably from about 1520 and with borrowings from two of Baldung's engravings. It differs from the nudes so far discussed in the warmth of its colour, the golden browns of the man's body contrasting with the lighter tints of the woman's, but finding an echo in her abundant hair. Even so, it is not an attractive picture, for the detailed Flemish realism with which it is painted makes the bodies seem uncomfortably naked.[8] The stronger colour is not, however, constant in Mabuse's later work, for the small semi-nude *Danae* (Munich) (Pl. 93), dated 1527, is again in the hard metallic blues and greys.

Naturally the change in Mabuse's style after about 1515 can be seen in his religious works also. The Davidian type of Virgin disappears and is replaced by a plumper woman, the curves of whose body are echoed by the new soft, curling forms of the draperies. The Child no longer sits peacefully on His mother's lap, but often adopts a twisting pose (Pl. 94c), or in the undated *Virgin and Child* (Berlin), where He seems to be bursting forward out of the frame. There is no doubt Italian influence in these highly plastic pictures, with their bold modelling and lively rhythms within the group, but their whole feeling is once more very close to engravings by Dürer, such as the *Virgin crowned by two angels* of 1518, though this is a full-length and not a half-length group. Indeed, it would seem that while Mabuse was undoubtedly aware that by the end of the second decade of the sixteenth century the traditional Flemish style was out of date, he found it easier to give his figures a new solidity by learning from the German rather than from the more austere Italian formula of Renaissance art.[9]

When he comes to portrait painting, however, he seems to be on surer ground. No early documented portrait remains, the *Jean Carondelet* (Louvre), which is the left half of a diptych (Pl. 94b), being dated 1517. Here the half-length figure with hands joined in prayer is set behind a frame with a rounded top, and against a neutral ground. The head is modelled with considerable subtlety and in the best Flemish tradition. The light falls on the farther cheek, as in the art of Van Eyck and Christus, and the gradation of light and shadow on the nearer cheek and the shadows round eyes and mouth are carefully perceived and skilfully rendered.

The artist's later portraits are harder in modelling. Moreover, in the later *Carondelet* (Guttmann Collection), where the sitter seems eight or even ten

years older, the so-called *Jacqueline de Bourgogne* (National Gallery), or the *Children of Christian II of Denmark* (Hampton Court) (Pl. 94*a*), which cannot be earlier than 1523,[10] he uses a device which brings the figure forward, but in many ways gives it less reality. For a painted frame is shown within the real frame, and the sitter is placed in front of it. To some extent this is a decorative device, for it does not in fact clarify the space around the sitter, but by pushing him forward helps to some extent to achieve the new plasticity for which Mabuse seems to have been searching in his later years. While he is both less sympathetic and less inventive as a portraitist than Matsys, he is nevertheless a portraitist of talent, and his work in this field has greater dignity than his more famous mythological pictures.

2

The other leading painter who is sometimes described as a 'Romanist', and whose work shows clearly enough an attempt to emulate Italian art is Bernard van Orley (*c.* 1488–1541). He appears to have lived and worked for almost the whole of his life in Brussels, where in 1518 he was appointed court painter to the Regent Margaret — a post he was to hold after 1530 under her successor, Mary of Hungary. He was a man of good family, and like other court painters both before and after him in Flanders was used by his patroness for services outside painting. He was evidently regarded as a person of some distinction; Albrecht Dürer was gratified by the banquet he gave for him in 1520 and drew his portrait,[11] and it is likely that he met most visitors of any importance who came to the Regent's court.

A number of his paintings before 1530 are signed and dated; after that time he was concerned with designs for tapestry and for stained glass. The remarkable tapestries of the *Hunts of Maximilian*, with their fine landscape backgrounds, were made from his cartoons, and his glass includes some of the magnificent windows with figures in Renaissance settings in the church of St. Gudule, Brussels.

The Italian influence, which is very visible in many of his paintings, is almost exclusively that of Raphael. It is possible that Van Orley visited Italy, though there is no clear documentary evidence for this; on the other hand, he is the most likely of all Flemish painters to have been privileged to see the Raphael cartoons when they were in the Netherlands, and he must certainly have known Tomaso Vincidor. His *Trials of Job* (1521: Brussels) (Pl. 95) is rather like a travesty of a late Raphael design, for the main action takes place in the middle distance, but from it figures in violent movement explode outwards

and forwards towards the spectator. Individual figures, such as the woman with her hand on the ground, are markedly Raphaelesque in type, but the breaking up of the picture by jerky rhythms and sharply curling draperies, and its setting in strange and over-decorated architecture is very far from Italian art.

The *Virgin and Child with St. Joseph and two angels* (1522: Madrid) (Pl. 96) is beyond question a direct imitation of Raphael, for the action of the Child running towards His mother, and the angel with outstretched arms flying in from the left and holding a crown are taken over from Raphael's *Holy Family of Francis I* (1518: Louvre). Vincidor had been in Raphael's studio when it was painted and had perhaps worked on it; it is therefore likely that he had some record of it with him when he came to Brussels. Raphael's design has, however, been sadly distorted and its balance not liked and therefore altered. His Virgin, seen almost in profile, leans inward towards the Child, and since she is shown full-length, the lines of her body strengthened by the upright St. Joseph behind are strong enough to hold and control the rushing movement of the Child and the angel from the left. Van Orley has placed his Virgin almost full-face and cut her body awkwardly below the knees. Her head is tilted so that the line of the moving child is accentuated rather than steadied, and the whole composition is no longer taut, but slips loosely across the picture. Other alterations include the reversal of the action of the legs of the Child — a proof that Van Orley has not grasped the importance of *contrapposto* — and the placing of an almost Eyckian crown instead of flowers in the hands of the flying angel. Nevertheless, if this painting with its attempt at compact composition, its idealization of types and its soft modelling is compared with Flemish art of some twenty-five years earlier, that is to say, with the tradition of Memlinc and David, it is clear that Van Orley has broken completely with the past, and has achieved something new.

The *Last Judgment* (1525: Antwerp) poses a more difficult problem, for though the semicircle of figures in the sky is certainly Raphaelesque, it derives from the early, Peruginesque phase of Raphael's art. In this case it does not seem likely that Vincidor was the channel of influence, for his contact with Raphael was only in the master's last years. Either, therefore, Van Orley had made a journey to Italy, or else some work, perhaps a copy from Raphael's early period was known in Flanders. The lower part of the picture, with the blessed and the damned, shows the same kind of misunderstanding of Italian methods of composition as in the Madrid picture just discussed. For instead of a balance between the two sides, a long row of nude figures stretches from the left diagonally across the picture, giving once more a curious unsteadiness to the design. Before the end of his life, however, Van Orley had gained a

greater understanding of Italian art. The *Crucifixion*, a late work painted for the Regent's chapel at Brou and now in the church of Notre Dame, Bruges, is an impressive fusion of Italian types, now from the late Raphael, with Flemish love of detail, while the placing of the three crosses shows a power and originality of design which is lacking in the earlier pictures.

As was the case with Mabuse, Van Orley's portraits throughout his life show far less striving after novelty than his subject pictures. His *Dr. Georges de Zelle* (1519: Brussels) (Pl. 84*b*) is probably his most distinguished work in this field. To some extent it picks up the theme of the scholar in his study, used two years before by Matsys, but the sitter is turned almost full-face, and part of the charm of the design lies in the silhouetting of the dark figure with his wide pointed cap against the tapestry behind. The modelling of the face is simple and the study of light less perceptive than in the portraits of Matsys or the best of those by Mabuse. A similar decorative quality may be seen in the portrait of *Charles V* (Budapest), in which the richly chased Order of the Golden Fleece and the ornaments in the hat, as well as the tilt of the head and the strange long features of the young Emperor, are used to make an interesting surface pattern. It is easy to see from such works why Van Orley was to become a highly successful designer of the flat patterns needed for tapestry and glass.

The careers of these two painters were to a very large extent to set the pattern of Flemish painting for the rest of the sixteenth century. Except for the highly individual Pieter Bruegel, artists tended to strive increasingly after an Italianate art, though in portraiture they were willing to continue steadily in the tradition established by Matsys, Mabuse and Van Orley in the first third of the century. Many mid-sixteenth century portraits have great distinction, but the subject pictures are seldom agreeable. Visits to Italy and also to France became more frequent, and the *terribilità* of Michelangelo's *Last Judgment* and the nervous elegance of the School of Fontainebleau had, in their different ways, a sad impact on Flemish painting. The virtues of neither were understood and their weaknesses were exploited till they became a clumsy brutality or a sly eroticism.

It was not, indeed, for almost a hundred years after the first coming of Italianism that it was to be finally integrated into Northern painting, and Peter Paul Rubens was able to find the way to amalgamate Flemish realism with a full understanding of the Italian principles of grand design.

NOTES

Chapter I: Background of the 15th Century

1 By Cyriac of Ancona (1391–1457) in his *Codex Trevisanus* (Rome, Capitoline Library) and Bernardo Facio in *De viris illustribus* of 1456.

2 The lives quoted in Note 1 and Dürer's travel diary were the main sources used by Giorgio Vasari in the short Flemish section in the first edition (1550) of his *Vite de' più eccellenti Architetti, Pittori, et Scultori Italiani,* which though confused is the first attempt at a history of Flemish painting. Vasari's example led to the appearance of a history written in Flanders by an Italian, Guicciardini, *Descrittione de' Paesi Bassi* (Antwerp, 1567), which is important, for though it repeats many of the errors of Vasari, it adds much drawn from local tradition, and was compiled before the worst destruction of the Wars of Religion. It was quickly followed by two books by Flemish humanists: Lampsonius, *Pictorum aliquot celebrium* (Antwerp, 1572) and Bishop Molanus, *De picturis et imaginibus sacris* (Louvain, 1570). All these, including Vasari, were drawn upon for the first full-scale history of Northern painting, Karel van Mander's *Schilderboek* (Alkmaar, 1604), which is unfortunately full of anecdote and confusion, and totally unreliable for 15th-century painting.

3 Jan van Eyck worked on eight statues for the Stadthaus at Bruges in 1434, painting and gilding six of them; Robert Campin painted a sculptured Annunciation for the church of the Madeleine at Tournai in 1428; Melchior Broederlam made many pennons and small flags for the campaigns of Philip the Bold, and carried out decorations in the Castle of Ypres, for which his pay was so low that they can hardly have been figure paintings; Jacques Daret was among the scene painters employed at the Feast of the Pheasant at Lille in 1454, though it is not certain if he was concerned with plays or with the elaborate representations set out on tables; Hugo van der Goes was concerned with decorations set up in Bruges at the time of the marriage of Charles the Bold to Margaret of York in 1468, and it is possible that Roger van der Weyden, Geertgen tot sin Jans and Gerard David all worked as book illuminators. Many other unrecorded examples of such activities must have existed.

4 Such cycles were widely used in many materials, manuscripts, painting, stained glass and sculpture, a well-known example of the last being the reliefs below the standing figures on the west front of Amiens Cathedral.

5 The October page shows the old château of the Louvre. The manuscript was

fully published by P. Durrieu, *Les très riches heures de Jean de France, duc de Berry* (Paris, 1904).

6 Jean-sans-Peur increased the Burgundian library to 248 books, but by the death of Philip the Good in 1467 it had risen to about 900 items, including some manuscripts in Italian (O. Cartellieri, *The Court of Burgundy* (1922), 164 ff.).

7 Champmol is now a suburb of Dijon. The Chartreuse was desecrated and the chapel destroyed at the time of the French Revolution, the remaining buildings now being a mental hospital. Most of the works of art it contained, including the portal and the tombs of Philip and Jean-sans-Peur, are now in the Dijon Museum, but the *Puits de Moïse* remains in the courtyard of the hospital, and a fragment of the figure of Christ from the Crucifixion which surmounted it is in the Archaeological Museum, Dijon.

8 The work on the portal had been begun by the Fleming, Jean de Marville (d. 1389).

9 Sluter did not live to finish the tomb, which was completed by 1410 by his nephew, Claus de Werve. Among other works executed for the Chartreuse was the painting of the *Holy Communion and Martyrdom of St. Denis* (Louvre), perhaps one of the five altarpieces commissioned from Jean Malouel in 1398, though in 1416 Henri Bellechose bought colours 'pour parfaire' a picture of the *Life of St. Denis*. The forceful figure of the executioner appears more advanced than the left-hand part of the picture, and might perhaps suggest a different hand. The circular *Pietà* (Louvre) has the arms of Burgundy on the back, but is more conservative in style.

Chapter II: Robert Campin

1 The identification of Robert Campin through the work of Daret was first made by the great Belgian scholar, Hulin de Loo (*Burl. Mag.*, xv (1909), 202–8; xix (1911), 218–25), but was violently opposed by E. Renders, *La solution du problème Rogier van der Weyden–Flémalle–Robert Campin*, 2 vols. (Bruges, 1931), and by T. Musper, *Untersuchungen zu Rogier van der Weyden und Jan van Eyck* (Stuttgart, 1948). The two last writers reject the identification of Campin's pupil Rogelet with Roger van der Weyden, and regard the group of works assigned to Campin as the early works of Roger van der Weyden. The stylistic differences which make this hard to accept will be discussed in Chapter IV. M. Friedlaender regarded the case as possible but non-proven, but other modern writers, Tolnay, Beenken, Panofsky and with reservations, Davies (see Bibliography under General books, and to Chapters II and IV) are inclined to accept the identification.

2 It was found in a monastery near Dijon in the early 19th century, and may perhaps have come from the Chartreuse. If this were really so it would prove that Campin had a high reputation outside his native town of Tournai, and so add something to our knowledge of his position.

3 The other panels of the St. Vaast altar are the *Visitation* and the *Adoration of the*

Magi (Berlin) and the *Presentation* (Paris, Petit Palais). All show similar links with Campin and also with Roger van der Weyden.

4 The arms on the left panel have been identified with less certainty as those of the Calcum family. The technical examination of the picture, made after it was acquired by New York, revealed that the left wing originally showed only the figure of the donor, and that his wife was added, apparently by the same artist. It may therefore have been painted when the man was still a bachelor, but, as his marriage has not been traced, this does not help with dating (see *Bull. of the Met. Mus., New York* (December 1957) and *Cat. of the Cloisters* (1963)). A poor copy, perhaps of the late 15th century, is in the Brussels Gallery.

5 The mouse-trap certainly has some iconographic meaning, and may relate to a famous Sentence by Petrus Lombardus: 'God set a mouse-trap for the Devil, and baited it with the human flesh of Christ.'

6 A 15th-century drawing in the Ashmolean Museum, Oxford, by a better hand than the Liverpool copy, also records the design of the centre panel.

7 Roger van der Weyden certainly knew this picture, for he borrowed the heads of the two men beneath the cross of the Thief in the right wing of his *Bladelin altar*. It may very well have been painted while he was in Campin's studio — i.e. between 1427 and 1432.

8 A *Crucifixion* (Berlin) with the figures awkwardly grouped, but including a tragic figure of St. John seen from the back, may be partly from Campin's own hand. Again the design was known to Roger. Other masters borrowed from a Campin design of the *Trinity*, with God the Father seated and holding the body of the Son, now only known in poor copies, one being at Leningrad, where there is also a Virgin by a fireplace, based on a Campin original.

9 The Lugano version has retained its original frame, but is in less good condition than the Berlin picture. Both seem to be from Campin's studio, the Lugano version being perhaps the original painted from life, and the other a replica for some member of the family after the sitter's death (see *The Times*, 22 April, 1961).

Chapter III: Hubert and Jan van Eyck

1 The fact that the name is quoted as 'Robert' could easily occur because a southerner was unfamiliar with northern pronunciation.

2 For the recent technical examination and for a summary of the history of the altarpiece see P. Coremans and others, *L'Agneau Mystique en Laboratoire* (Brussels, 1953), and for a discussion of this report: O. Paecht, *Burl. Mag.*, xcviii (1956), 110.

3 The examination proved that the lower central panel has never been cut at the top. It cannot, therefore, as has been suggested, have been extended upwards to include a small figure of God the Father, and so complete the Trinity without the upper row. A further suggestion that the Dove is a later addition has also been proved false.

NOTES

4 The *Golden Legend* was a manual containing the Lives of Saints and Treatises about Festivals, written by Jacobus de Voragine between 1255–66, and translated into French in the 14th century. Its popularity is proved by the fact that it was one of the first books to be printed by Caxton in England.

5 A painting of the *Fountain of Life* (Madrid), which really shows the *Triumph of the Church*, has the Trinity with the Virgin and the Baptist as in the Ghent altar. It is either a copy of a lost Eyckian original, or a work by a close follower of Jan van Eyck.

6 Jodoc Vyt who appears as the donor was a rich man who had married into a Ghent patrician family, and became both alderman and burgomaster.

7 The only other painting with a slightly Campinesque Virgin universally accepted as by Jan is the undated *Annunciation* (N.G. Washington), which may well date from the early 1430's.

8 A picture of *Women Bathing* is recorded by Facio in 1456 as being in the possession of Cardinal Ottaviano; another of *A Lady at her Toilet* appears in a painting by W. van Haecht of the gallery of Cornelis van der Geest (1628: Van Berg Coll., New York), and a half-length group, said to be dated 1440, of a master settling accounts with his agent, was recorded by the Venetian, Marcantonio Michiel, in Milan in the early 16th century. There is also a possibility that Jan painted a hunting scene.

9 It has been claimed that a reflection of the painter appears on the shield behind St. George (D. G. Carter, 'Reflections on the Armor in the Canon van der Paele Madonna', *Art Bulletin*, xxxvi (1954), 60).

10 It was set up, though unfinished, in 1445, over Maelbeke's tomb in St. Martin's at Ypres, he being Provost. It is constantly referred to in the 16th century as an important work by Van Eyck, though it was known that the wings were not painted by him. Its entire history is known, including the fact that it has been more than once over-painted. The recent cleaning has stripped most of the restorations, and though the possibility that pupils worked on it cannot be excluded, the flat modelling is paralleled in other late works — e.g. the *Portrait of the Artist's Wife* (1439). The standing *Madonna with St. Elizabeth of Hungary, St. Barbara and a donor* (Frick Coll., New York) is probably also an unfinished work, perhaps ordered by Jean de Vos, Prior of the Carthusians at Bruges, soon after his election in 1441. This has many of the same characteristics as the *Maelbeke Madonna*, but must have been finished by another hand, possibly that of Petrus Christus, for the landscape on the right is a weak version of that in Van Eyck's *Madonna of Chancellor Rolin* (see p. 53).

11 Jan also painted small pictures of the *Madonna in her Chamber*. The beautiful example at Frankfurt, known as the *Lucca Madonna*, must be close in date to the *Madonna of Canon van der Paele*. The picture at Melbourne (formerly Ince Hall) is now known to be a non-Flemish copy, probably of an Eyckian original, and though it bears the somewhat dubious date: *1434* the design may well have been earlier, since the Virgin does not sit firmly, but slides forward off her throne, and the play of curves is much stronger than in Jan's known works of the 1430's. It should be noted that in these pictures, in contrast to Campin's *Madonna of the*

NOTES

Firescreen, the Virgin is enthroned under a cloth of honour, no doubt of a kind Jan had seen in use at the Burgundian court.

12 For an attractive but non-proven suggestion that he was one of the musicians, Guillaume Dufay or Gilles Binchois, at the ducal court, see E. Panofsky, *Journal of Warburg & Courtauld Insts.*, xii (1949), 80 ff.

13 For the importance of these as symbols, see E. Panofsky, *Burl. Mag.*, lxiv (1934), 117.

14 The weak hand appears to be a later addition.

15 For conclusive arguments against the identification of the sitter as Cardinal Albergati, see R. Weiss, *Burl. Mag.*, xcvii (1955), 145.

16 Max Dvořák, and following him Tolnay and Baldass, challenged the date of the manuscript, regarding it as a work of the 1430's commissioned by William's daughter, Jacqueline, who married Humphrey, Duke of Gloucester as her third husband. More recently it has been dated *c.* 1445 by F. Lyna, *Miscellanea Panofsky* (1955), 7. Though he throws some doubt on the miniature of *William on the Sea-shore* (a destroyed page now only represented by a particularly poor reproduction), the rest of his argument is not entirely convincing, and can at most suggest that minor portions of the paintings were left unfinished and completed later. It is almost impossible to believe that the *Birth of the Baptist* and the *Mass of the Dead* are later than dated works by Jan van Eyck in the 1430's, and further evidence for an early date has been put forward by O. Kurz, 'A Fishing Party at the Court of William VI, Count of Holland', *Oud Holland*, lxxi (1956), 117, where Durrieu's identification of Count William is upheld by comparison with a drawing of a Fishing-party in the Louvre.

17 I am here especially indebted to Professor Otto Paecht (see *Burl. Mag.*, xcviii (1956), 110).

18 This much discussed manuscript has been variously dated between *c.* 1400 and 1415. The most recent dating on grounds of iconography is during Boucicault's governorship of Genoa (1401–9) (C. Nordenfalk, 'St. Bridget of Sweden', *Essays in Honour of Erwin Panofsky* (ed. M. Meiss, 1961), 392).

19 Other controversial works which cannot be fully discussed include the panels of the *Crucifixion* and the *Last Judgment* (Met. Mus., New York), which have closer links with manuscript painting than any known work by Jan; the *Annunciation* in the same museum, thought by some to be by the same hand as the *Three Maries*, and by others to be a copy by Petrus Christus of an early Eyckian picture, and the *St. Jerome* (Detroit). A picture by Van Eyck of this last subject was in the Medici Collection in Florence in 1492, and was used by Ghirlandajo about 1480 as the basis of his St. Jerome in the church of Ognissanti. The Detroit picture is, however, dated 1442, the year after Jan van Eyck's death. It has given rise to much speculation, some regarding it as an early work by Jan, partly repainted by Christus, others as a copy by Christus of an Eyckian picture. Neither the still-life on the table and shelf nor the drawing of the figure seem to have the precision of Jan's work.

Chapter IV: Roger van der Weyden

1 It is possible that Roger and Campin were related by marriage for Roger's mother, Catherine van Stockem, had the same surname as Campin's wife. Confusion has been caused by the fact that Italian writers, and those Flemish writers after 1550 who drew upon Vasari, refer to Roger as Roger of Bruges. This is an understandable mistake, for Bruges was probably the only Flemish town well known to Italians, since it was the centre of the Italian trading colony, and associated with the only other early 15th-century painter known to them, Jan van Eyck. It is far easier to believe that one man is meant by the references to Rogelet or Rogier de la Pasture and Roger van der Weyden, and Roger of Bruges or of Brussels than to believe anything else, for no other explanation accounts for both his style and his renown.

2 The picture was sent to Spain by Mary of Hungary, Regent of the Netherlands (aunt of Philip II of Spain), and is described as by 'Rugier' in an Inventory of the Spanish Royal Collection of 1574. It had also been engraved by C. Cort in 1563 as by Rogier. Bishop Molanus, writing in 1570, mentions the copy, but adds to the confusion by assuming with local patriotism that the Roger who painted it was a native of Louvain.

3 The wings of this altarpiece, the left showing a kneeling donor and the right the *Visitation*, are in Turin. The right wing is connected with one of the panels in Jacques Daret's St. Vaast altarpiece of 1434 (though his figures are more rigid) and may go back to a lost design by Campin. Roger's version was popular, for it is repeated with slight alterations in a smaller panel at Leipzig.

4 The other version consists of the *Holy Family* and *Lamentation* panels, both cut at the top (Capilla Real, Granada) and an uncut *Christ appearing* (New York). They differ somewhat in colour from the Miraflores version, but recent technical examination has established the high quality of the Granada panels. These were in the collection of Isabella of Castille in 1505, and may conceivably be the earlier of the two versions, though there is no agreement about this, or about the date of the conception of the work. In the Miraflores version the panel of *Christ appearing* is superior to the others, which may be later copies. For the evidence concerning both versions, see R. van Schoute, *Les Primitifs Flamand: La Chapelle Royale de Grenade* (Brussels, 1963), 87 ff. and pls. clv–clxxxix.

5 Much difference of opinion exists as to which is the original. Dürer saw a picture of this subject by Roger in the chapel of the Guild of Painters in Brussels in 1520. The Boston picture belonged to Anthony, the Grand Bastard of Burgundy at some time after 1465, when he became Knight of the Golden Fleece, and found its way to Spain. The Munich picture was bought in Brussels in the early 19th century. Both have passages of high quality, but seen hanging together in an exhibition in Bruges in 1960 (*Le Siècle des Primitifs Flamands*, 13 and 14) the Boston picture, though damaged, seemed superior in drawing. The Leningrad version is also said to be of fine quality. It seems likely that all three were made in Roger's studio, and that he may have executed parts of all of them himself. For

other dependent versions, see J. Destrée, *Roger de la Pasture van der Weyden*, I (Paris, Brussels, 1930), 115–16.

6 Two showed a classical theme, the Justice of Trajan, and the other two a mediaeval story, the Justice of Herkinbald, the second pair being perhaps some fifteen years later than the first. The designs are thought by some to be reproduced in tapestries given to Lausanne by Bishop Georges de Saluces, and now in the Berne Museum, but the change of technique destroys any possibility of close resemblance of the originals.

7 E. Kantorowicz, *Warburg Journal*, iii (1940), 156, proves this, and shows that a number of payments were made through Este agents in Bruges, though some of these could be for the pictures painted in Italy.

8 Kantorowicz has suggested that Sts. Cosmas and Damian are portraits of Burgundian courtiers, but this does not explain the Italianate character of the design.

9 Fra Angelico's *Last Judgment* (S. Marco) has also the semi-circle of saints, but it is very different in feeling, since Christ is shown in splendid robes, and not displaying His wounds, and there is a ring of dancing angels in Paradise.

10 The wings show the announcement of the Birth of Christ to East and West — i.e., on the right the Magi, one head being taken from a figure in Campin's *Dying Thief*, and on the left the Vision of the Emperor Augustus and the Tiburtine Sibyl.

11 For such works see Destrée, *loc. cit.*, under e.g., the Vienna *Crucifixion* and the National Gallery (ex. Earl of Powis Coll.) *Pietà*. The condition of many of the variants makes it hard to decide from photographs how far they were executed under Roger's supervision.

12 The bright blue background of the *Charles the Bold* has been repainted, but presumably it was always blue, like the colour of the eyes, in a picture otherwise black and pale gold.

13 The picture, which is large, is in tempera, partly over-painted in oil in the 17th century, and originally had a crimson cloth behind the Cross. It underwent a drastic restoration in 1946, but the head of St. John is relatively undamaged. Two rather earlier panels of the same subject and in the same technique in the Johnson Collection, Philadelphia, are only slightly less impressive.

Chapter V: Christus and Bouts

1 The theory put forward by E. Panofsky, *Early Netherlandish Painting* (1953), that Christus and not Roger was the major formative influence on younger artists in the middle of the century would be more convincing if direct influence of Christus could be seen in painting in Bruges of the 1460's, and particularly in the works of Hans Memlinc. Moreover, many of his arguments are based on undated pictures by Christus and other artists, which if arranged in a different order, would suggest other conclusions.

2 It was at one time thought that Christus visited Italy about 1456, and that payments in Milan to a 'Piero of Bruges' and an 'Antonio da Sicilia' referred to him and to Antonello da Messina. Most though not all scholars now reject this identification. On the other hand, it can be argued that Christus' interest in the mathematical organization of space must have at some time been re-inforced by contact with Italian artists, and it is an indubitable fact that Antonello had a knowledge, unique in Italy at the time, both of Flemish oil technique and of Flemish interest in detail (cf. Antonello's *St. Jerome in his Study*, National Gallery). He could have acquired this in a visit to Flanders, though none is recorded. His work seems nearer to Christus than to any other Flemish painter, but that may be due to his innate Italian tendency towards simplification, and does not necessarily prove direct contact between the two artists.

3 Christus almost certainly painted the small second version, with the Prior and St. Barbara in front of the Virgin, known as the *Exeter Madonna* (Berlin), perhaps commissioned by the monks in 1450 when the Prior took the original picture with him to Utrecht. The pose of the Exeter Virgin and her relation to the setting appears to be derived from Jan van Eyck's *Madonna with Nicholas Maelbeke*, which was probably one of the unfinished pictures in Jan's studio at the time of his death.

4 Roger's *Medici Madonna*, which at first sight appears to be a *Sacra Conversazione*, is probably earlier, but there is a possibility that his St. Cosmas and St. Damian are in fact donor portraits.

5 A tau cross is one in which the upright does not project above the arms. The framing arch must also be derived from Roger's *Miraflores altar*. It and the parallel back of the stable are also used in a polyptych attributed to Bouts (Madrid), but there is no proof if this or the Christus *Nativity* is the earlier.

6 M. Friedlaender, 'The Death of the Virgin by Petrus Christus', *Burl. Mag.*, lxxxviii (1946), 159, where the picture is dated close to the Frankfurt *Virgin and Child with Saints* of 1457 because of the type of head, the style of the draperies and above all, on the use of cast shadows, which do not appear in the earlier dated works. It is also noted that this appears to be the first Flemish representation of the subject, which was later to become popular.

7 Attempts to work out the stylistic development of Christus have been made by M. Friedlaender, *Die altniederländische Malerei* (I and XIV); E. Panofsky, *Early Netherlandish Painting* (1953), 311 ff., and in a long article by O. Paecht, *Belvedere* (1926), 155.

8 The record of the marriage has not survived, but the eldest son, Dirk, also a painter, was twenty-five in 1473. The Louvain documents sometimes seem to confuse Dirk (or Thierry) Bouts and his two painter sons, Dirk and Albrecht, with another family of painters, Hubrecht Stuerbout and his sons.

9 The programme was chosen by an Augustinian, Brother Jean van Haeght. For a full account of the history of panels and their recent cleaning, with excellent detail photographs, see *Bulletin de l'Institut Royal du Patrimonie Artistique, Brussels*, I (1958).

10 It is not certain that the panel was completed by his sons; Albert was too young,

but it may have been worked on by the younger Dirk, about whom nothing is known. Hugo van der Goes was twice called (in 1480 and 1481) to inspect this panel.

11 Molanus (c. 1575) recorded a second altarpiece by Bouts in this church, and the St. Erasmus is so entirely in his manner that the identification has never been questioned.

12 The Granada version which belonged to Queen Isabella of Castille is slightly cut by the later frame. For a full discussion, with many plates, see R. van Schoute, *Les Primitifs Flamands: La chapelle royale de Grenade* (Brussels, 1963), 35 ff., and pls. XL–CX.

13 All these works have at times been challenged, but the recent examinations of the Granada altarpiece and the *Justice* scenes seem to strengthen the attribution of the Madrid panels as an early work, and the *Pearl of Brabant* altar as more likely to be by Bouts himself than by his sons or his workshop; but scholars differ greatly in their dating, though those that accept the works place them from before 1450 to about 1460.

14 Cf. p. 98 below.

Chapter VI: Hugo van der Goes

1 Justus must have met Piero della Francesca in Urbino, and he possibly painted the hands of Federigo da Urbino in Piero's Brera altarpiece. His influence may perhaps be seen in the latter's *Nativity* (National Gallery), which is painted with oil. For a discussion of his possible connection with the two figures of *Liberal Arts* (National Gallery) and with the Spanish painter, Pedro Berruguete, see M. Davies, *National Gallery Catalogues, Early Netherlandish School* (2nd ed. 1955), 52 f. Such other pictures as have been attributed to him before he left Flanders (e.g., *The Adoration of the Magi*, New York), show so strong an influence of Hugo van der Goes that it is easier to believe that they are by a follower of the latter than by the painter of the Ghent *Crucifixion*.

2 Tomaso Portinari was sent to the Netherlands for the marriage of Charles the Bold in 1468 and led the foreign contingent at the celebrations. He married Maria Baroncelli in 1470, their second son, Pigello, who appears on the left wing, being born in 1474.

3 The column serving as support to the shed on the left had also appeared in Roger's *Bladelin altar*. Its appearance is due to a misunderstanding of St. Bonaventura's *Life of the Virgin*, which was thought to say: 'She leant against the column which she found there.'

4 For an interesting discussion of the iconography, see E. Panofsky, *Early Netherlandish Painting* (Princeton, 1953), 330 f. The pot holding the flowers has a different interest for it is of blue and gold lustre Hispano-Moresque ware, and provides an early date for its export from Spain.

5 These figures, and also other parts of the work, have been much restored.

6 See E. Panofsky, *loc. cit.* Earlier writers attributed the change in colour to the influence of Bouts, but this does not explain the new female types, or the link with the Maître de Moulins.

7 The earliest example of its influence seems to be the relief of the Nativity by Antonio Rossellino (d. 1481) in the Piccolmini Chapel in S. Maria di Monte Oliveto at Naples. Rossellino appears to have left Florence by 1479, and must have seen it by then. The shepherds, more restrained in feeling and gesture, were also borrowed by Domenico Ghirlandajo in his *Adoration* (1485: Uffizi).

8 His greatness was not unrecognized, for Dürer in 1521 was shown works by him which cannot now be identified, as well as paintings by Roger and Van Eyck.

Chapter VII: Hans Memlinc

1 The left wing is one of the few places in Memlinc's work where German influence can be seen, for the design of the Blessed entering Heaven is more closely related to Stefan Lochner's *Last Judgment* (*c.* 1450: Cologne) than to Roger's picture. It was perhaps the fame of this work which caused Heinrich Greverade, a banker in Lübeck, another of the Hanseatic towns, to order from Memlinc in 1491 a triptych of the Crucifixion for the Chapel of the Holy Cross in the cathedral of Lübeck. For a full discussion of the *Last Judgment*, with excellent plates, see J. Bialostocki, *Les Primitifs Flamands; Les Musées de Pologne* (Brussels, 1966), 55 ff.

2 Four donors, all inmates of the Confraternity, are shown on the outside of the wings, one being the Master, Anthonis Seghers, who died in 1475. It is likely to have been ordered before his death.

3 The inconography has been very carefully thought out, for the capitals of the columns in the central panel are related on the left to the life of the Baptist and on the right to that of the Evangelist.

4 It is worth noting that on the backs of the wings Memlinc uses the painted arches introduced by Roger in the *Miraflores altar*, but sets behind them seated figures of the Baptist and St. Veronica in front of fine wooded landscapes.

5 The date and the names of the donors were recorded on the original frame, now lost.

6 A similar, but less successful panel is the *Scenes from the Passion* (Turin), in which the donors have been thought by some to be Tomaso Portinari and his wife.

7 The work was commissioned by two nuns, who appear on one of the end panels kneeling beside the Virgin, while the other end shows St. Ursula sheltering a number of small Virgins under her cloak. The shrine is known to have been in use by 1489.

8 By no means all the pictures of this type are from Memlinc's own hand, though in some cases, such as the *Virgin and Child with an Angel, St. George and a donor* (National Gallery) he may have touched up an assistant's work. The highest in quality is probably the picture in Vienna, but many variants exist.

9 The sitter was at one time wrongly supposed to be the Italian medallist, Niccolò Spinelli, who is known to have been in the service of Charles the Bold in 1468. It is unlikely that the picture, so mature in handling, is as early as this. It has also been identified as Giovanni de Candida, another medallist working in Flanders from 1477–9, which would be a more acceptable date, but since the figure seems to be holding an antique coin, he may well be a collector rather than a medallist.

10 Moreel, who was Burgomaster of Bruges in 1484, ordered in that year a large triptych from Memlinc for the church of St. Jacques (now in Musée Communal, Bruges), showing St. Christopher with St. Maurice and St. Giles in the centre, and the donor and his wife with their large family on the wings. The Brussels portraits are perhaps slightly earlier in date.

Chapter VIII: Ouwater and Geertgen

1 It is likely that Bouts retained links with Holland, for Van Mander records that he had seen an altarpiece in Leyden with an inscription stating that it was painted in 1462 by Dirk Bouts in Louvain. It is, moreover, just possible that Bouts had returned to Haarlem for an interval during his work in the south, which would make the lasting identification of his house, recorded by Van Mander, easier to understand than if he had lived there as a young man only and never returned in his maturity.

2 The Berlin picture was bought from a Genoese family, to whose ancestor it had been given in the late 16th century by Philip II of Spain.

3 E. Panofsky, *Early Netherlandish Painting* (1953), I, 320, denies the influence of Bouts, and holds that Van Ouwater was trained in the studio of Petrus Christus, where he acquired a style which was a blend of that of Van Eyck and Roger. While the bearded figure behind Lazarus, with his short neck and hunched shoulders has some links with the work of Christus and some of the facial types can be paralleled in the San Diego *Death of the Virgin*, the methods of composition, the treatment of light and of most of the heads are closer to the work of Bouts than to any other artist. Scholars have also differed widely in their dating of the *Lazarus*, some putting it at *c.* 1450 and others as late as *c.* 1470. The latter, judging by the proportions of the figures, would seem to be too late, and a date of *c.* 1460 is easier to accept.

4 Julian the Apostate, nephew of Constantine the Great, was Roman Emperor from 360–363. He was strongly anti-Christian and desecrated the tomb of the Baptist at Sebaste in 362.

5 The same kneeling figure appears in an *Adoration of the Magi* (Reinhart Coll., Winterthur), where the whole composition owes much to Hugo.

6 R. Koch in *Art Bulletin*, xxxiii (1951), 259.

7 A number of small pieces in the Rijksmuseum, Amsterdam, all dated between *c.* 1490 and *c.* 1510, have something of the same sincerity of purpose and

simplicity of handling of form. They are no doubt only survivals of a much larger output, for much work in wood must have perished during the Wars of Religion in the 16th and early 17th centuries.

8 Certain works near in style to those of Geertgen, but probably not by him, are discussed by M. Friedlaender, *Die Altniederländische Malerei*, vi (1927), 51 ff. The best-known and most controversial picture is the *Nativity at Night* (National Gallery), whose authorship is doubted by M. Davies, *Nat. Gal. Cat., Early Netherlandish School* (2nd ed., 1955), 43. Recently this and other versions of the subject have again been held to be derived from a lost painting by Hugo van der Goes (F. Winkler, *Hugo van der Goes* (1964), 148).

Chapter IX: Jerome Bosch

1 Recorded by Don Felipe de Guevara, *c.* 1560, a Spanish collector of Bosch's works, in *Comentarios de la Pintura* (ed. A. Ponz, Madrid, 1788), 41–44.

2 Most of these have now been transferred to the Prado.

3 W. Fraenger, *Hieronymus Bosch* (Coburg, 1947; Eng. trans., 1952).

4 Freudian analysis was first applied by C. de Tolnay, *Hieronymus Bosch* (Basle, 1937; Eng. trans. with no new material, 1966), the first modern monograph and still a book of importance. Other recent and useful works are J. Combe, *Jerome Bosch* (Paris, 1946) and L. Baldass, *Hieronymus Bosch* (Eng. ed., 1960) which summarizes much conflicting opinion and has superb plates.

5 In a description of the collection of Cardinal Grimani by Marcantonio Michiel.

6 J. Huizinga, *The Waning of the Middle Ages*, Chap. xiv, though there are many references to the pessimism of the age elsewhere in the book.

7 Jerome and Hieronymus are, of course, the French and Dutch form of the same name. In contemporary documents the painter appears as Jheronimus Anthonissen van Aken, but all the remaining signatures on his paintings are either Jheronimous or Iheronimous Bosch, and all 16th-century documents use these names. It seems therefore clear that during his own lifetime he dropped the family name, and was known by an abbreviated version of the name of his town. Members of the Van Aken family are recorded in the town from 1399–1531.

8 The Master of the Virgo inter Virgines (M. Friedlaender, *Die Altniederländische Malerei*, v (1927), 65–77), so-called after a painting in Amsterdam, was thought to be working in Delft from *c.* 1470–*c.* 1490. His *Annunciation* (Rotterdam) and *Entombment* (Liverpool) (Pl. 62) are pictures which have some relation to those of Bosch, though the handling of drapery is richer and the modelling more sculptural.

9 Attempts have been made to identify the *Last Judgment* of 1504 with a triptych in Vienna, not universally accepted as original, or with a fragment at Munich, which appears to be in the artist's last known manner. If, however, he was working in this style in 1504, it is hard to know what pictures might date from the last ten years of his life. Other versions of the subject exist elsewhere, but

all appear to be by imitators. The Regent Margaret's picture of *St. Anthony* was sent to her husband's burial place at Brou in France, and cannot be traced among the known paintings of this subject.

10 Usually accepted as an original, though L. Baldass, *op. cit.*, 220, suggests it is an early copy, perhaps painted in Bosch's lifetime.

11 In contemporary literature the name Lubbert is used for a dupe, and sometimes for a betrayed husband.

12 For other early works, see the books quoted in Note 4.

13 L. Baldass, *op. cit.*, 223, who also quotes other 15th- and 16th-century references to hay as a symbol of perishability and covetousness.

14 C. de Tolnay, *op. cit.*, 37 f.

15 Many copies of the whole or of parts are known, at least four of them being signed. The signed copy at Brussels and an unsigned one in Madrid are of good quality.

16 C. de Tolnay, *op. cit.*, 28 f., connects the groups in the central panel with the theme for the Witches Sabbath, set out in the *Malleus Maleficarum* of 1487.

17 Many copies of it exist, one in England at Petworth House, Sussex.

18 The shields of arms show that the donors belonged to the Bronckhorst and Bosshuye families, but no references to the commission is known.

19 The *Rolin Madonna* was at the time almost certainly in Autun. It is not possible to prove if Bosch had seen it or not, or whether he knew a copy.

20 The semi-clothed man has been thought to represent heresy, or more specifically, Anti-Christ. For a summary of these arguments, see L. Baldass, *op. cit.*, 223 f.

21 For a summary of the main opinions, see *Hieronymus Bosch: The Garden of Delights* (ed. W. Hirsch, Amsterdam, 1954, Eng. trans., 1955); also E. H. Gombrich, *Journ. of Warburg and Courtauld Insts.*, xxx (1967), 403.

22 Such fruits had, since Antiquity, been regarded as symbols of sexual delight (C. de Tolnay, *op. cit.*, 32).

23 The back of the wings shows one of Bosch's most remarkable inventions, the globe of the world during the Days of Creation, when man had not yet appeared on the earth.

Chapter X: Gerard David

1 A Book of Hours in the Escorial, one miniature of which is dated 1486, was attributed by Hulin de Loo to David. The relation between these miniatures and David's paintings is discussed by W. Schoene, *Prussian Jahrbuch*, lviii (1937), 107 ff. For attributions of miniatures now in England, see R.A. Exhib., *Flemish Art* (1953/4), Nos. 606, 607.

2 It has recently been suggested (*Les Primitifs Flamands*, I (1957), 33–48) that since the Chapel of the Confraternity to which it was eventually given was begun in 1503, the work was ordered about that time. This does not seem conclusive, since the gift did not take place till 1520.

NOTES

3 A Genoese nobleman, Andrea della Costa, who lived for many years in Bruges, commissioned from an unknown Bruges artist a triptych in 1499 of the *Martyrdom of St. Andrew*, still in the parish church of San Lorenzo della Costa, Liguria (A. Morassi, *Trittico Fiammingo a San Lorenzo della Costa* (Florence, 1947)). In 1506 David painted a large polyptych, the centre being the Virgin and Child, for the Abbey of Cervara near Genoa. This is now dismembered, though the main panels are in the Palazzo Bianco, Genoa (G. V. Castelnuovi, 'Il polittico di Gerard David nell'Abbazia della Cervara', *Commentari*, iii (1952), 22 ff.).

4 The donor is probably Richard de Visch de la Chapelle, who obtained leave to restore the chapel of St. Anthony in the church of St. Donatian, Bruges, from which the picture is said to have come, in 1500 and died in 1511.

5 A Genoese journey was first suggested by G. E. Hoogewerff, *Vlaamsche Kunst en Italiannsche Renaissance* (Malines and Amsterdam, 1934), 91, though he supposed that the Cervara triptych mentioned in Note 3 above, the date of which was then unknown, was painted at the same time. The style of this work of 1506 seems far more traditionally Flemish than that of the Crucifixion, and though G. V. Castelnuovo (see Note 3) suggests that it formed part of the same polyptych, being set above the Virgin and Child, this is not easy to accept, either on stylistic or on practical grounds.

6 For the controversy over this painter, see *Nat. Gal. Cat., Early Netherlandish School* (2nd ed., 1955), under Ysenbrandt.

Chapter XI: The Early 16th-Century Background

1 Juana's younger sister, Katherine of Aragon, was to become the first wife of King Henry VIII.

2 M. Conway, *Literary Remains of Albrecht Dürer* (1889), 98 ff.

3 The most famous of Antwerp presses (now the Musée Plantin-Moretus) was not established by Christophe Plantin till 1549.

4 For Erasmus' life and the range of his interests, see J. Huizinga, *Erasmus of Rotterdam* (Eng. trans., Phaidon Press, 1952). G. Marlier, *Erasme et la Peinture Flamande de son temps* (Brussels, 1954) contains useful material, but is at some points controversial.

5 The Regent owned Jan van Eyck's *Marriage of Giovanni Arnolfini*, which was so much prized that it was sent by her successor to the Spanish Royal Collection.

6 Vitruvius, who lived in the time of the Emperor Augustus, was not of great importance as an architect, but his treatise is among the most influential books in the whole of art history. It was never entirely forgotten, for instance a manuscript copy was in the library of the Abbey of Cluny in the late 12th century, but its great fame dates from the early 15th century, when a manuscript was re-discovered at the time of the Council of Constance (1414–18), and caused great excitement among the scholars attending, especially those from Italy. The treatise, which stresses the importance of ideal human proportions in rela-

tion to art and architecture, was the basis of other famous Italian treatises, and after the discovery of printing was to be issued in many editions.

7 M. Conway, *op. cit.*, 121.

8 For the history of the Cartoons, see J. Pope-Hennessy, *The Raphael Cartoons*, Victoria & Albert Museum Picture Book, No. 5 (1950). All the cartoons may soon have been sent back to Italy (one was certainly there by 1521), but if so copies must have been kept and used for later weavings, which are known to have continued in Brussels till 1620. The cartoons themselves were bought in Genoa in 1623 for use at the Mortlake Tapestry factory by Charles, Prince of Wales, later Charles I.

9 Henry VIII's set is now in Berlin.

10 Vincidor had entered Raphael's studio by 1517. He returned to Rome in 1521, but was back in the Netherlands in 1527, is known to have been in Antwerp in 1542, and was dead by 1556 (information kindly supplied by Dr. John Shearman).

11 When Dürer met Vincidor in Brussels in 1520 he gave him a whole set of his own prints to send to Rome in exchange for prints after Raphael by Marcantonio Raimondi. On a later occasion Vincidor gave Dürer 'an Italian work of art' (M. Conway, *op. cit.*, 105, 125).

Chapter XII: Quentin Matsys

1 Van Mander records the tradition that his father was a smith and that Quentin started life in this profession, but abandoned it either owing to ill-health, or because the girl he wished to marry objected to so dirty a trade. This cannot be proved or disproved.

2 M. Conway, *Literary Remains of Albrecht Dürer* (1889), 97; A. B. Chamberlain, *Hans Holbein* (1913), Vol. I, 255.

3 The larger Brussels picture has the arms of Louvain in the stained glass on the right behind the throne, but this does not prove that it was painted there. A further picture of this group is the standing *Virgin and Child* in Count Seilern's Coll., but there though the types are similar the tone is lighter, for the Virgin is in white and gold.

4 Although the name of St. Anne, the mother of the Virgin, does not appear in the New Testament, the legend of her life is found as early as the 2nd century. The cult, part of the special reverence for the Virgin, gained increased popularity in the late Middle Ages. Luther, who like other reformers was violently opposed to it, stated in a sermon that it was little known till he was fifteen (i.e. in 1498), but this does not necessarily apply outside Germany.

5 The wings show the Martyrdoms of St. John the Baptist and Evangelist, the former being especially fine in its colour scheme of pinks, reds and greys.

6 The channel through which knowledge reached Matsys can hardly have been the Lombard painter, Ambrosius Benson, who did not settle in Bruges till 1518.

NOTES

It should perhaps be noted that Leonardo's work was well known and admired in France, and Leonardesque works probably existed there before the *Virgin and Child with St. Anne* (Louvre) entered the collection of Francis I in 1516. There is, however, no more proof that Matsys made a journey to France than to Italy.

7 The painting, unusually, is on paper, which has been put forward as an argument that it was painted outside the Netherlands, perhaps during a journey.

8 Another portrait based on a Leonardo caricature is *The Grotesque Old Woman* (National Gallery), sometimes called *The Ugly Duchess*, which is attributed to Matsys, but is possibly a copy of a work by him.

9 The cartoon of the Leonardo was made about 1501, but the picture was not painted till 1508–12 in Milan. A number of early copies exist.

10 The landscape may have been painted by Joachim Patinir, see p. 133.

11 *Mona Lisa* was painted in Florence by 1505, probably taken by Leonardo to Milan in 1506, and was in France by 1517.

12 As already noted (p. 147, n.8) Marcantonio Michiel saw in Milan 'a picture with half-length figures representing a patron making up his accounts with an agent' by Jan van Eyck.

13 The presence of a cut lemon among the still-life may indicate that the picture represents the time of the weaning of the Child, which would account for the fact that He no longer appears as an infant.

14 Other pictures with slender gesticulating figures include a *Crucifixion* known in various versions, one being in the National Gallery, and the damaged *Marriage of St. Catherine* (National Gallery), which is interesting both because it is painted in tempera on linen, and also for its fine design of three half-length figures. This, as has been noted by Professor E. K. Waterhouse, is closer in idea to pictures by Giovanni Bellini than to any Flemish paintings.

15 The Longford Castle picture has been enlarged at the top and bottom and on the left. Several early copies of the *Erasmus* are known, but there seems little doubt that the picture in Rome is the original, though it has been transferred from panel to canvas. A further proof of More's friendship with Gilles lies in the fact that in his *Utopia* the scene of the dialogue is set in Gilles' garden.

16 These details are recorded in a Latin poem sent by More to Gilles in October 1517, with a letter expressing his pleasure at receiving the pictures.

17 It is sometimes argued that the type is a development of the well-known theme of *St. Jerome in his study*. In view of the previous history of Flemish portraiture this need not necessarily be the case, though since Erasmus had just published his edition of the works of St. Jerome, it is possible that Matsys used the pattern as a deliberate compliment.

18 For the arguments identifying Joos van Cleve with the artist formerly known as 'The Master of the Death of the Virgin', see *National Gallery Cat., Early Netherlandish Schools* (2nd edit., 1955), under Joos.

19 M. Conway, *op. cit.*, 119. By about the middle of the century Patinir's work was to be sufficiently admired in Spain for Don Felipe de Guevara in *Commentarios de la Pintura* to name him with Van Eyck and Roger as the greatest painters of the Netherlands.

20　*The Rest on the Flight* (Prado), which again shows links with David, also displays an interest in rural life. On the other hand, Patinir seems to have been attracted to the *Legend of St. Jerome*, no doubt because it offered a chance of painting wild, rocky landscape. Another of his signed pictures (Karlsruhe) is of this subject, and there are others, including one in the National Gallery, which are ascribed to him.

Chapter XIII: Mabuse and Van Orley

1　.The word 'poesie' was used in the 16th century to denote a subject drawn from classical mythology or literature. For instance, Titian employed it in a letter to Philip II about the series of paintings which include *Perseus and Andromeda* (Wallace) and *Diana and Actaeon* and *Diana and Callisto* (Earl of Ellesmere Coll., on loan to Nat. Gal. of Scotland).

2　The date 1507 was at one time held to be on the fringe of the cloth held by the black king, Balthazar, but the strokes are now regarded as part of the ornament.

3　Dürer's engraving of the *Nativity* (1504) shows such features. The dog seated on the right is taken from Dürer's *St. Eustace* of *c.* 1501, and the other dog is probably based on an engraving by Martin Schongauer of 1491.

4　There is also a drawing of the Colosseum (Berlin).

5　This extremely ornate form of late Gothic is common enough in Northern Europe in the first thirty years of the 16th century, but never appeared in Italy. Characteristic examples of it can be seen in the tombs which the Regent Margaret erected at Brou, mainly in the 1520's, and in the screen at Lierre, Belgium, finished in 1535.

6　The *Malvagna Triptych* may have been painted for the Chancellor, Jean de Carondelet, who was Bishop of Palermo. This group of works has been reasonably dated *c.* 1510–15, and probably includes a small diptych (Doria Coll., Rome), the left wing of which is a copy of Van Eyck's *Madonna in a Cathedral*, and the right shows a donor, Antonio Siciliano, in a landscape. Since he was an envoy at the Regent's court in 1513, the picture was probably painted at that time (G. Gluck, 'Mabuse and the Development of the Flemish Renaissance', *Art Quarterly*, viii (1945), 116 ff.).

7　G. von der Osten, 'Studien zu Jan Gossaert', in *Essays in Honour of Erwin Panofsky* (New York, 1961), I, 454; II, pls. 154–160. Meit remained in the Regent's service and worked on the tombs at Brou from 1526–32.

8　For a discussion of the treatment of the nude in the North, see K. Clark, *The Nude* (1956 and later edits.), Chap. VIII.

9　He also made a few engravings, both on wood and metal, in which his use of cross-hatching to give volume may have been imitated from the prints of Marcantonio Raimondi after Raphael, which were known and prized in the North (see above, p. 158, n.11).

10　Christian II of Denmark, who married Charles V's sister Isabella, was deposed

in 1523 and with his family spent his exile in the Netherlands. The princess on the right became better known as Christina, Duchess of Milan, whose portrait by Holbein (Nat. Gal.) was painted for Henry VIII in 1538, when he was considering her as a possible bride.

11 M. Conway, *Literary Remains of Albrecht Dürer* (1889), 102.

BIBLIOGRAPHY

A large number of books on Flemish painting exists, but many are now out of date and others are not available in English. The following list is not intended to be complete and includes only books which are of real importance, or which have exceptionally good plates. Books in Dutch and Flemish have been excluded. Many controversial points have been discussed in articles. These are not listed here, but references to a number of them have been given in the Notes to the text.

The place of publication, unless otherwise stated, is London.

General books

The following standard works are detailed and often difficult, but they are the basis of any advanced study of the subject:

Friedlaender, M. J. *Die altniederländische Malerei*, 14 vols. (Berlin, 1923–37). An English trans. is in progress; Vol. I (Leyden and Brussels, 1967) is now published.

Panofsky, E. *Early Netherlandish Painting*, 2 vols. (Harvard, 1953).

Corpus des Primitifs Flamands: Series I. Corpus de la peinture des anciens Pays-Bas méridionnaux au 15e siècle, 10 vols. so far issued (Antwerp and Brussels, 1951–1966 in progress).

Valuable information can also be obtained from:

M. Davies: *National Gallery Catalogues: Early Netherlandish Schools* (2nd edit., 1955); Plates (1947).

Friedlaender, M. J. *From Van Eyck to Brueghel* (Eng. trans., 1956).

Books arranged according to chapters

If a chapter or artist is omitted it implies that no up-to-date work exists.

CHAPTER I

Cartellieri, O. *The Court of Burgundy* (1929).

Huizinga, J. *The Waning of the Middle Ages* (1924 and later edits., including Penguin Books).

CHAPTER II

Tolnay, C. de *Le Maitre de Flémalle et les Frères van Eyck* (Brussels, 1949).

CHAPTER III

Baldass, H. *Jan van Eyck* (1952). Good catalogue and plates.

Coremans, P. etc. *L'Agneau Mystique au Laboratoire* (Antwerp, 1953).

[162]

BIBLIOGRAPHY

CHAPTER IV

Destrée, J. *Rogier van der Weyden*, 2 vols. (Brussels, 1930). Out of date, but useful plates.

Beenken, H. *Rogier van der Weyden* (Munich, 1951). Excellent plates.

CHAPTER V

Schoene, W. *Dirk Bouts* (Berlin and Leipzig, 1938).

CHAPTER VI

Winkler, F. *Hugo van der Goes* (Berlin, 1964).

CHAPTER VII

Baldass, L. von *Hans Memlinc* (Vienna, 1942). Good plates.

CHAPTER IX

Tolnay, C. de *Hieronymus Bosch* (Basle, 1937; Eng. trans., 1966).

Combe, J. *Jerome Bosch* (Paris, 1946).

Baldass, L. *Hieronymus Bosch* (Eng. trans., 1960). Sensible text and superb plates.

INDEX OF NAMES

Figures in italic refer to plates

INDEX

INDEX

INDEX

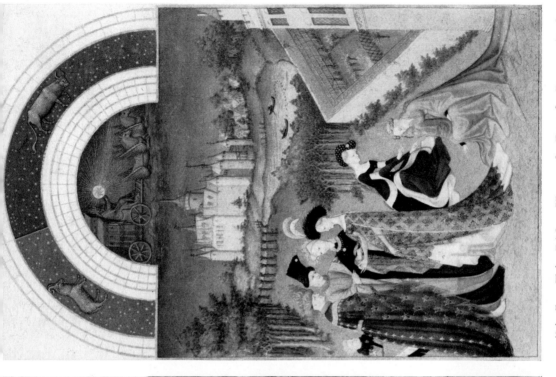

1(a) *Les Très Riches Heures du Duc de Berry: January* (Before 1416). Chantilly, Musée Condé.

1(b) *Les Très Riches Heures du Duc de Berry: April* (Before 1416). Chantilly, Musée Condé.

2(b). Melchior Broederlam: *The Presentation and the Flight into Egypt* (1399–99). Dijon, Musée

2(a) Melchior Broederlam: *The Annunciation and the Visitation* (1392–99). Dijon, Musée

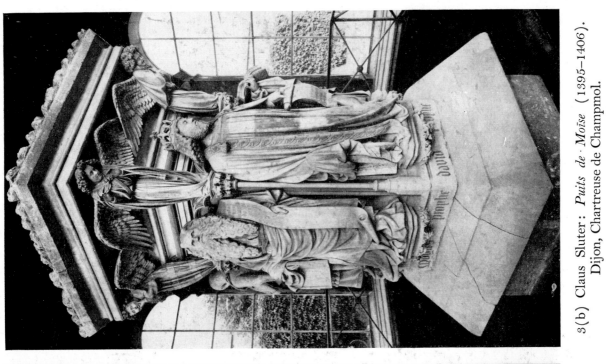

3(b) Claus Sluter: *Puits de · Moïse* (1395–1406). Dijon, Chartreuse de Champmol.

3(a) Claus Sluter: *Portal of the Chartreuse de Champmol*. Dijon, Musée.

4(a) Jacques de Baerze: *Carved altarpiece from the Chartreuse de Champmol* (1392–99). Dijon, Musée.

4(b) Robert Campin (?): *Marriage of the Virgin*. Madrid, Prado.

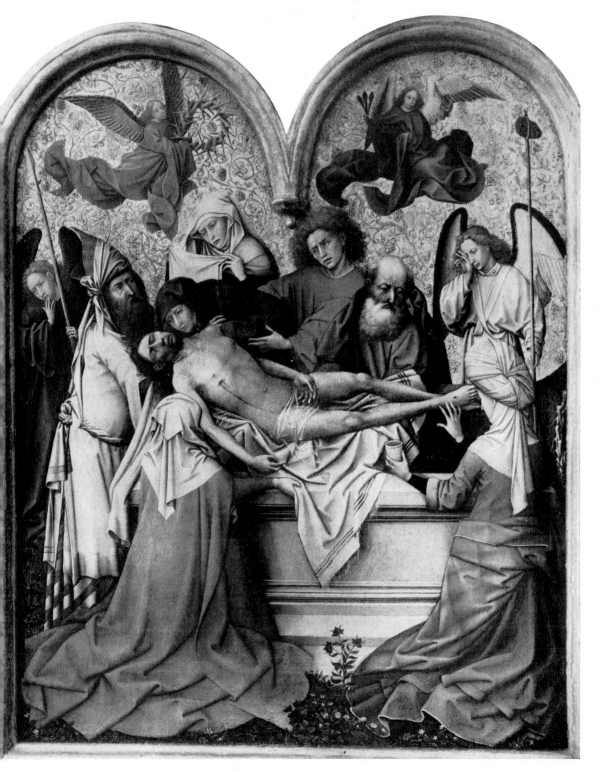

5 Robert Campin (?) : *The Entombment*. London, Count Seilern Coll.

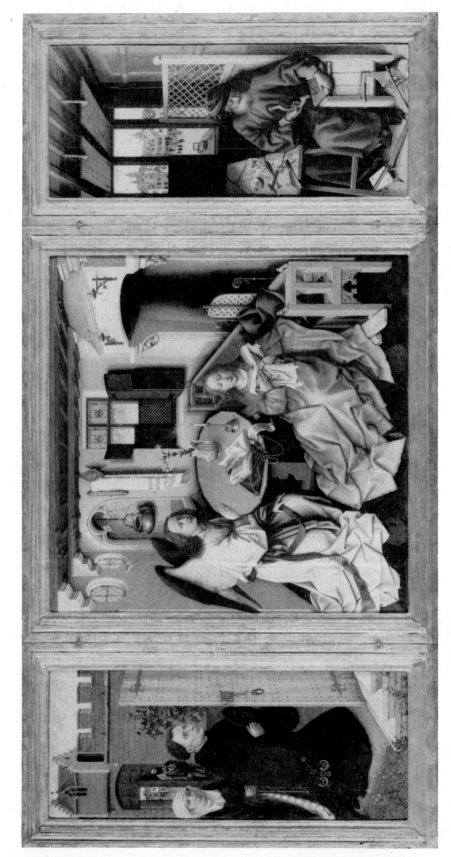

6 Robert Campin (?) : *The Annunciation.* New York, Metropolitan Museum of Art, The Cloisters Coll. (Purchase).

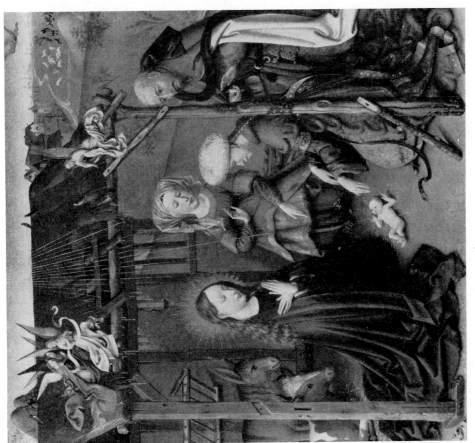

7(b) Jacques Daret: *The Nativity* (1434). Lugano, Baron Thyssen-Bornemiza Coll.

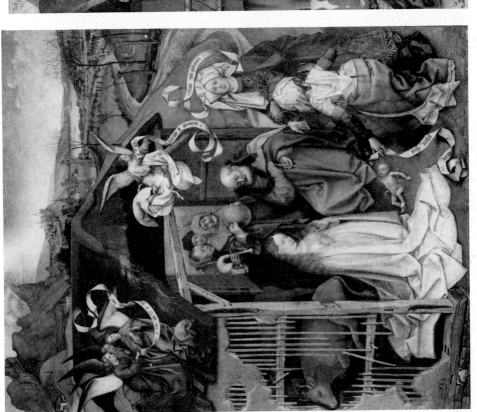

7(a) Robert Campin (?) : *The Nativity*. Dijon, Musée.

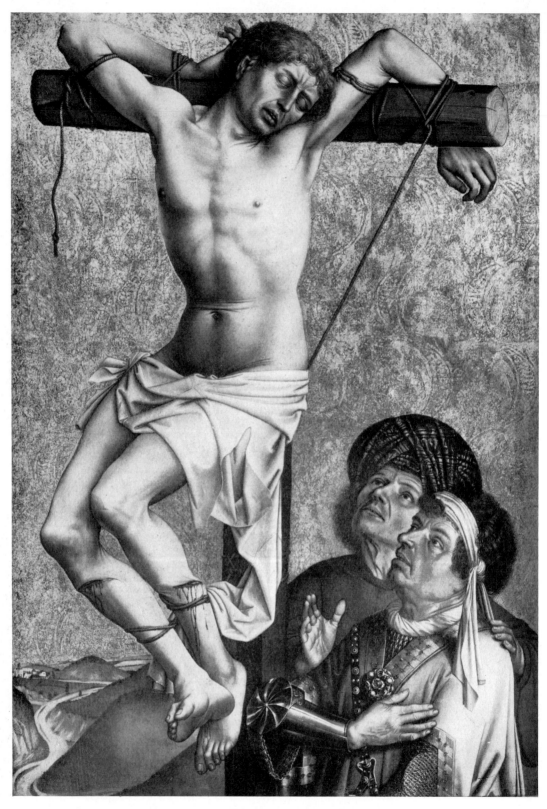

8 Robert Campin (?) : *The Dying Thief*. Frankfurt, Staedel Institut.

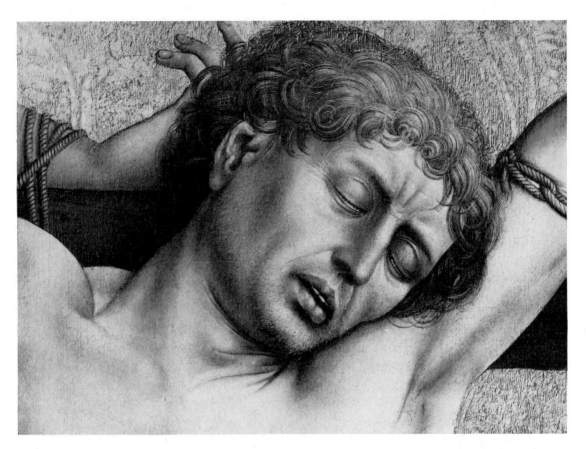

9(a) Robert Campin (?) : *The Dying Thief* (*detail*). Frankfurt, Staedel Institut.

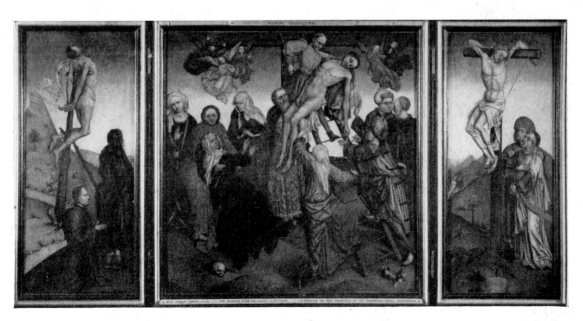

9(b) After Robert Campin (?) : *The Descent from the Cross*. Liverpool, Walker Art Gallery.

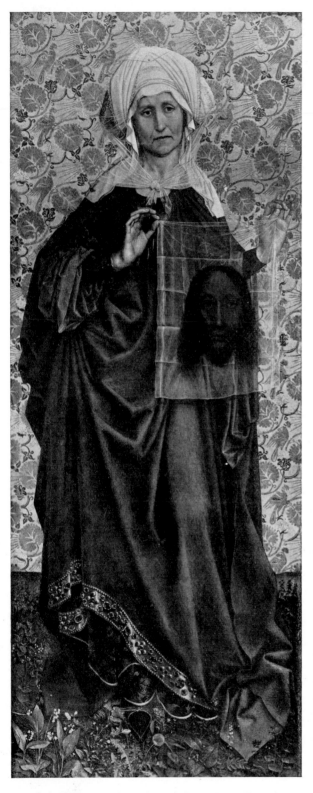

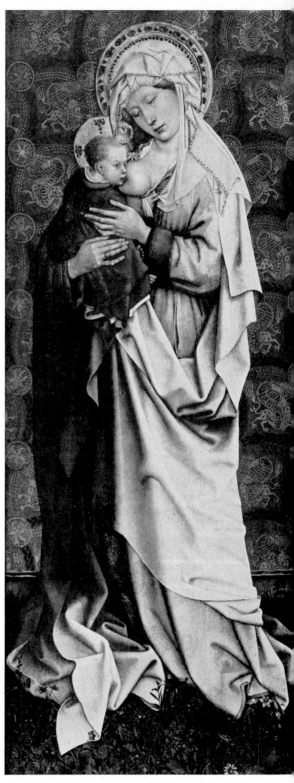

10(a) Robert Campin (?): *St. Veronica.*
Frankfurt, Staedel Institut.

10(b) Robert Campin (?): *Virgin and Child.*
Frankfurt, Staedel Institut.

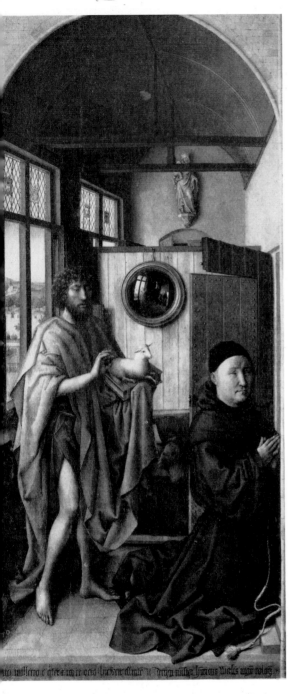

11(a) Robert Campin (?): *Heinrich Werl and St. John the Baptist* (1438). Madrid, Prado.

11(b) Robert Campin (?): *St. Barbara* (1438). Madrid, Prado.

12 Hubert and Jan van Eyck: *The Adoration of the Lamb altar (wings open)*. (Finished 1432). Ghent, Cathedral.

13 Hubert and Jan van Eyck: *The Adoration of the Lamb altar, Adoration panel.* (Finished 1432). Ghent, Cathedral.

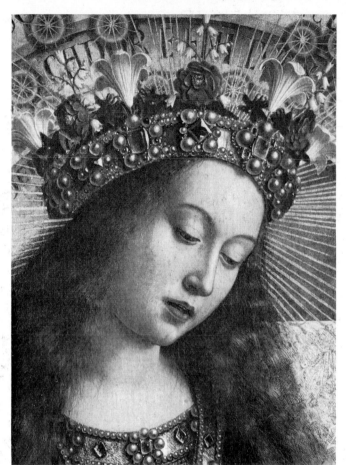

14(a) Hubert and Jan van Eyck: *The Adoration of the Lamb altar* (*detail, head of the Virgin*). (Finished 1432.) Ghent, Cathedral.

14(b) Hubert and Jan van Eyck: *The Adoration of the Lamb altar* (*detail, group of Virgins from Adoration panel*). (Finished 1432.) Ghent, Cathedral.

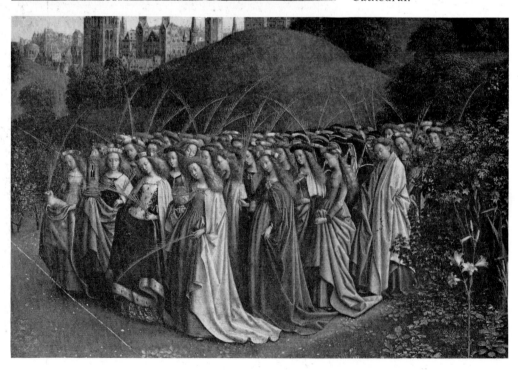

15 Hubert and Jan van Eyck: *The Adoration of the Lamb altar* (*wings closed*). (Finished 1432). Ghent, Cathedral.

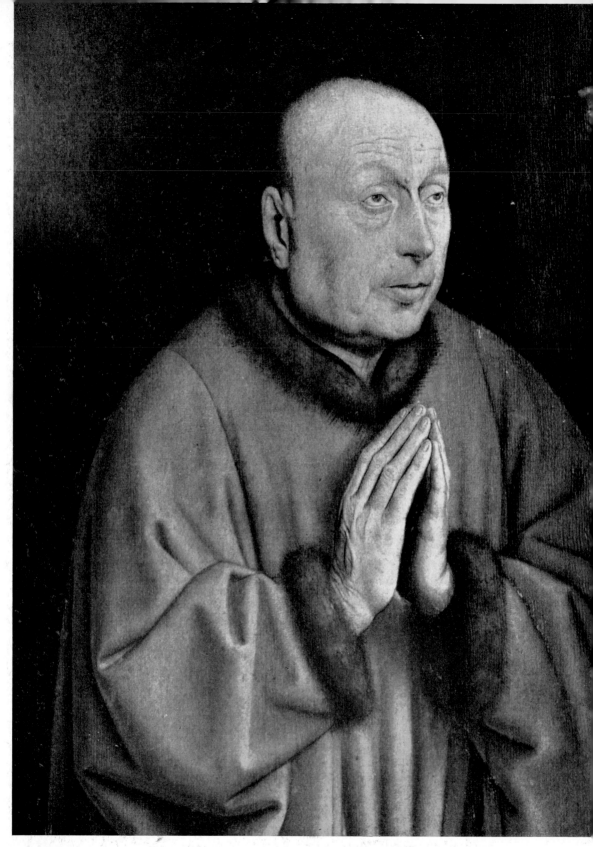

16 Hubert and Jan van Eyck: *The Adoration of the Lamb altar* (*detail, Jodoc Vyt*). (Finished 1432).
Ghent, Cathedral.

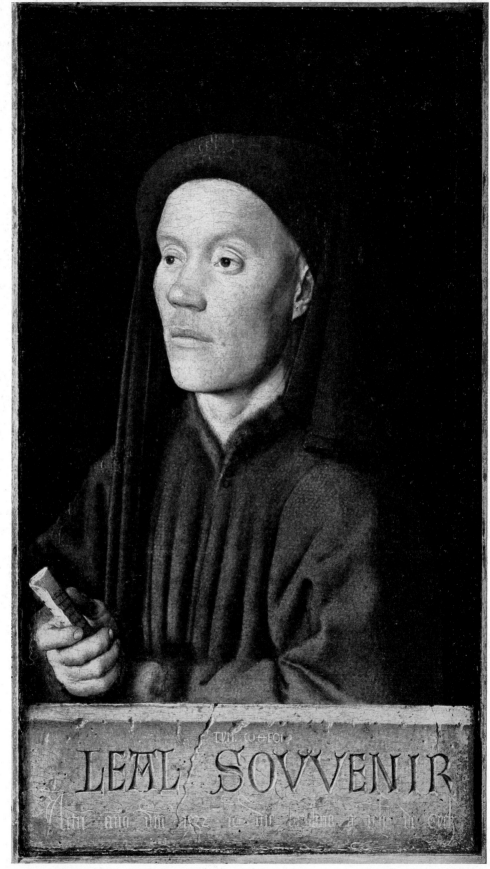

17
Jan van Eyck:
*Portrait of
ng Man* (1432).
London,
National Gallery.

18 (a) Jan van Eyck:
*The Madonna of
Canon van der Paele*
(1436). Bruges,
Musée Communale
des Beaux-Arts.

18 (b)
Hubert and
Jan van Eyck (?):
*The Three Maries
at the Sepulchre*.
Rotterdam,
Boymans–Van
Beuningen Museum.

19
Jan van Eyck:
Barbara (1437).
Antwerp,
Musée Royal
des Beaux-Arts.

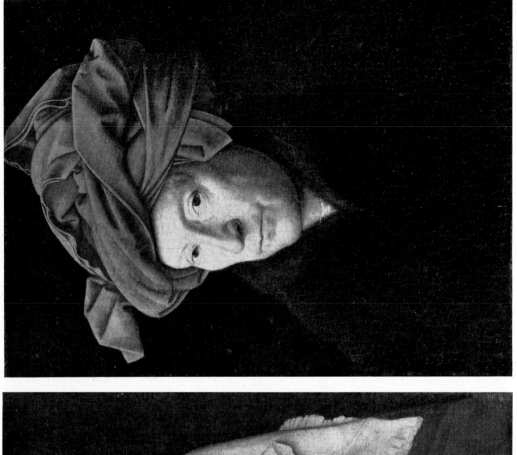

20(b) Jan van Eyck: *A Man in a Turban* (1433).
London, National Gallery.

20(a) Jan van Eyck: *Margaret van Eyck* (1439). Bruges, Musée
Communal des Beaux-Arts.

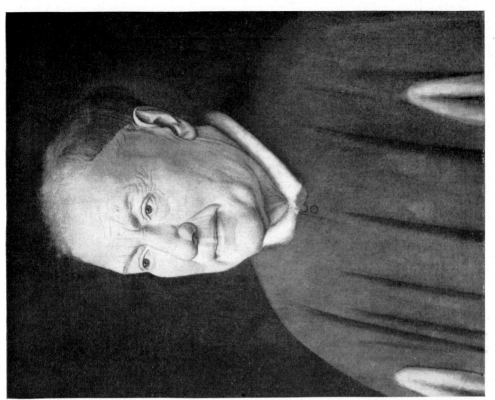
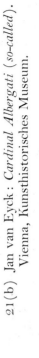

21(b) Jan van Eyck: *Cardinal Albergati* (*so-called*). Vienna, Kunsthistorisches Museum.

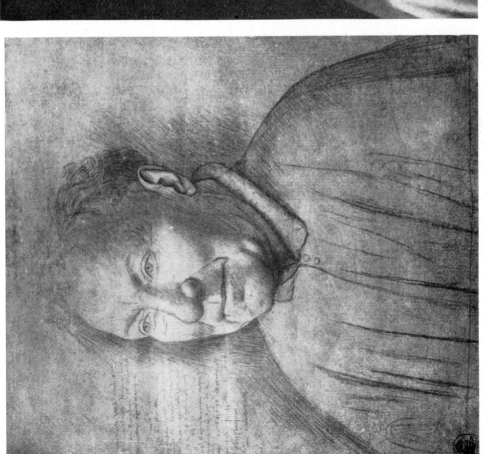

21(a) Jan van Eyck: *Cardinal Albergati* (*so-called*). Drawing. Dresden, Staatliches Kunstsammlungen.

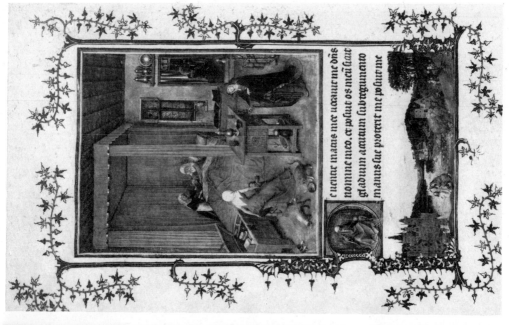

22(b) Hubert van Eyck (?) : *The Hours of Turin.
Birth of the Baptist.* Turin, Museo Civico.

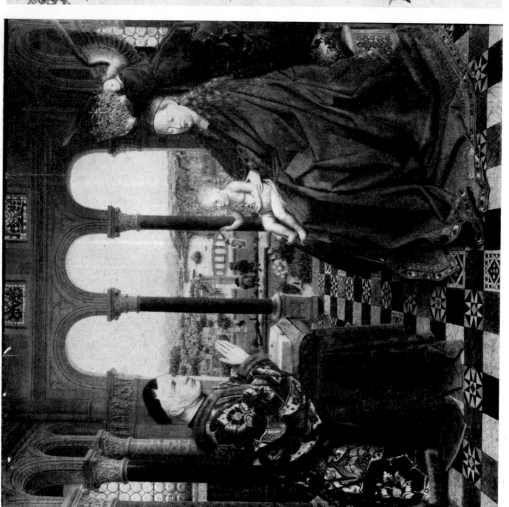

22(a) Jan van Eyck: *The Madonna of Chancellor Rolin.* Paris, Louvre.

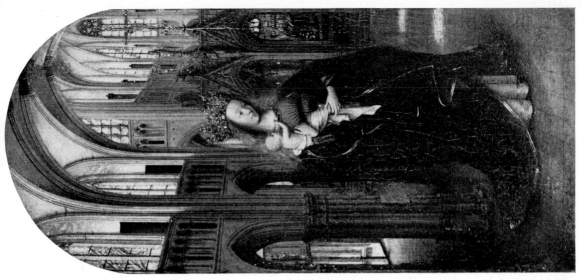

23 (a)
Jan van Eyck:
*The Madonna
of the Fountain*
(1439). Antwerp,
Musée Royal
des Beaux-Arts.

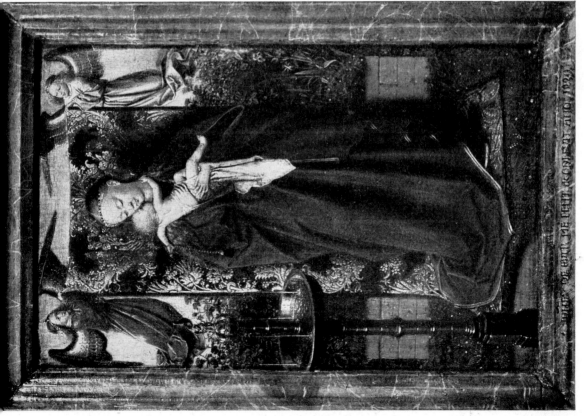

23 (b)
Jan van Eyck:
*The Madonna
in a Cathedral.*
Berlin-Dahlem,
Staatliche Museen.

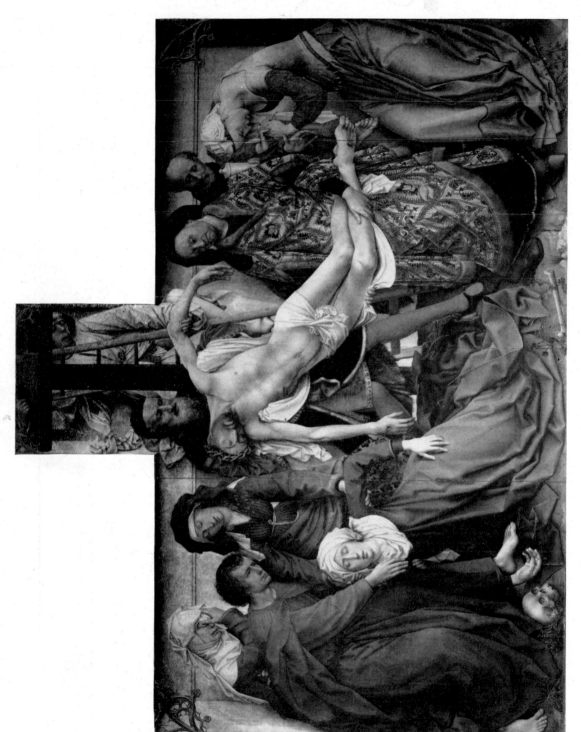

24 Roger van der Weyden : *The Descent from the Cross*. Madrid, Prado.

25(b) Roger van der Weyden: *Christ appearing to His Mother*. New York, Metropolitan Museum.

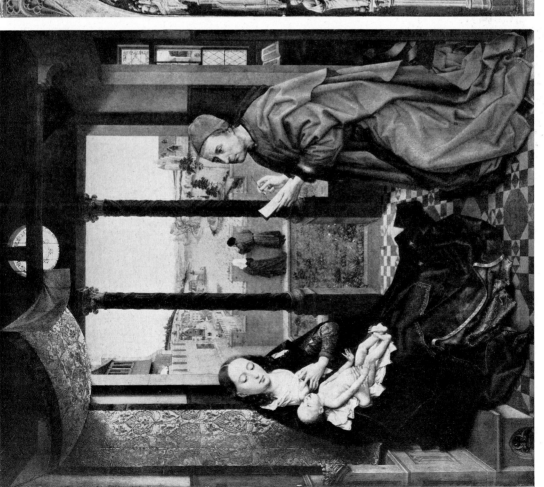

25(a) Roger van der Weyden: *St. Luke painting the Virgin*. Boston, Museum of Fine Arts.

26(a) and (b) Roger van der Weyden: *The Descent from the Cross (details)*.
Madrid, Prado.

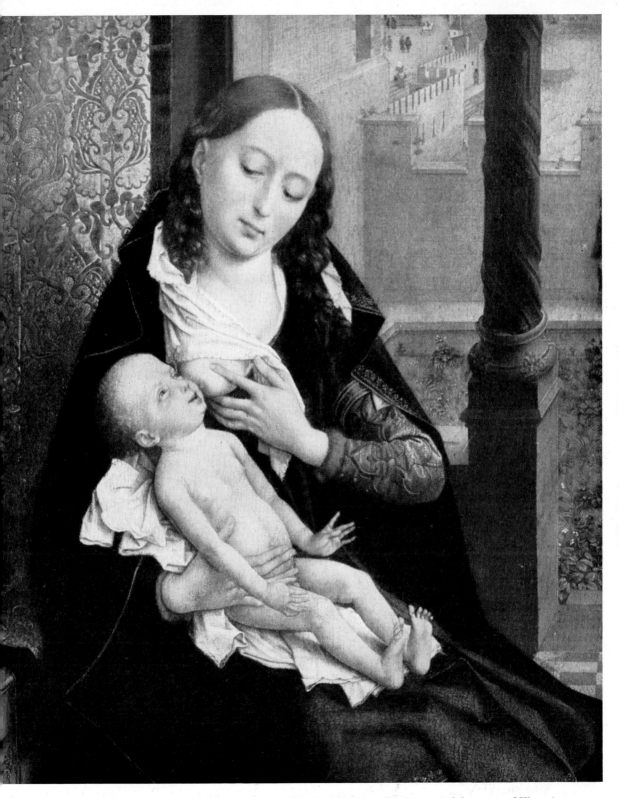

27 Roger van der Weyden: *St. Luke painting the Virgin* (*detail*). Boston, Museum of Fine Arts.

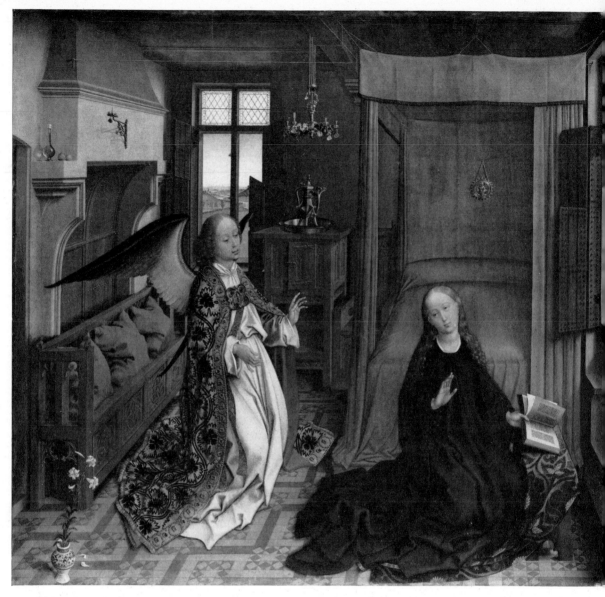

28 Roger van der Weyden: *The Annunciation*. Paris, Louvre.

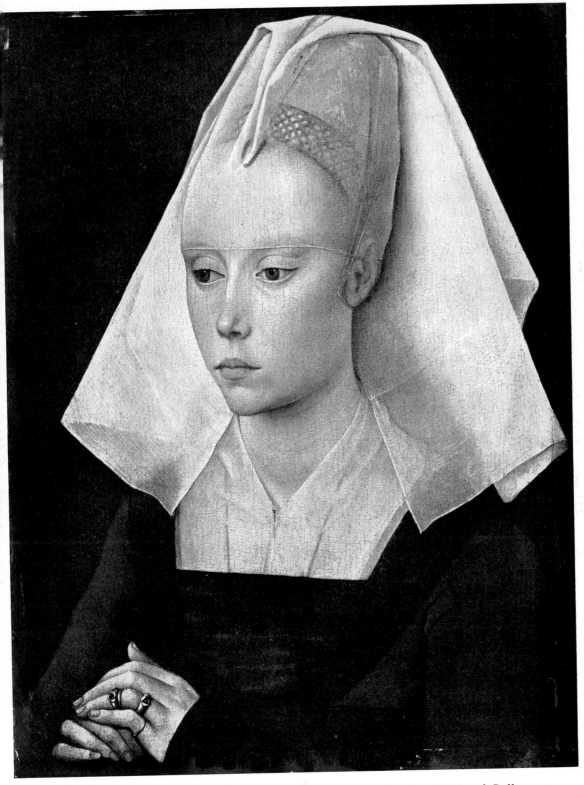

29 Roger van der Weyden: *Portrait of a Young Woman*. London, National Gallery.

30 Roger van der Weyden : *The Crucifixion*. Vienna, Kunsthistorisches Museum.

31 Roger van der Weyden : *The Last Judgment*. Beaune, Hôtel Dieu.

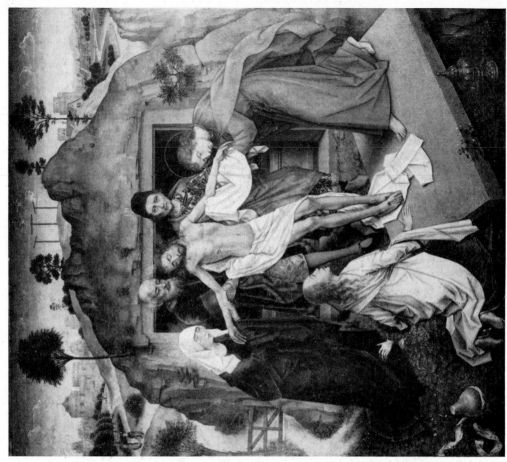

32(b) Roger van der Weyden : *The Entombment*. Florence, Uffizi.

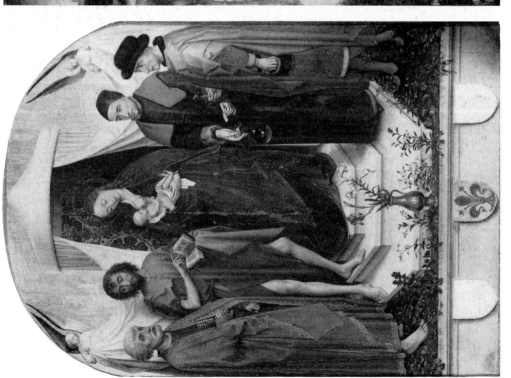

32(a) Roger van der Weyden : *The Madonna and Child with four Saints*. Frankfurt, Staedel Institut.

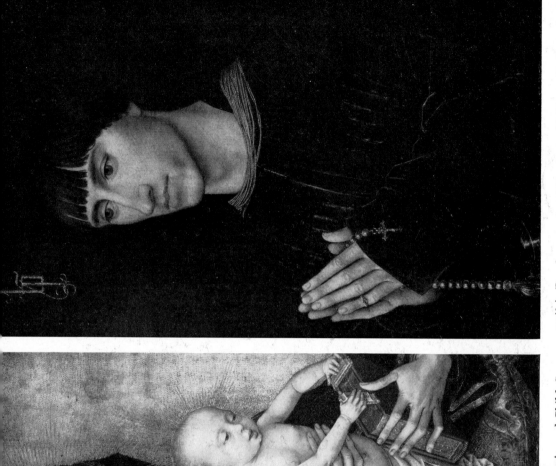

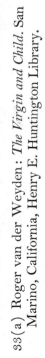

33(a) Roger van der Weyden: *The Virgin and Child.* San Marino, California, Henry E. Huntington Library.

33(b) Roger van der Weyden: *Philippe de Croy.* Antwerp, Musée Royal des Beaux-Arts.

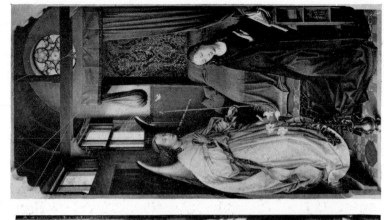

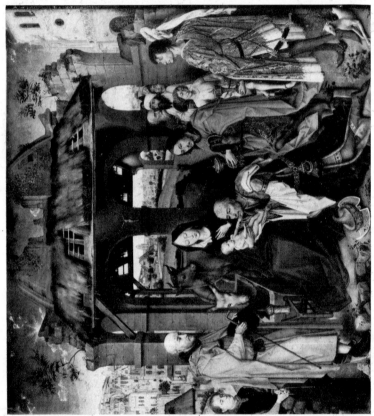

34 Roger van der Weyden: *The Adoration of the Magi* (*The St. Columba altar*). Munich, Staatsgemäldesammlungen.

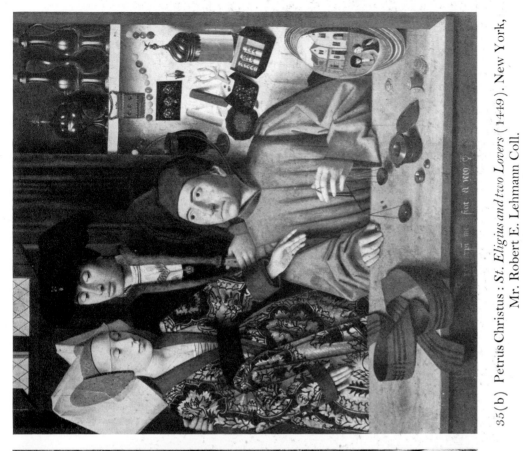

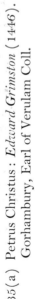

35(b) Petrus Christus: *St. Eligius and two Lovers* (1449). New York,
Mr. Robert E. Lehmann Coll.

35(a) Petrus Christus: *Edward Grimston* (1446).
Gorhambury, Earl of Verulam Coll.

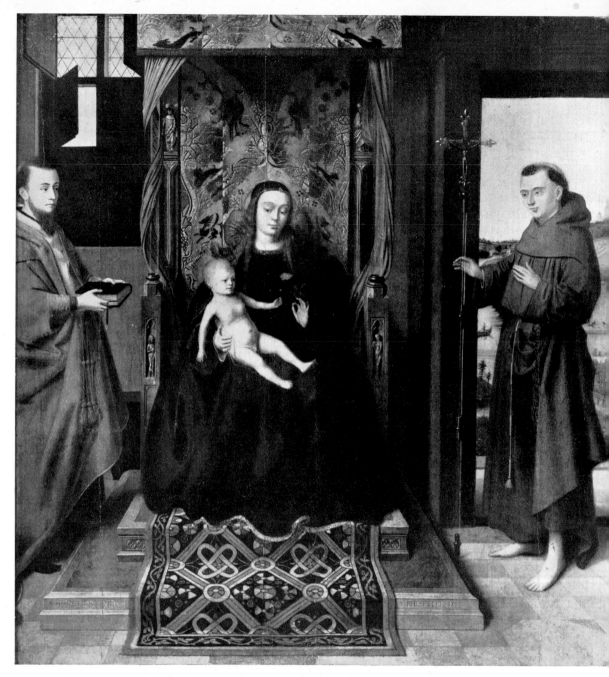

36 Petrus Christus: *The Virgin and Child with St. Francis and St. Jerome* (1457). Frankfurt, Staedel Institut.

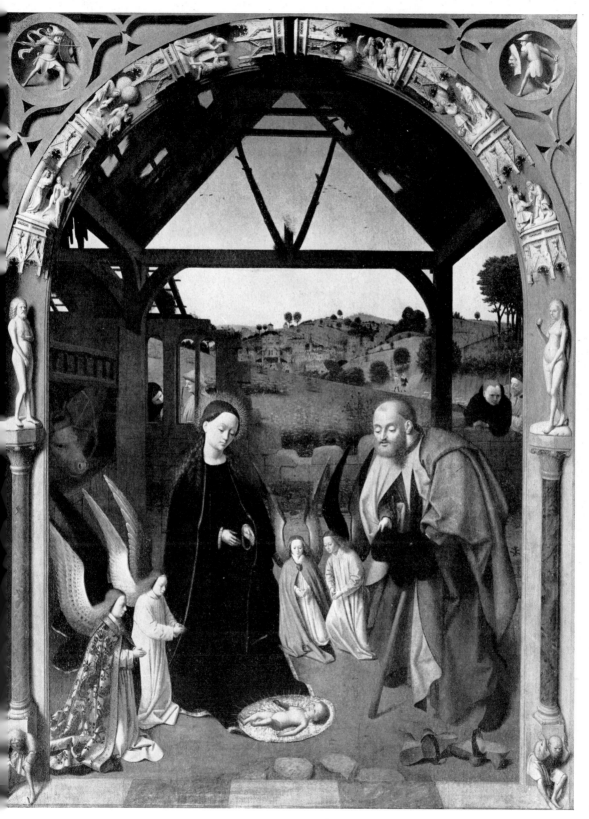

37 Petrus Christus: *The Nativity*. Washington, National Gallery.

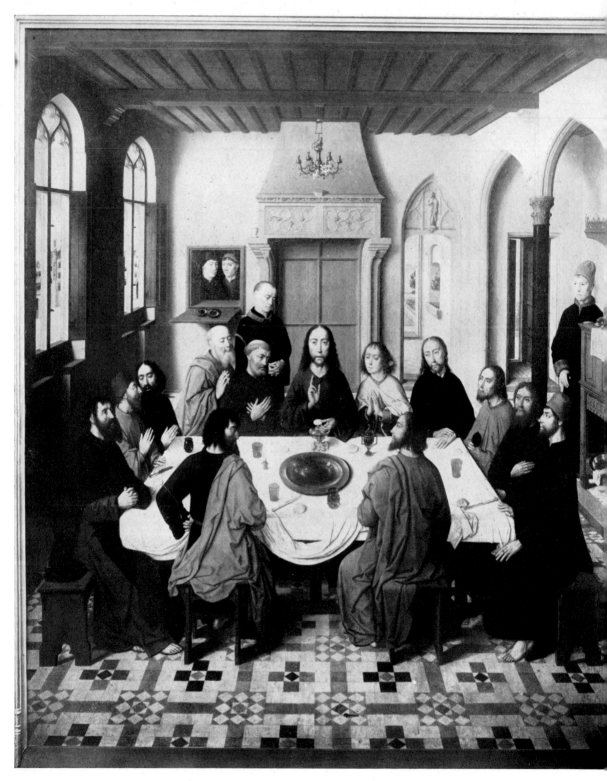

38 Dirk Bouts: *The Last Supper altar (centre panel)* (1464–68). Louvain, S. Pierre.

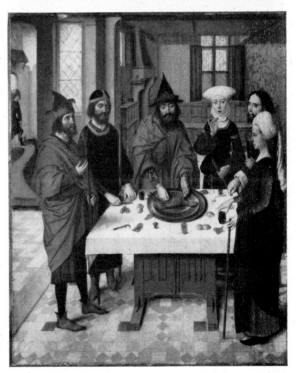

39(a) Dirk Bouts: *The Last Supper altar* (*left wing panels*) (1464–68). Louvain, S. Pierre.

39(b) Dirk Bouts: *The Last Supper altar* (*right wing panels*) (1464–68). Louvain, S. Pierre.

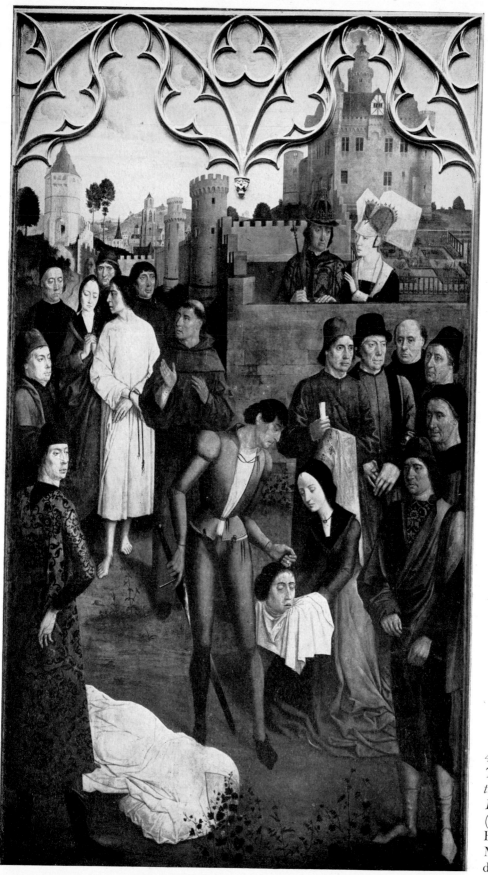

40 Dirk Bouts:
*The Justice of
the Emperor Otto,
Execution panel*
(1473–82).
Brussels,
Musées Royaux
des Beaux-Arts.

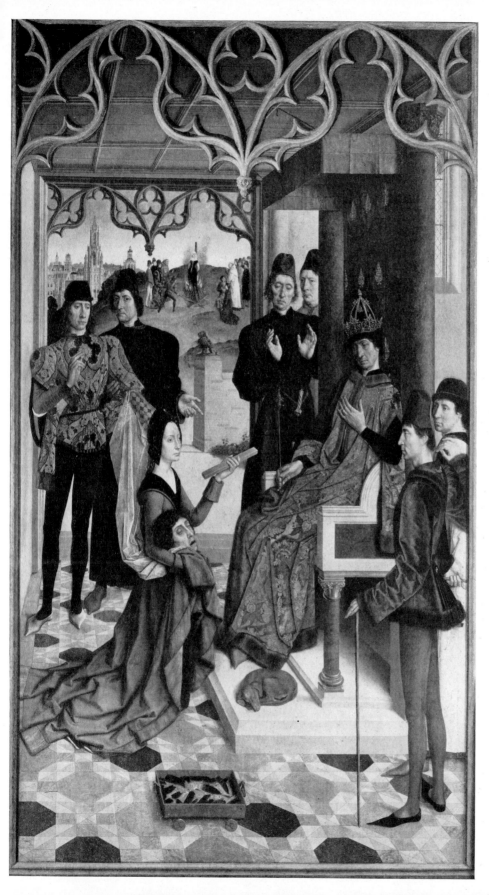

41 Dirk Bouts:
*The Justice of
the Emperor Otto,
The Ordeal by Fire*
(1470–73).
Brussels,
Musées Royaux
des Beaux-Arts.

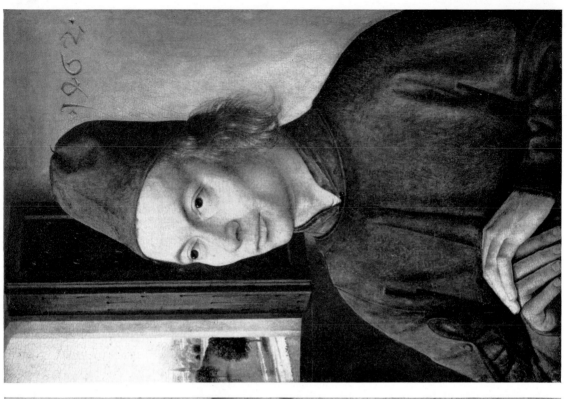

42(a) Dirk Bouts : *The Justice of the Emperor Otto. The Ordeal by Fire* (detail) (1470–73). Brussels, Musées Royaux des Beaux-Arts.

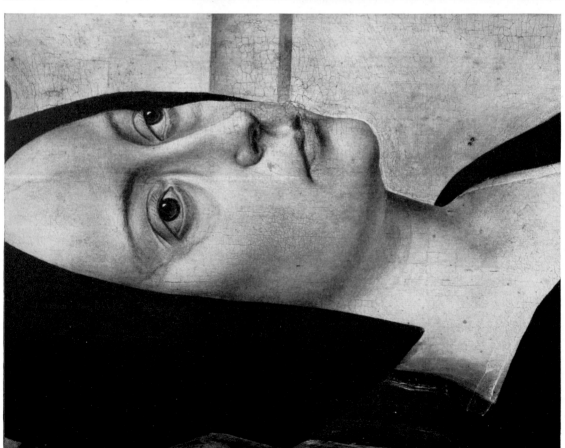

42(b) Dirk Bouts : *Portrait of a Man* (1462). London, National Gallery.

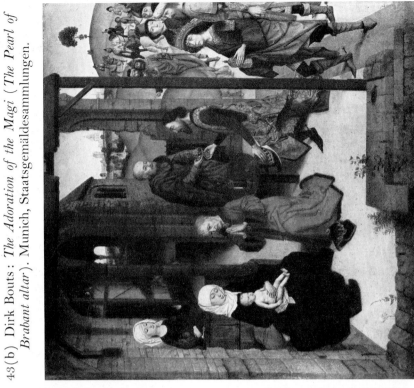

43(a) Dirk Bouts: *The Descent from the Cross.* Granada, Capilla Real.

43(b) Dirk Bouts: *The Adoration of the Magi (The Pearl of Brabant altar).* Munich, Staatsgemäldesammlungen.

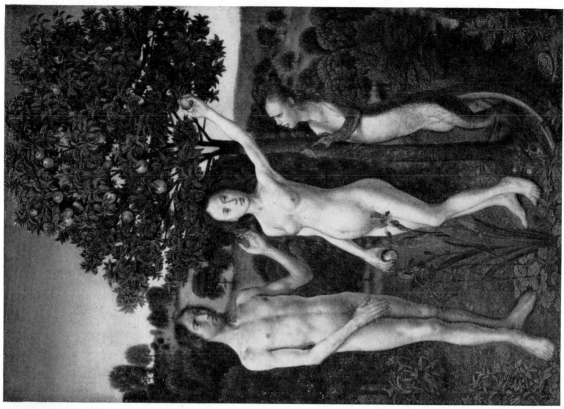

44(b) Hugo van der Goes: *The Fall of Man.*
Vienna, Kunsthistorisches Museum.

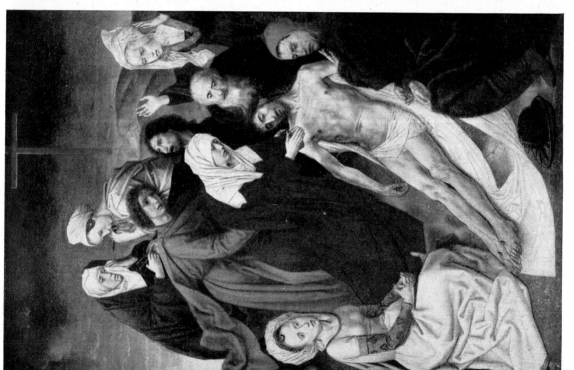

44(a) Hugo van der Goes: *The Lamentation.*
Vienna, Kunsthistorisches Museum.

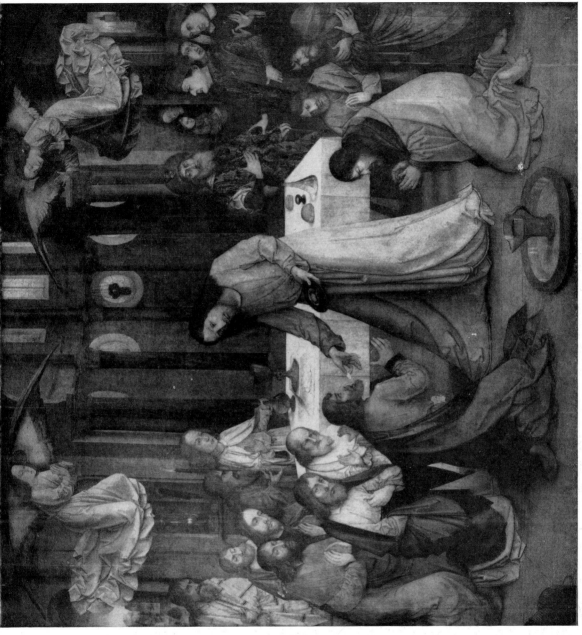

45

Justus of Ghent:
*The Communion
of the Apostles* (1472).
Urbino, Palazzo Ducale.

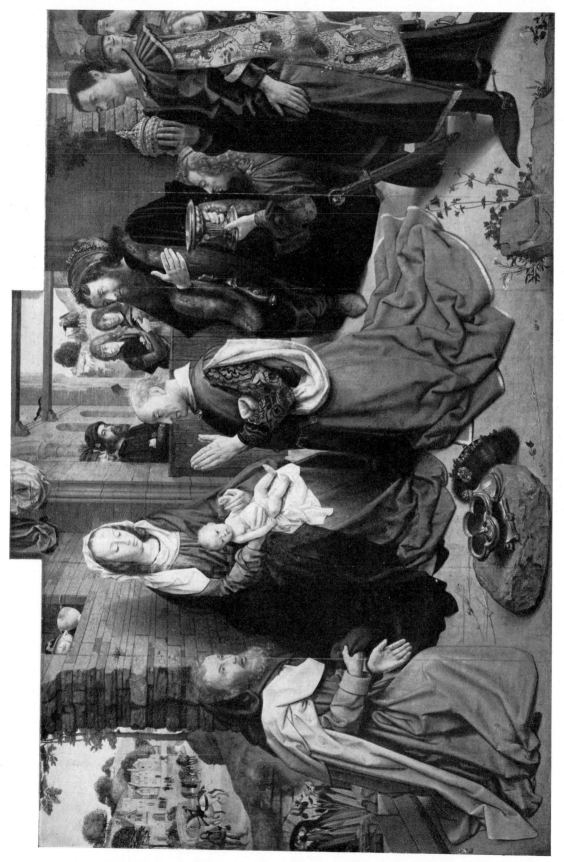

46 Hugo van der Goes: *The Adoration of the Magi (The Monforte altar)*. Berlin-Dahlem, Staatliche Museen.

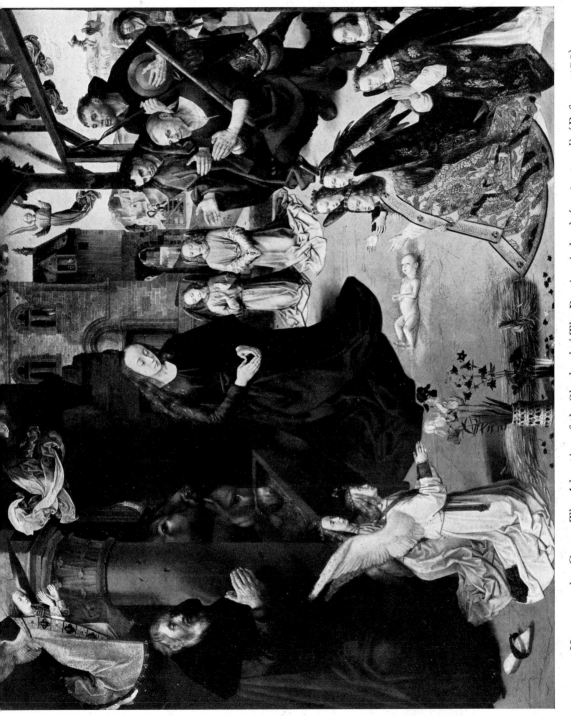

47 Hugo van der Goes: *The Adoration of the Shepherds* (*The Portinari altar*) (*centre panel*) (Before 1476). Florence, Uffizi.

48(a) Hugo van der Goes: *The Portinari altar*
(*left wing*) (Before 1476). Florence, Uffizi.

48(b) Hugo van der Goes: *The Portinari altar*
(*right wing*) (Before 1476). Florence, Uffizi.

49 Hugo van der Goes: *The Portinari altar (detail of right wing)* (Before 1476). Florence, Uffizi.

50 Hugo van der Goes : *The Death of the Virgin*. Bruges, Musée Communale des Beaux-Arts.

51(a) Hugo van der Goes : *The Portinari altar* (*detail of left wing*)
(Before 1476). Florence, Uffizi.

51(b) Hugo van der Goes : *The Death of the Virgin* (*detail*). Bruges, Musée Communale des
Beaux-Arts.

52 (a) Hugo van der Goes:
The Bonkil wings,
The Trinity.
H.M. the Queen
(on loan to National
Gallery of Scotland,
Edinburgh).

52 (b)
Hugo van der Goes:
The Bonkil wings,
donor panel.
H.M. the Queen
(on loan to National
Gallery of Scotland,
Edinburgh).

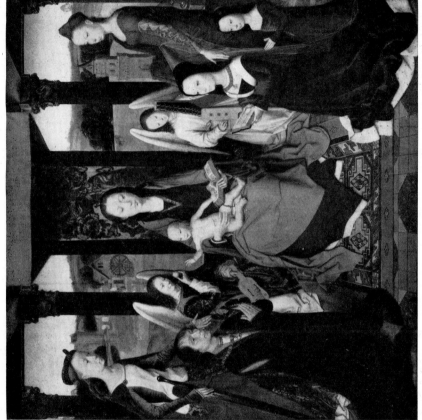

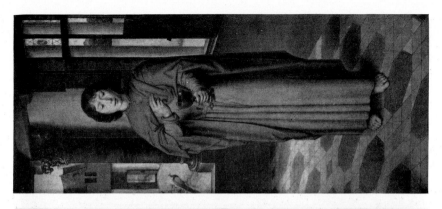

53 Hans Memlinc: *The Donne Triptych.* London, National Gallery.

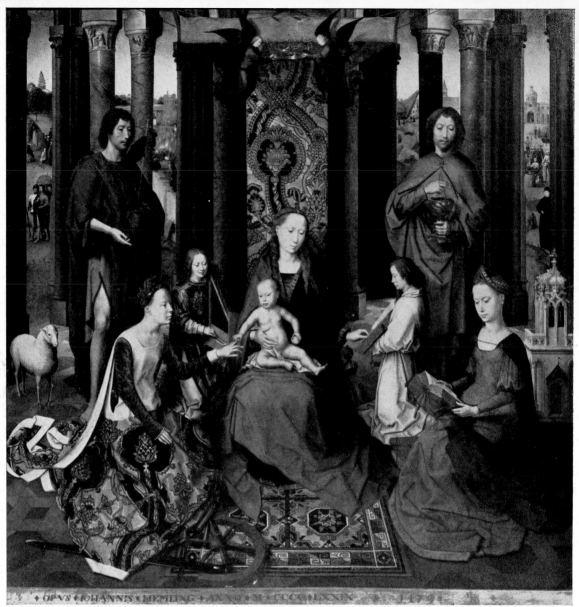

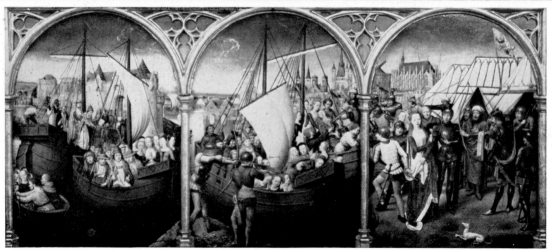

54 Hans Memlinc: (a) *The Marriage of St. Catherine* (1479); (b) *The Shrine of St. Ursula* (1489). Bruges, Hôpital de St. Jean.

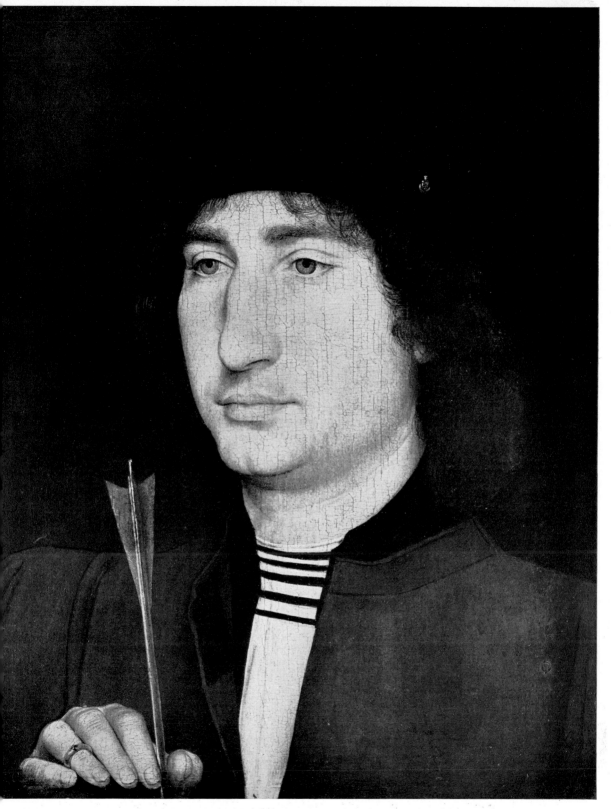

55 Hans Memlinc: *The Man with the Arrow*. Washington, National Gallery.

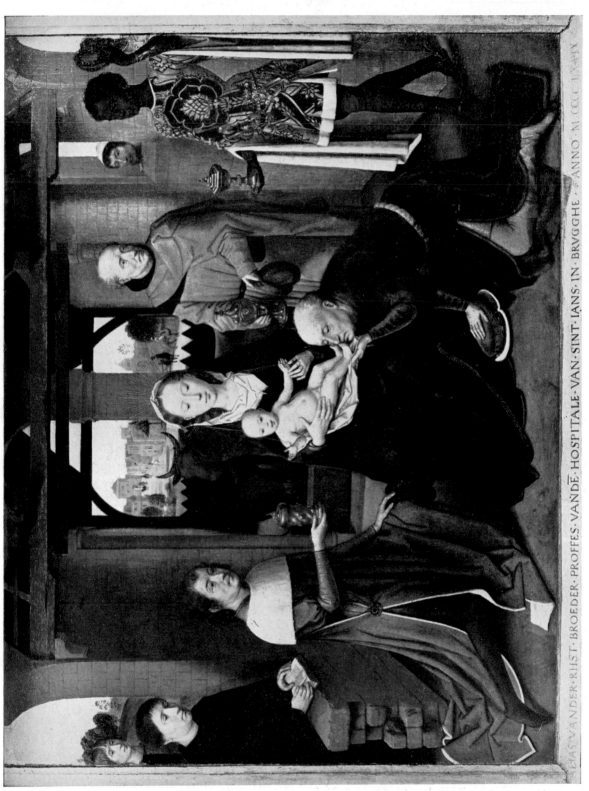

56 Hans Memlinc: *The Adoration of the Magi (The Floreins altar)* (1479). Bruges, Hôpital de St. Jean.

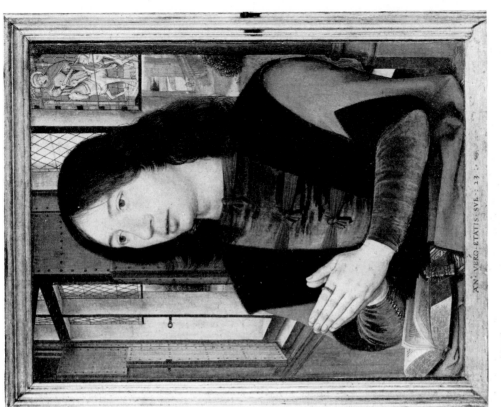

57(a) Hans Memlinc: *The Diptych of Martin van Nieuwenhove (left panel)* (1487). Bruges, Hôpital de St. Jean.

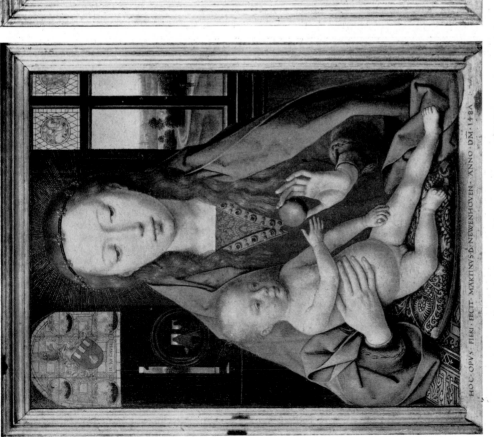

57(b) Hans Memlinc: *The Diptych of Martin van Nieuwenhove (right panel)* (1487). Bruges, Hôpital de St. Jean.

58(a) Geertgen tot Sin Jans: *The Virgin in Glory.* Rotterdam, Boymans-Van Beuningen Museum.

58(b) Hans Memlinc: *Portrait of a Man.* Venice, Accademia.

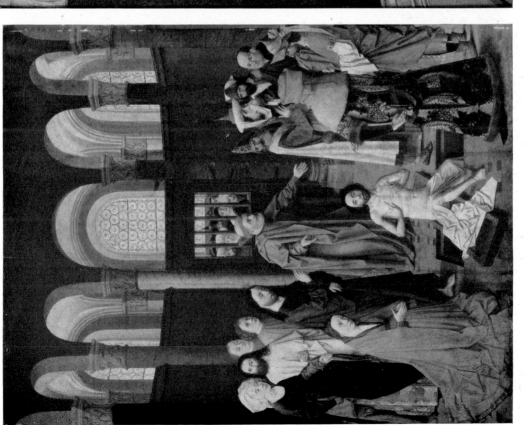

59(a) Aelbert van Ouwater: *The Raising of Lazarus*. Berlin-
Dahlem, Staatliche Museen.

59(b) Geertgen tot Sin Jans: *The Relations of the Virgin in a
Church*. Amsterdam, Rijksmuseum.

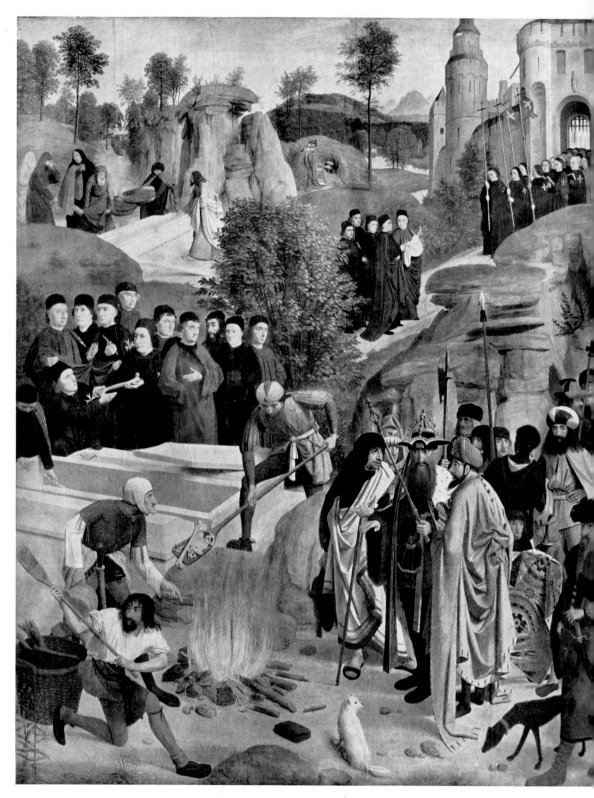

60 Geertgen tot Sin Jans: *The Burning of the Bones of St. John the Baptist.*
Vienna, Kunsthistorisches Museum.

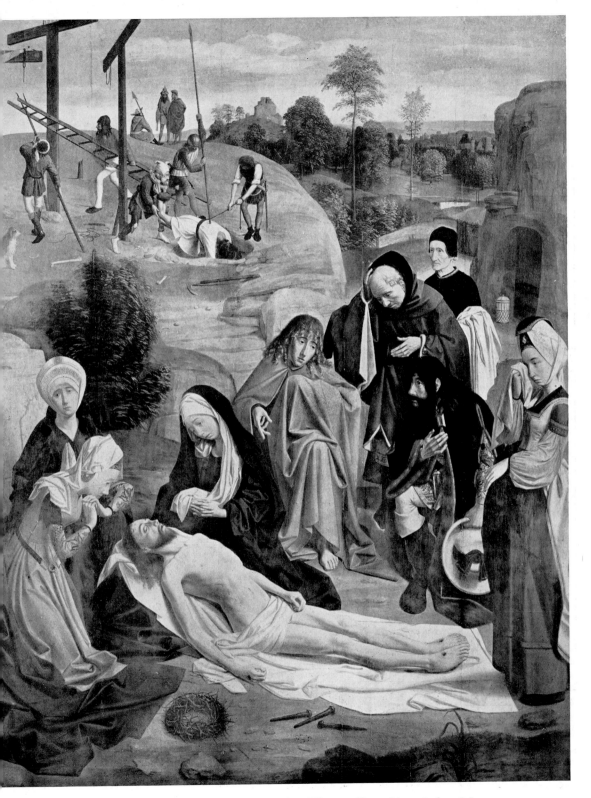

61 Geertgen tot Sin Jans : *The Lamentation*. Vienna, Kunsthistorisches Museum.

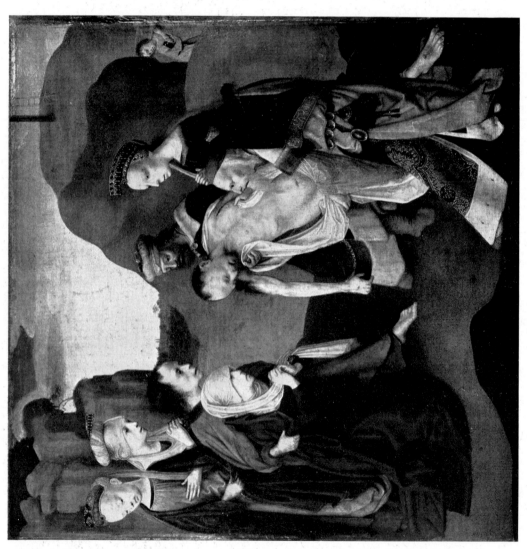

62 The Master of the Virgo inter Virgines : *The Entombment.*
Liverpool, Walker Art Gallery.

63 Geertgen tot Sin Jans : *Christ as the Man of Sorrows*. Utrecht, Centraal Museum.

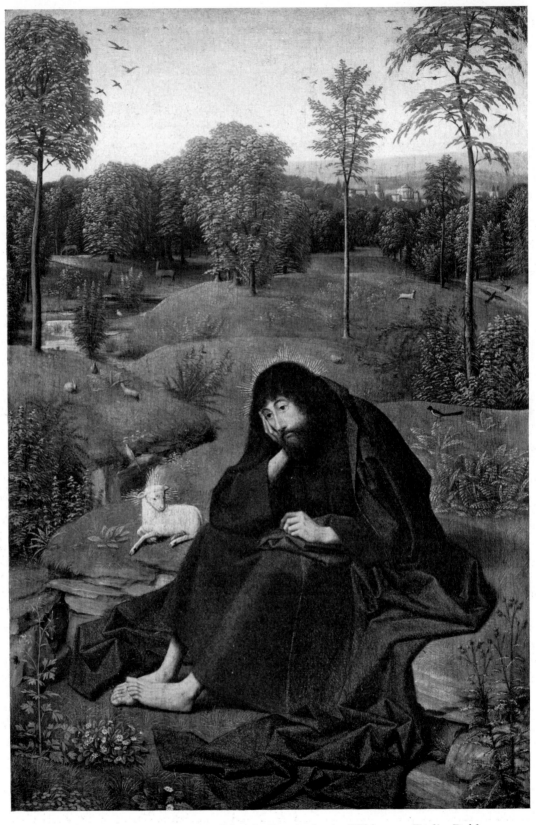

64 Geertgen tot Sin Jans: *St. John the Baptist in the Wilderness*. Berlin-Dahlem,
Staatliche Museen.

65 Jerome Bosch: *The Cure of Folly*. Madrid, Prado.

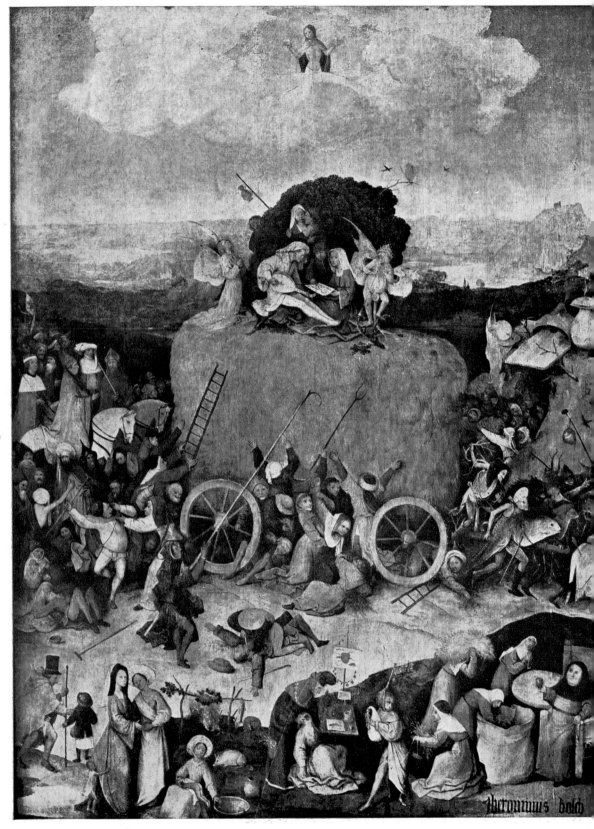

66 Jerome Bosch: *The Hay-wain* (*centre panel*). Madrid, Prado.

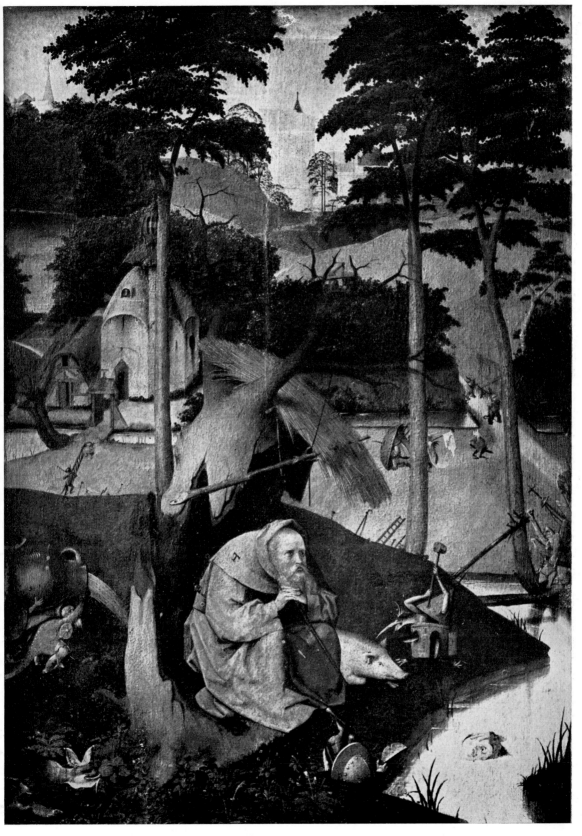

67 Jerome Bosch: *The Temptation of St. Anthony*. Madrid, Prado.

68 Jerome Bosch: *The Temptation of St. Anthony*. Lisbon, Museu Nacional de Arte Antiga.

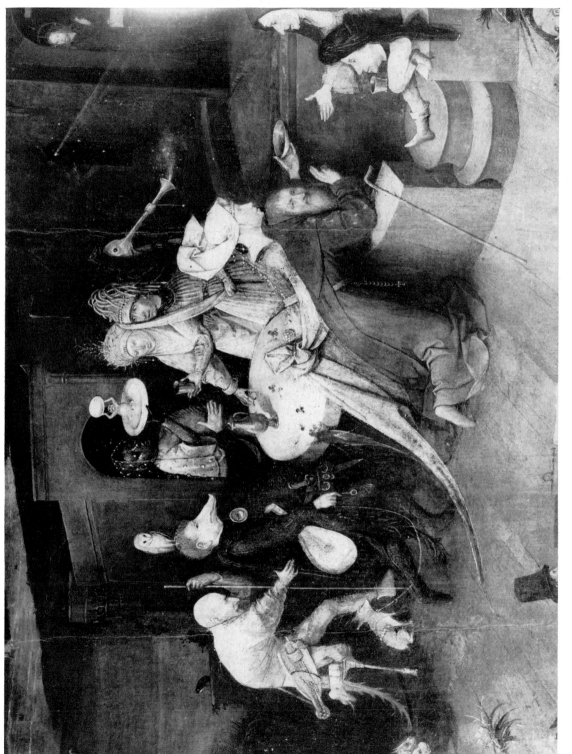

69 Jerome Bosch: *The Temptation of St. Anthony* (*detail*). Lisbon, Museu Nacional de Arte Antiga.

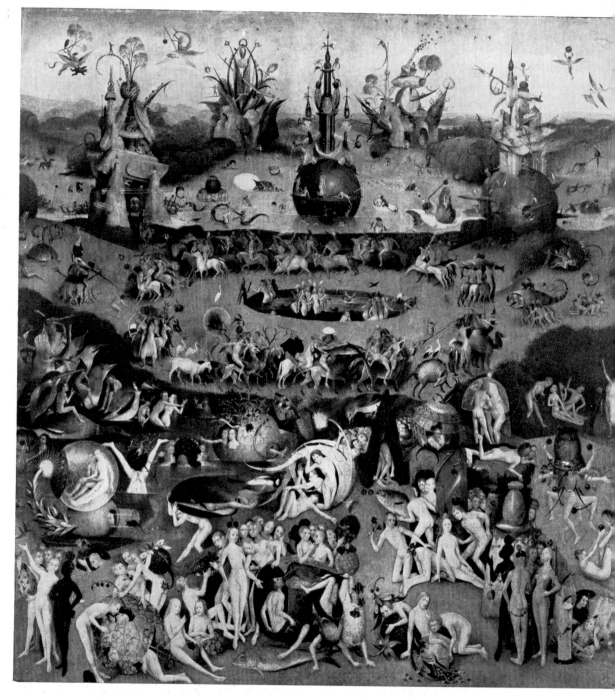

70 Jerome Bosch: *The Garden of Delights* (*centre panel*). Madrid, Prado.

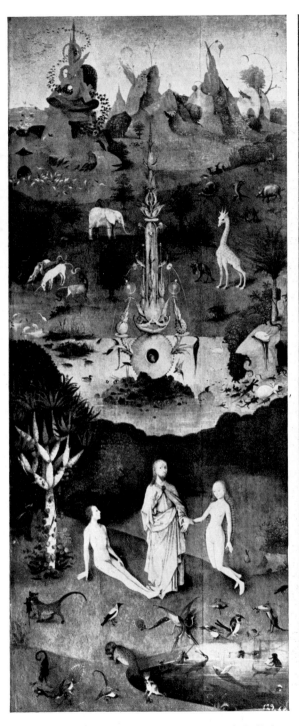

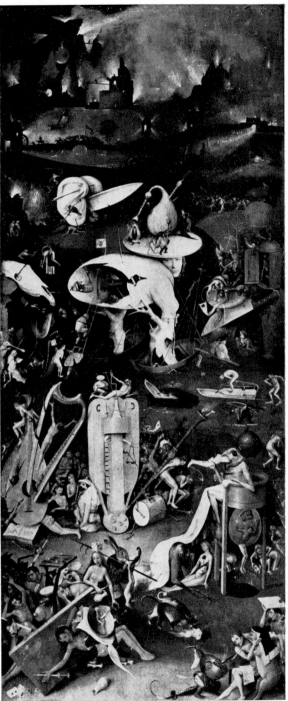

71(a) Jerome Bosch: *The Garden of Delights*
(*left wing*). Madrid, Prado.

71(b) Jerome Bosch: *The Garden of Delights*
(*right wing*). Madrid, Prado.

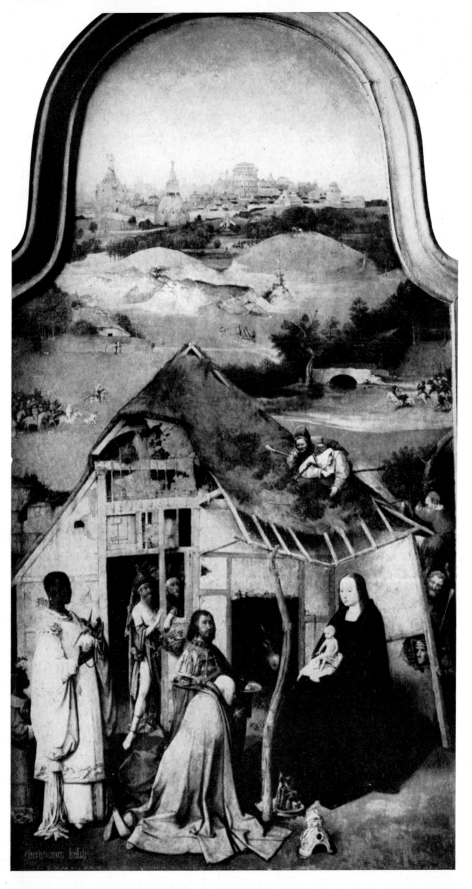

72
Jerome Bosch:
*The Adoration
of the Magi.*
Madrid, Prado.

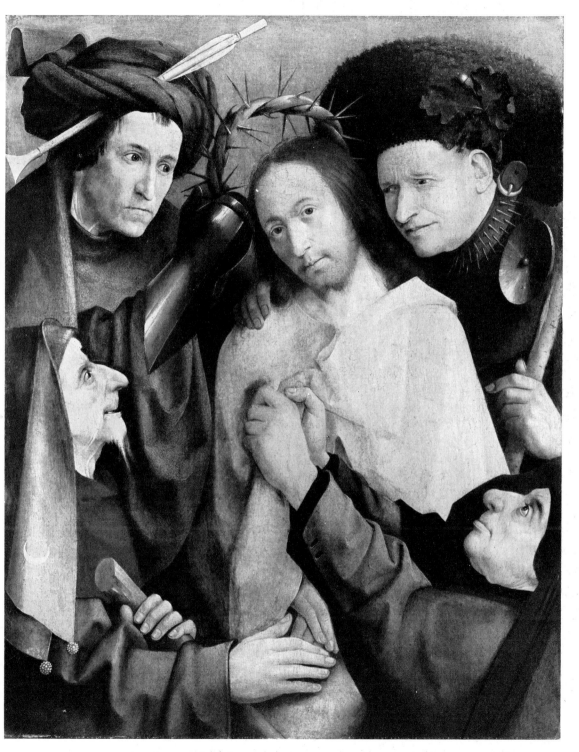

73 Jerome Bosch: *Christ Mocked*. London, National Gallery.

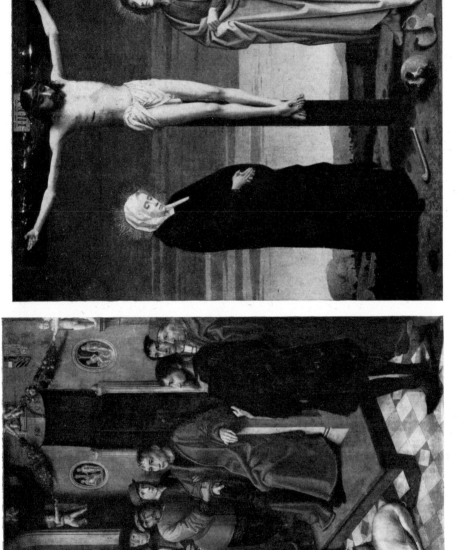

74(a) Gerard David: *The Judgment of Cambyses* (1498). 74(b) Gerard David: *The Crucifixion*. Genoa, Palazzo Bianco. Bruges, Musée Communale des Beaux-Arts.

75 Gerard David : *The Baptism of Christ* (1502–8). Bruges, Musée Communale des Beaux-Arts.

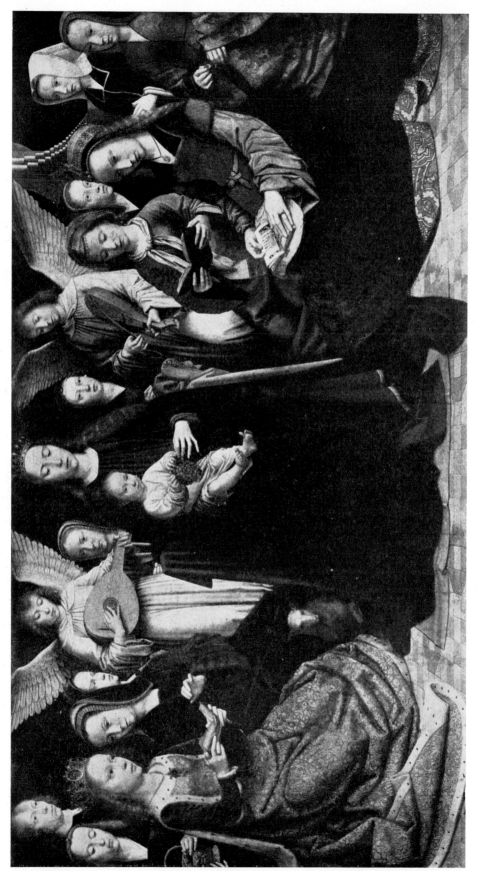

76 Gerard David: *The Virgin and Child with female Saints* (1509). Rouen, Musée.

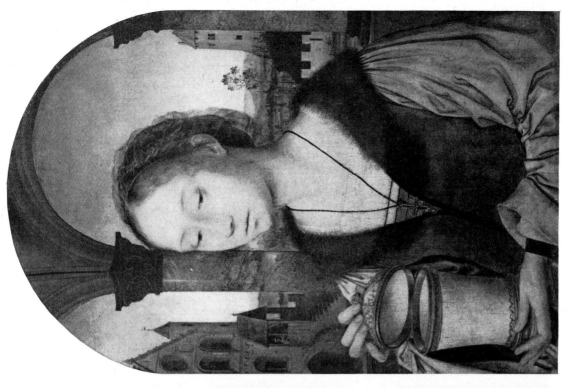

77(b) Quentin Matsys: *St. Mary Magdalen.* Antwerp, Musée Royal des Beaux-Arts.

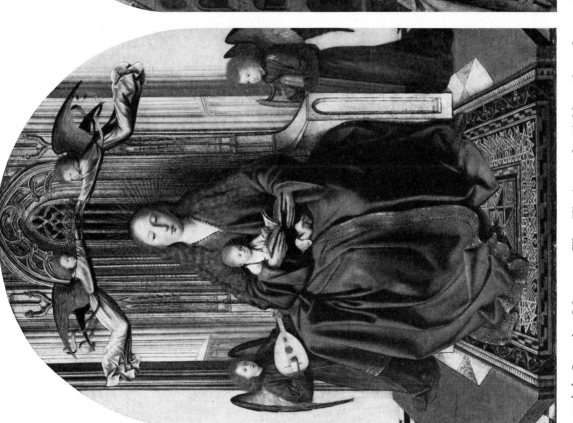

77(a) Quentin Matsys: *The Virgin and Child enthroned.* London, National Gallery.

78 Gerard David: *The Virgin with a Bowl of Milk*. Brussels, Musées Royaux des Beaux-Arts.

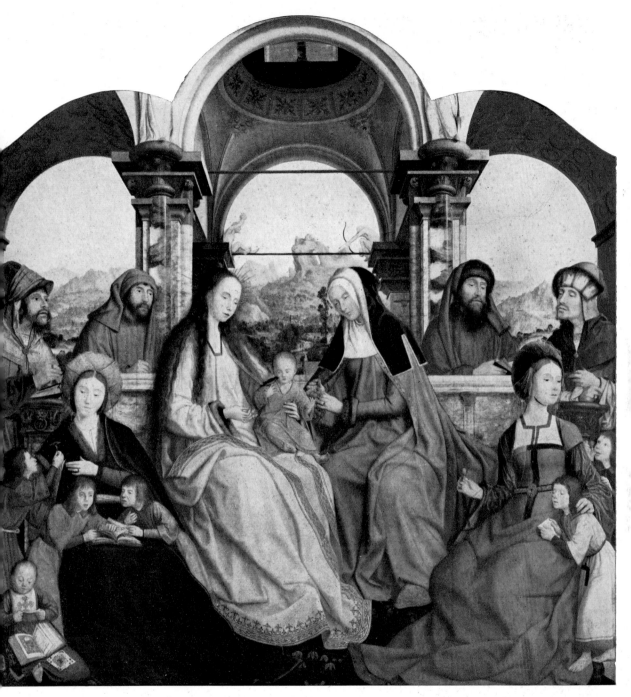

79 Quentin Matsys: *The St. Anne altar (centre panel)* (*1507–9*).
Brussels, Musées Royaux des Beaux-Arts.

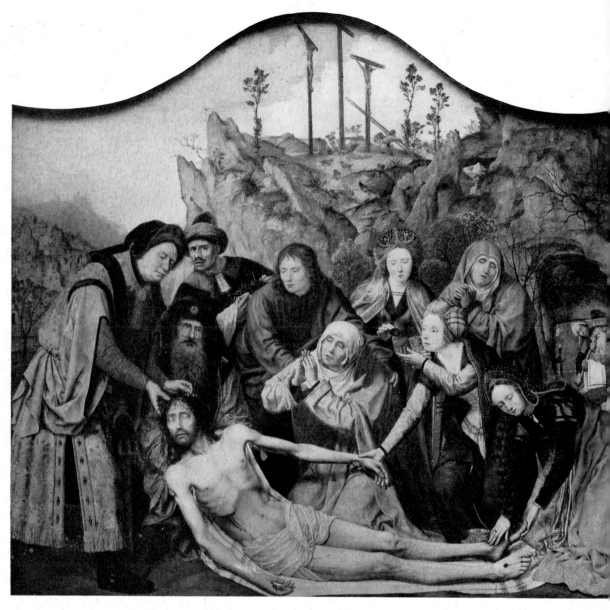

80 Quentin Matsys: *The Entombment* (1508–11). Antwerp, Musée Royal des Beaux-Arts.

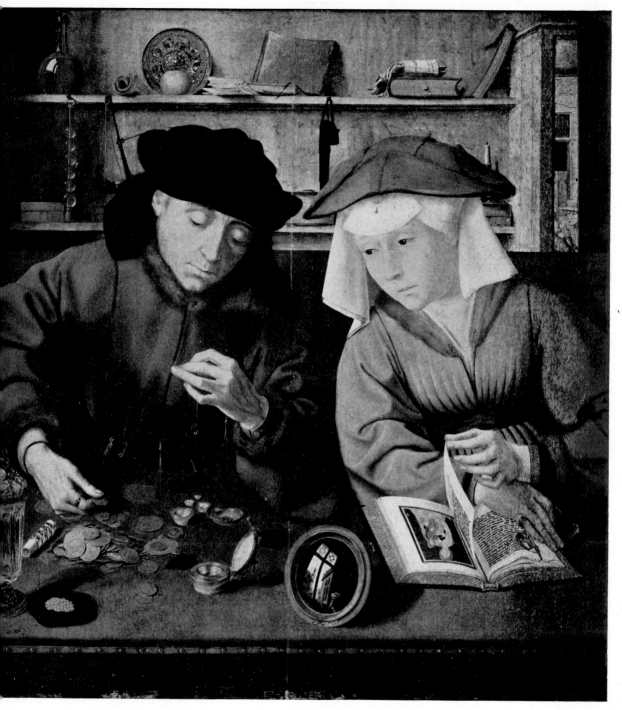

81 Quentin Matsys: *The Banker and his Wife* (1512). Paris, Louvre.

82(a) Quentin Matsys: *Erasmus* (1517). Rome, Museo Nazionale. 82(b) Quentin Matsys: *Aegidius* (1517). Longford Castle, Earl of Radnor Coll.

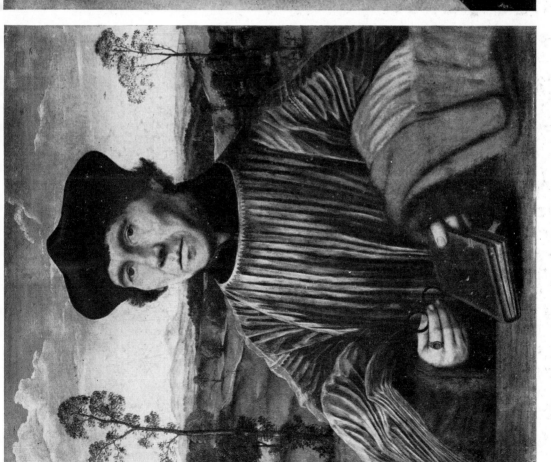

83(a) Quentin Matsys: *Portrait of a Man* (1513). →
Paris, Jacquemart-André Museum.

← 83(b) Quentin Matsys: *Portrait of a Canon*. Vaduz,
H.S.H. The Prince of Liechtenstein Coll.

for (a) read (b)

84(a) Quentin Matsys: *Portrait of a Man.* Frankfurt, Staedel Institut.

84(b) Bernard van Orley: *Dr. Georges de Zelle.* Brussels, Musées Royaux des Beaux-Arts.

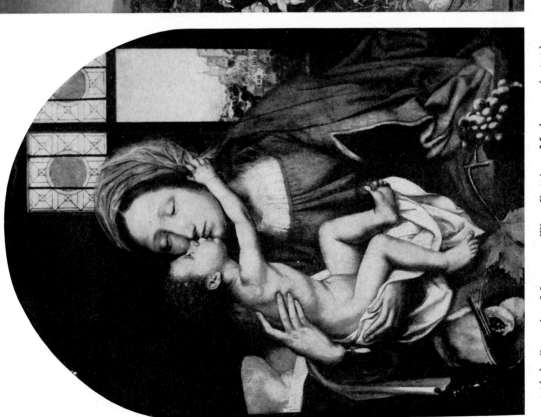

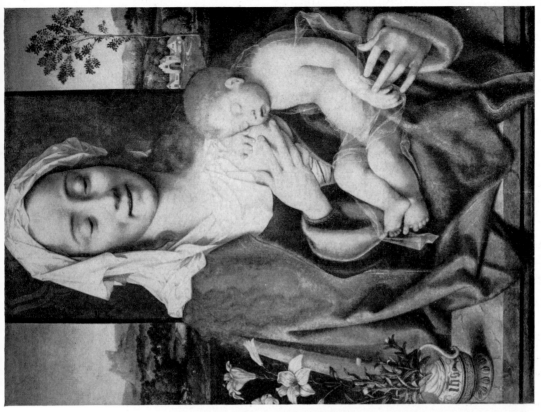

85(a) Quentin Matsys: *The Rattier Madonna* (1529). Paris, Louvre.

85(b) Joos van Cleve: *The Virgin and Child*. Cambridge, Fitzwilliam Museum.

86(a)
Quentin Matsys
and
Joachim Patinir:
*The Temptation
of St. Anthony.*
Madrid, Prado.

86(b)
Joachim
Patinir:
St. Jerome.
Madrid, Prado

87 Joachim Patinir: *St. Jerome* (*detail*). Madrid, Prado.

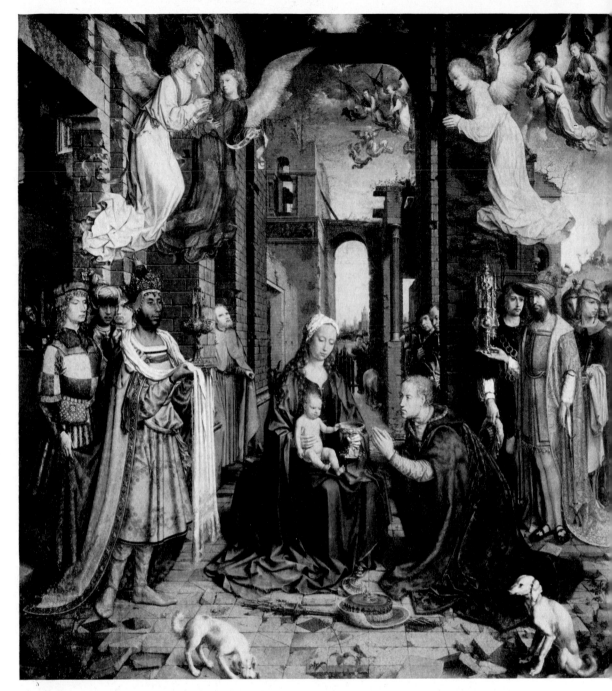

88 Mabuse: *The Adoration of the Magi*. London, National Gallery.

89 Mabuse: *The Virgin and Child* (*The Malvagna Triptych, centre panel*). Palermo, Museo.

90 Mabuse: *St. Luke painting the Virgin*. Prague, Rudolfinum.

91 Adriaen Isenbrandt: *The Virgin of Sorrows*. Bruges, Musée Communale des Beaux-Arts.

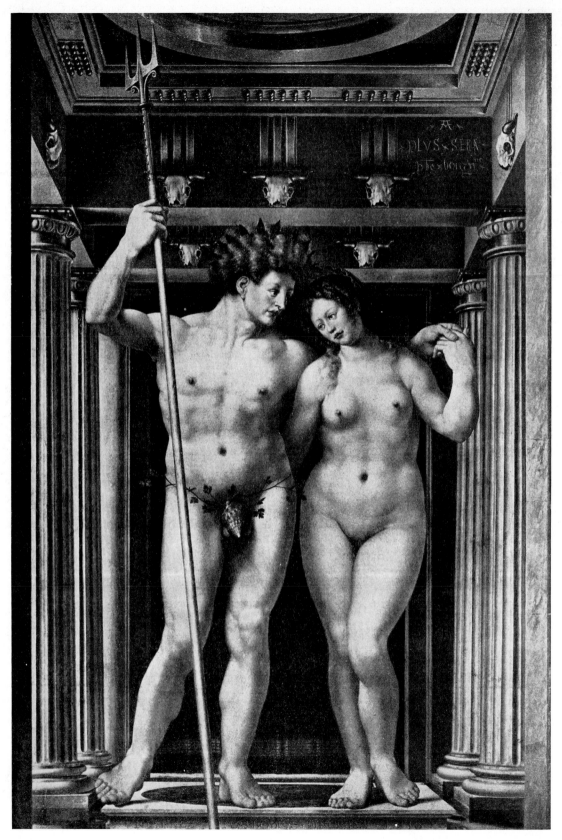

92 Mabuse: *Neptune and Amphitrite* (1516). Berlin-Dahlem, Staatliche Museen.

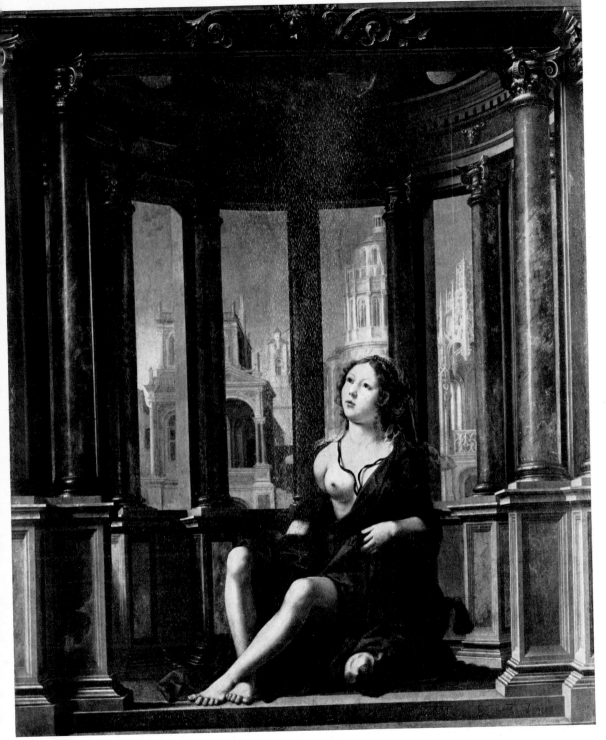

93 Mabuse: *Danae* (1527). Munich, Staatsgemäldesammlungen.

94(a) Mabuse: *The Children of Christian II of Denmark* (After 1523). H.M. the Queen.
Hampton Court Palace.

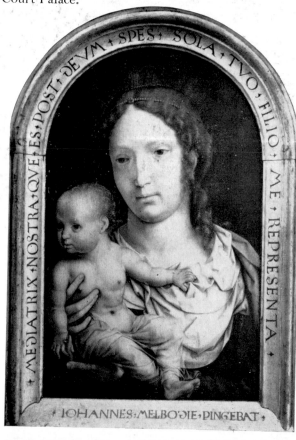

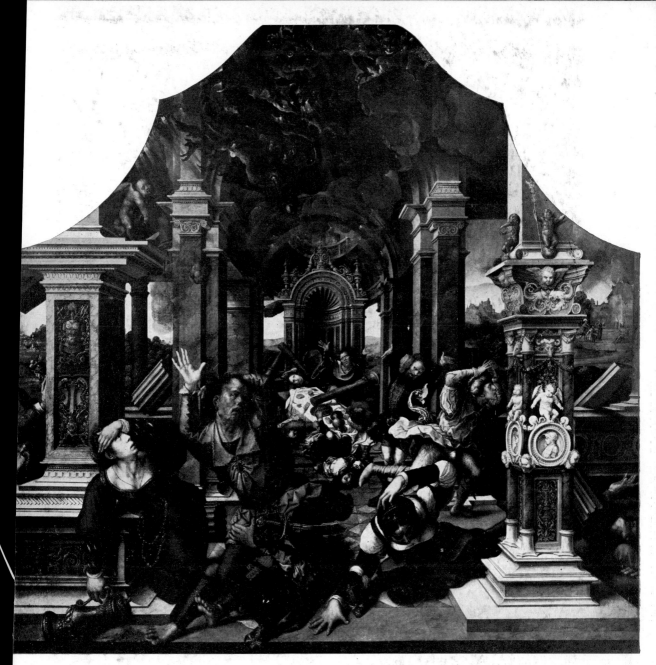

95 Bernard van Orley: *The Trials of Job* (1521). Brussels, Musées Royaux des Beaux-Arts.

Opposite
94(b) Mabuse: *The Carondelet Diptych (left panel)* (1517). Paris, Louvre.
94(c) Mabuse: *The Carondelet Diptych (right panel)* (1517). Paris, Louvre.

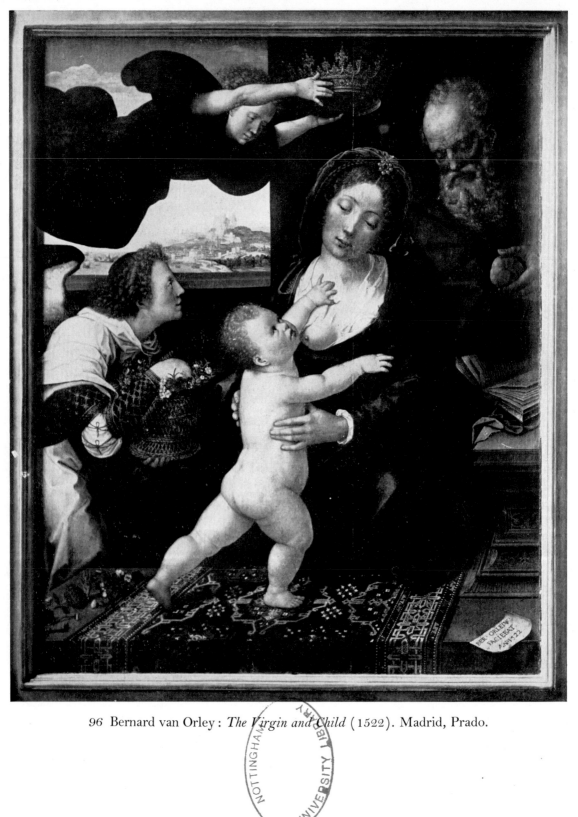

96 Bernard van Orley: *The Virgin and Child* (1522). Madrid, Prado.